"The twilight zone that lies between living memory and written history is one of the favorite breeding places of mythology...It is my hope in these pages to turn a few beams of light into the twilight zone and if possible to light up a few of its corners."

C. Vann Woodward
The Strange Career of Jim Crow

"A historian, in my estimation, has to do two things, especially when dealing with a subject such as this: one, research and analyze; and two, remember that there is a story to be told, a story that relates to people's lives. So a real historian is also a person who tells [true] stories...a historian must also be a teacher, and teachers have to remember that their pupils, and indeed themselves, are just like the people they talk about in their telling of history."

Yehuda Bauer
Rethinking the Holocaust

"Every moment one delays his efforts to redeem captives when he could have helped them, is considered as if he had shed blood."

Shulchan Aruch
Yoreh De'ah *252:3*

Barbara Jacobs

the Virginia Plan

WILLIAM B. THALHIMER
& A RESCUE FROM NAZI GERMANY

Robert H. Gillette

Foreword by Elizabeth Thalhimer Smartt

Charleston · London

THE
History
PRESS

Published by The History Press
Charleston, SC 29403
www.historypress.net

First published 2011

Manufactured in the United States

ISBN 978.1.60949.171.0

Library of Congress Cataloging-in-Publication Data

Gillette, Robert H.
The Virginia plan : William B. Thalhimer and a Rescue from Nazi Germany / Robert H.
Gillette.
p. cm.
Includes bibliographical references and index.
ISBN 978-1-60949-171-0
1. Hyde Farmlands. 2. Jews--Virginia--Burkeville--History--20th century. 3. World War,
1939-1945--Jews--Rescue--United States. 4. Jewish refugees--Virginia--Burkeville. 5. Jews,
German--Virginia--Burkeville. 6. Jews--Germany--History--1933-1945. 7. Jewish youth-
-Germany--History--20th century. 8. Jüdisches Auswandererlehrgut Gross-Breesen. 9.
Thalhimer family. 10. Bondy, Curt, 1894-1972. 11. Virginia--Emigration and immigration.
12. Burkeville (Va.)--Ethnic relations. I. Title.
F234.B87.G55 2011
975.5'637--dc22
2011002120

My Hope…

That this book adequately honors the memories of William B. Thalhimer and Dr. Curt Bondy, for their courage and unlimited desire to rescue young people from Nazi Germany.

That the "Gross Breesen Spirit" that was embodied within each student's lifelong love of life itself be conveyed to generations to come and give them hope and guidance.

That this book testifies to the best inclinations of the human spirit.

For Jodi Gillette, who clung to the hunch that there was a glorious story at Hyde Farmlands and urged me to find out.

CONTENTS

CONTENTS

FOREWORD

My great-grandfather, William B. Thalhimer Sr. (known to our family as "Gramps"), saved dozens of German Jewish teenagers from Nazi persecution by instituting the Hyde Farmlands project. One might think that our family has proudly passed down stories of Gramps's experiences with the farm, but the opposite has happened. The stories were brushed under the rug and rarely discussed. We heard tidbits about Hyde Farmlands over the years, but nothing substantial.

When I wrote the book *Finding Thalhimers* about six generations of my paternal family and the history of their department store, Thalhimers, I began to uncover layers of the Hyde Farmlands story. I met original Hyde Farmlanders and trekked around the farm with them in September 2004, microphone and digital tape recorder in hand. I scouted out the old chicken coops with Ernst Cramer, explored the main farmhouse with George Landecker and, months later, attended synagogue services with Hans George Hirsch. Their unshakable resilience, strength of character and love of life was exhilarating. I had the pleasure of meeting these incredible survivors because of something phenomenal that my great-grandfather did almost seventy years prior, something about which I still knew very little.

With trembling hands, I read Werner T. Angress's *Between Fear and Hope: Jewish Youth in the Third Reich*, which included mentions of Gramps's involvement in bringing the young refugees to a remote farm that he had purchased with his cousin in rural Virginia. The more I learned, the more I sought to know. Writing my own book required research on nearly two centuries of history, and unfortunately I could not focus solely on researching Hyde Farmlands.

Things changed the day my father, William B. Thalhimer III, and I met Bob Gillette at the Virginia Holocaust Museum. We had been informed by one of the museum staff that Mr. Gillette was interested in the Hyde Farmlands story. Seven months pregnant, I slowly eased into a chair and listened as Mr. Gillette spoke of his own unusual discovery of Hyde Farmlands and of his desire to document the whole story. I felt such joy, delight and relief that someone else, who happened to be a respected former educator, wanted to pursue diligent study of this little-known chapter in our family's history, as well as the overarching history of American immigration in the 1930s.

I feel that same joy now as I introduce this story to you. After reading, I hope that you will pass this book along to others so that it will not be forgotten. Set during a time of unspeakable tragedy and human failing, the Hyde Farmlands story invokes hope, spirit and something that Gramps called "stick-to-it-iveness." It is a ray of light shining through the darkest part of the attic. Thanks to Bob Gillette, it is now once again illuminated.

–Elizabeth Thalhimer Smartt

ACKNOWLEDGEMENTS

T hroughout my research, even people who did not know me opened their doors and welcomed me into their homes, their libraries and their memories. To all I am indebted, for their helpfulness and their trust.

My research journey started in and eventually returned to Richmond, Virginia. At the Virginia Holocaust Museum, Dianna Gabay—curator, archivist and director of exhibitions and collections—was my greatest cheerleader right from the beginning. She led me through the tangled jungle of archives and photographs and connected me to the Thalhimers. Bonnie Eisenman, director of the Beth Ahabah archives, steered me to Thalhimer materials. Inge Horowitz connected me to people in the community and to her memories of Dr. Curt Bondy as a professor. The Thalhimer family offered insights and materials: Charles Thalhimer, son of William Thalhimer, shared memories and photographs; Barbara Thalhimer, daughter-in-law of William, allowed me to peek into Thalhimer family life; William Thalhimer III shared his enthusiasm for the project; his daughter, Elizabeth, William's great-granddaughter and author of *Finding Thalhimers*, shared family archives and encouraged me so that her own family could learn more about a family patriarch; and the son of William's cousin Morton Thalhimer, also Morton, provided materials and insights into his father's life and personality. Richard Hamlin shared stories of being a neighbor to those at Hyde Farmlands. John Cohen, son of Leroy Cohen, and Lou Bowman fleshed out Leroy's personality.

Monty and Donna Stokes, "caretakers" of Hyde Farmlands, opened the farm and provided historical background. Through love and commitment,

they have single-handedly brought the farm back to life and restored it to vintage condition. Joanne Casper, daughter of Ann Scott (who still owns the farm), graciously unlocked the gates and donated tools that the students had used in the 1930s. In Crewe, Francis and Gloria Weishaar warmly provided information about their town, its people and Piedmont Sanitarium. Edwina and Julian Covington of Prospect taught me about tobacco and farming life in the 1930s. Greg Eanes taught me about Civil War history and the local Civilian Conservation Corps (CCC) camps. Dr. Paul Siegel and Suzie Jackson of Virginia Tech shared their enthusiasm for the project, and Paul also provided vast insight into raising chickens.

At the Leo Baeck Institute, Dr. Frank Mecklenburg was constantly enthusiastic about the project and aided me in my research. Gunner Berg helped me find significant material. At the National Archives, David Pfieffer, the star of all archivists, led me to the State Department files on Hyde Farmlands, and Louis Holland steered us through the microfilm collection. Larry Hall, the *Times-Dispatch* librarian, helped me find real history in the making through newspapers. Phyllis Collazo and Marvin Orellana of the *New York Times* and Radhika Chauhan of Redux Pictures helped me acquire Raymond Geist's photograph. Candace Thompson, reference librarian at the Lynchburg Public Library, procured even the obscurest publications through the magic of interlibrary loan. Laurie Rizzo, librarian at the special collections (George S. Messersmith Papers) center at the University of Delaware, cheerfully made my research life easier. The research staff of the University of Virginia's Alderman Library patiently taught me how to manage the microfilm machines and directed me through the maze of stacks. Jennie Cole of the American Jewish Archives provided important Thalhimer/Billikopf letters. Shelley Helfand of the Joint Distribution Committee steered me in untapped directions. Steve Strauss encouraged my efforts and shared the archival photographs of his historical exhibit on Gross Breesen. Nelson Lankford of the Virginia Historical Society introduced me to The History Press.

Bat Ami Zucker, history professor at Bar-Ilan University, Israel, encouraged my research and provided insight into the immigration realities of the 1930s. Dr. Gabriel N. Finder of the University of Virginia shared his studies of the early professional life of Dr. Curt Bondy. Dr. Phyllis Leffler of the University of Virginia boosted my efforts continually.

Herbert Cohn (Herko) opened the world of Gross Breesen and Hyde Farmlands through the *Circular Letters* (see bibliography note) and communicated regularly from Australia. George Landecker and his wife,

Jesse, hosted us and continually communicated through telephone and e-mail. He was a principal supporter of Hyde Farmlands and Gross Breesen reunions. He willingly shared his photographs and experiences. Eva Loew sent me her Hyde Farmlands diary, photographs and even the seed tags purchased on the farm. Her memory of events and people astounds me. Her daughter, Jacqueline Jacobsohn, sensitively transcribed her mother's diaries and helped translate them from German to English. Her natural "feel" for her mother's experiences enlightened me. Werner Angress (Tom), who recently died, sent me his personal diary and other writings in German. He was the most prolific historian of the Gross Breesen/Hyde Farmlands experience. A fellow Wesleyan University alumnus, he spoke encouragingly from his home in Berlin. His children—Percy, Nadine and Miriam—all contributed to understanding their father's experience and providing photographs. Dr. Hans George Hirsch, son of Dr. Otto Hirsch, welcomed me into his home several times and offered insights into the people and history of the times.

The Southern Jewish Historical Society demonstrated its faith in the project by awarding me a research/writing grant in 2009. Members were intrigued and supportive, especially Sumner Levine and Phyllis Leffler. Mark Bauman, editor of the society's annual publication, encouraged my research and shared his vast knowledge of the publishing world.

My old Wesleyan University roommate, Svend Waltenberg of Copenhagen, translated from the German parts of Werner Angress's writing. Ellen Hinkson, recorder partner, also extensively translated Angress's writings from the original German into English.

My own family members have been the loudest cheerleaders for my research and writing. Marsha, my wife and computer "technician," shared my obsession to tell the story right from the beginning. My daughter-in-law, Jodi, got me started in the first place and so wanted a piece of Jewish history to be saved. My three sons, David, Michael and Daniel, along with Susan, my daughter-in-law, were always encouraging and cheered on their old man. Granddaughters Rachel, Becca, Hannah and Sara were awed by the students' spirits. Neighbors, friends and extended family graciously listened to Hyde Farmlands stories and discoveries ad nauseam.

Hannah Cassilly, editor at The History Press, first saw the significance of the Hyde Farmlands story, lobbied for its publication and offered crucial suggestions. Ryan Finn, copy editor, corrected language errors and preserved the book's voice. Many thanks.

The exhilaration of researching a project is experienced in the meeting of fascinating people who offer information and advice. Research is often

frustratingly arduous, but at times unharnessed rapture overwhelms the researcher when a significant insight is uncovered. For this amateur historian, I have always been overwhelmed by the willingness shown by absolute strangers who trusted enough to expose treasures of the past. To all these people, I say thank you.

INTRODUCTION

Guest: What are those log buildings all in a row in the backyard?
Young waitress: Those are the Jew huts. There were these people called Jews who
lived here.
—conversation at a breakfast table at Hyde Farmlands Bed-and-Breakfast,
Burkeville, Virginia, mid-1990s

Fast forward to 2006. That dialogue was told to me by my daughter-in-law, Jodi. It was conveyed to her by a coworker in Massachusetts just before she and my son moved to Lynchburg, Virginia. She wrote the name and telephone number of Ann Scott, the owner of Hyde Farmlands B&B, into her yearly calendar. She was curious. For ten years, she faithfully copied the information into each new year's calendar with the intention of finding out more. As so often happens, she became busily involved with the raising of two daughters while also working. She never called, but she kept on noting the name and number. And then she told the story to me. It stopped me dead in my tracks. "Jew huts" on a Virginia farm? "People called Jews"? Immediately I launched a quest to find out what it all meant.

Four years later, I now know what that waitress was talking about, even though she did not have a clue. The story is a veritable saga that began in the tumultuous years of the 1930s. It is the true story of the rescue of twenty-one Jewish adolescents from Nazi Germany through the efforts spearheaded by William B. Thalhimer of Richmond, Virginia. My questions, like incessant mayflies swarming on a Virginia field, multiplied. Who were these adolescents? What were their lives like in Germany during the rise of

Hitler? How did they escape? How did they manage to climb over the visa "paper walls" of the State Department? What was their life like on Hyde Farmlands? And above all, who was this William Thalhimer, and what drove him to help refugees?

My research led me up and down the East Coast and into virtual space to Germany, Israel and Australia. I interviewed several of the rescued students, now in their late eighties and early nineties, and continually spoke with them on the phone and through e-mail. Their memories were sharp. They shared their recollections through oral histories and writings, and some sent me their personal diaries and photograph albums. I read extensively about Germany in the 1930s and American immigration history of the times and conversed with historians. Countless hours were spent sifting through newspapers, squinting at microfilm and reading the 1,500 pages of letters collected in the *Circular Letters*. After two years of hunting in the National Archives, David Pfeiffer, veteran archivist, led me to a colossal breakthrough: the State Department records of the Hyde Farmlands' "Virginia Plan." He spoke words that have both guided and haunted me: "You are the first in seventy years to open this box. You now know more than anyone else in the world about this story!" My sense of responsibility took on an added weightiness.

After comprehending the complete story, I was humbled by the courage of the students, adrift in uncertainty and personal loss. I was inspired by the stamina and patient persistence of the rescuers, Dr. Curt Bondy in Germany and William B. Thalhimer in America, and by the Jewish leaders in Germany who volunteered to remain in Germany to help—and who were, subsequently, murdered by the Nazis. It was reassuring to learn firsthand about the empathy of certain State Department officials. I realized that I was in a race against time, for I wanted to pay tribute to the students while they were still alive, but I could not rush the research and sacrifice its integrity. So, I have tried to tell the true story about ordinary people, both German and American, who led extraordinary lives—courageous people who were all "shareholders" on a farm in rural central Virginia.

I.

HOPE

In the late 1930s, Friedrich Borchardt, as an agent of New York's Joint Distribution Committee, was charged with the enormous task of finding countries that would accept Jewish refugees from Nazi Germany. As he scoured Central and South America for potential opportunities, he searched for the faintest possibility of hope, much as an archaeologist sifts through the sands of antiquity yearning to uncover even the tiniest clue to a mystery of the past. Everyone who feverishly labored to find immigrant havens was haunted by the now famous words that had become a mantra of despair, the warnings uttered at a summer meeting in 1933. That meeting in Berlin gathered together the elite leaders of the German Jewish community, who knew one another well from business, professional and social activities. Hitler had been proclaimed dictator, and anti-Semitic activities were proliferating, with devastating effectiveness. The Jewish community was being crushed with each new Nazi edict. The atmosphere at the meeting was uneasy and tense.

The muted conversations of those assembled suddenly stopped when Rabbi Leo Baeck began to speak in almost a stage whisper. His round, metal-rimmed, penetrating eyes and bearded visage, along with his tall, imposing stature, made him appear ambassadorial. His words reverberated in the room and then exited to the world much as smoke ascends a chimney and disperses into the air: "Das Ende des deutschen Judentums ist gekommen!" ("The end of German Judaism has arrived!") Rabbi Baeck saw with prophetic insight the horrible end of the Jewish People in his beloved homeland.[1]

A letter from his dear friend and colleague, Julius Seligsohn, a chief aide to Rabbi Baeck, reminded Borchardt that time for the Jews of Germany

was running out. One sentence pleaded for his immediate attention: "I do not need to emphasize, dear Borchardt, to what an extent all of us who struggle greatly with the solutions of these difficult problems, count on your prudence and activity."[2] A German immigrant himself, Borchardt, treasurer of the Reichsvertretung (Central German Jewish Committee, or CGJC), was a board member of the Gross Breesen Agricultural Training Institute, which the Central Committee had created in 1936. Dr. Curt Bondy, a recognized social psychologist whose professorship had been stripped away by the Nazi legislative pogroms of the 1930s, was selected to head the school. Borchardt knew firsthand what was happening to the Jewish youth of Germany. He knew the truth: "If the future of adult Jews of Germany is hopeless, what shall we say of the future of Jewish children?"[3] That is why Gross Breesen was created, to train Jewish adolescents in agriculture in hopes that countries would be willing to accept them for immigration. The goal: get out of Germany, quickly.

On that January day in 1938, Borchardt perused file after file in desperation, looking for a shred of possibility that could lead to a potential immigration placement. The doors of most countries had been slammed shut to Jewish immigration. He fingered the stiff file folders. He glanced at a letterhead printed with the words "Thalhimer Brothers, Department Store."

William B. Thalhimer, who had been incredibly successful in resettling refugees in America, was the national chairperson of the Refugee Resettlement Committee of the National Coordinating Committee (NCC), the umbrella organization for Jewish immigration to the United States. Borchardt skimmed the letter that was addressed to the NCC Board. Several words must have appeared boldly in his mind: **VIRGINIA**, **FARM**, **REFUGEES**. His eyes must have been riveted to one particular sentence in which Thalhimer suggested that refugees "be settled upon farms in the rural communities of this country in order to relieve their increasing concentration in the cities and in addition… hasten the process of rehabilitation."[4] Thalhimer's suggestion was general in substance, but Borchardt began to think in particulars. Attached to the letter was an acknowledgement of receipt, but there was no suggestion for further action or consideration. Would this Thalhimer be interested in settling the Gross Breesen students in Virginia? Prospects for finding new homes for the students were vanishing painfully each day. Perhaps, by some stroke of luck, this letter might lead to a willing partner.

Borchardt contacted Thalhimer to be assured of the seriousness of his intent. He was more than convinced, so he contacted Dr. Bondy with the hopeful news and arranged for the two men to meet in early February

1938 to discuss the possibilities. Borchardt became a broker of human cargo. This newfound prospect imbued him with renewed energy; could the three men become entwined in the rescue of the Jewish students from Gross Breesen?[5]

Bondy crossed the Atlantic, and Thalhimer traveled from Richmond. The two men met and an instant friendship was created. The personalities of the two were similar. They were both hard-driving, no-nonsense, sometimes brusque, forceful men who made decisions quickly but rationally. They both believed that hard work and integrity could overcome personal obstacles. Their word could be trusted with a handshake. But though they were blunt and at times heavy-handed, they could also be affable and charming. They were Jewish, of German roots, non-Zionist and totally consumed in their efforts to save and settle refugees.

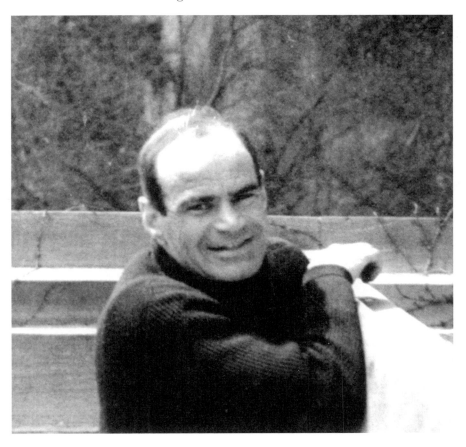

Dr. Curt Bondy at Gross Breesen. *From the* Circular Letters.

19

It was from this initial meeting in New York that the Virginia Plan germinated. Bondy was hopeful that the establishment of a Gross Breesen colony in America could become a reality—at least it was given a chance. For Thalhimer, his vision of an agricultural center for Jewish refugees took on the glimmer of possibility. For the past eight years, since 1930, he had been plagued by the scenes of the Nazi Brownshirts he had encountered in Germany while on a combined business and family trip to Europe. The drumming and anti-Semitic chanting so branded him, so seared his heart, that he pledged to help those who would flee the growing madness. So, while he continued his refugee resettlement work under the auspices of the NCC and the Richmond Jewish Community Council, he set out to develop a new plan. Finding a farm to house the Gross Breesen students became his first item of business, another project in his passion to rescue the victims of Nazi Germany.

2.

FINDING A FARM

Late Winter, 1938

O ne can easily imagine the excitement that was ignited as William and his cousin and close friend, Morton Thalhimer, discussed the new resettlement plan. Morton was a very successful real estate broker who had a large network of realtors whom he could depend on for possible leads of farms for sale. His sharp eyes could spot the potential of a promising farm, and in the late 1930s Depression, it was a buyer's market. The farm that the cousins searched for would have to fulfill certain requirements. It would need to be located not too far from Richmond in central Virginia. It had to be large enough to house potentially thirty young adults and staff, both male and female, and have expansion possibilities. Naturally, it would also have to be agriculturally viable. But of utmost importance, it had to be available soon.

In midwinter, the two were summoned to the small town of Burkeville, a rural community just a few hours south of Richmond. One can safely assume that the fact that the farm would house German Jewish refugees was not highlighted in exploratory conversations. Memories of World War I left little room for a positive view of Germans, and Jews were suspect in this farming community of white-power conservatives, some of whom were active Ku Klux Klan members. If a large political billboard had been erected near Burkeville, it would have been emblazoned, "This is Jim Crow Country."

Even with these concerns, the cousins pushed on in their efforts to purchase a farm. They entered a time warp—the entirely different world of rural life in the 1930s. The differences between Richmond and Burkeville were stark. No matter. The two were shrewd businessmen, and Morton was an expert in conversing in

real estate jargon. In Burkeville, they met the agent who was representing the seller of the farm. The three would have been dressed in business suits, vests, hats and overcoats, as the winter hung on.

As the three businessmen stood next to the roadside mailbox six miles south of town, any local farmer who passed by would have quickly spread the word that there was some real estate action going on at the farm. News spread rapidly in this rural town over the potbellied stove in the general store, over the seed counter and at the Sunday morning church gatherings. The name on the mailbox read R.J. Barron, and next to it was a painted sign for Hyde Farmlands.[6] Before the three drove up the road that led to the farm, one of the Thalhimers probably asked the realtor, "What can you tell us about this farm?" In a slow though enthusiastic manner, he might have responded, "This place is full of history. It's a great farm, but it was always a great farm."

Hyde Farmlands had a pedigree that few others could boast. This was not just some parcel that was hacked out of the woods and transformed into fruitful fields. The birth of this homestead occurred in 1746 as a land grant patent bestowed by the king of England through his governor to Samuel and Hezekiah Yarbrough. In 1752, John Fowlkes purchased the nearly 1,500 acres over a few years and kept the farm in his family for five generations.[7] The plantation was called Old Field, but when one of the Fowlkes sons,

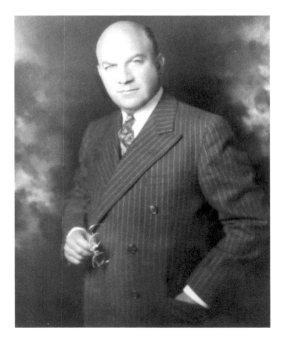

William B. Thalhimer. *Courtesy of the Thalhimer Family Archives.*

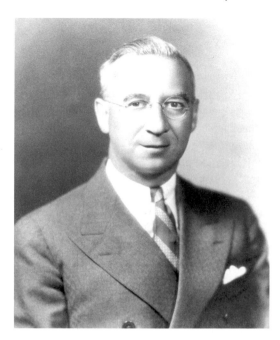

Morton Thalhimer, cousin of William Thalhimer. *Courtesy of the Virginia Holocaust Museum.*

Paschal, married Martha Anne Hyde, the name was changed to Hyde Park.[8] The farm survived the transformations that all large farms went through in central Virginia. By the mid-1800s, it had grown into a prosperous plantation. The 1860 slave census listed Hyde Park as owning forty-six slaves ranging in age from one to seventy years old: fifteen females and thirty-one males. The estate supported various crops, livestock, cotton and tobacco, the chief money crop.

One story that has been attached to Hyde Farmlands involved the visit of the notorious John Brown, who stayed overnight. He traveled by the name of Dr. McLean, and his supposed secret mission was to stir the slaves into an insurrection. The visit gained credibility after John Brown's raid, when his picture appeared in the newspaper and locals identified McLean as Brown. During the Civil War, Hyde Farmlands escaped being burned when Grant's army marched to Burkeville on the very road that bordered it. Specific orders had been given by the officers that only food and water could be appropriated as the army advanced.

Nearby Burkeville was a railroad hub in the mid-1800s, with lines to Lynchburg to the west and the Carolinas to the south; it was of vital significance to the transport of troops and matériel for the Confederate forces, so it was a significant Union target. The Unionist troops scored a

decisive victory at Burkeville, as the entire railroad facilities and tracks were completely destroyed. Smoke billowed high in the air and could easily be seen from the farm, as could the sounds of cannons reverberating throughout the area. Union generals Wilson and Kautz convincingly routed the retreating Confederate defenders of the town. The famous Battle of Sailors Creek was waged just north of the homestead.

Even though Hyde Park came out of the war unscathed, the owners contributed to the war effort nonetheless. In a personal letter written to Mrs. Paschal J. Fowlkes by Robert E. Lee, the general thanked her for the contribution of clothing to the war effort.[9] Years later, the farm was purchased by a Northerner, Thomas B. Scott, who enlarged the main structure to include thirty rooms and a large ballroom for elaborate social events. It was a large house of eight thousand square feet, "known as one of the handsomest homes in the county."[10]

The long driveway leading to the main compound was hard-packed clay mixed with some fine gravel. In late winter, it was soft but not muddy enough to make driving impossible. In that day, no farmer's horses were needed to pull out a stranded auto, as often happened before roads were paved. The pastures adjacent to the drive were brown, though a hint of colored haze washed the trees in the dense forest. One could smell the first suggestion of spring in the air. The real estate agent must have told the two that there were

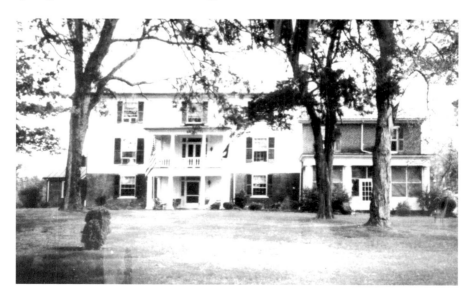

The main house at Hyde Farmlands, Burkeville, Virginia, 1939. *Courtesy of Eva Loew.*

ample fields of alfalfa, clover and hay and that the soil was fertile enough for tobacco, corn and other vegetables.

After driving a quarter of a mile or so, the road bent off to the right next to an old tree. Evergreens bordered the way, as if a tunnel funneled the visitor into a safe place quite removed from the outside world. It was not quite spring, but soon the farm would be blanketed with violets, and after that clover blossoms would cover the rolling landscape. A motley collection of weather-beaten buildings and shacks appeared behind the manor house: a cow barn, chicken sheds, garages, tenant houses, a kitchen house, corncribs, tobacco sheds, toolsheds and even the slave quarters of a past era. Customary farm clutter was scattered around the compound. This was not the scene of a sanitized Richmond house or business establishment. Resembling a great albino whale gracefully rolling out of an ocean of sea-lawn, the sight of the main house distinguished itself from the rustic and run-down buildings.

The first impression was dramatic. With affluent, substantive pillars and a sweeping porch, it stood tall and proud of its Southern heritage. The long dark windows invited the imagination to envision social events with women in flowing gowns and men in top hats. The people who lived in this grand house never strayed too far from home; several were buried in the family cemetery in the backyard, which included an imposing

Paschal Fowlkes Memorial, Hyde Farmlands Cemetery, Burkeville, Virginia. *Photo by Robert Gillette.*

monument memorializing Paschal Fowlkes. One marker, outside of the formal plot near one corner, cited the burial place of a peddler who, while spending the night at Hyde Park, became sick and died.[11] As it did long ago, Hyde Farmlands would welcome strangers once again.

The house was an antique, almost run-down if viewed from the more cosmopolitan perspective of Richmond. There was no electricity, no indoor plumbing or running water and no telephone, but there were wood stoves and a coal- and wood-fired boiler that supplied steam heat to the cast-iron radiators. It was typical of many in the area in the late 1930s in that it stood on the very edge of greeting the modern age. Plans to electrify the county had been drawn by the Southside Electric Cooperative, and within the near future, electric lines would be strung and an entirely new way of life would be available to Virginia farmers. As the Thalhimers gazed at the central house, they superimposed a picture of modernization to come. They were evaluating the property with every realtor's constant mantra, one that Morton must have uttered so often: "Does the structure have good bones?" And it did. Indeed, this farm was structurally sound, and it had all the potential to house a sizable contingent from Gross Breesen. The Thalhimers could easily envision young men and women transforming the place into a productive farm. This was the property that Morton Thalhimer had hoped to recommend to William.

Before the sale could be finalized, two important associates in refugee resettlement activities, Friedrich Borchardt and Ingrid Warburg, traveled to Richmond from New York to look over the property. They toured the farm and were most satisfied with its potential. Before it could be purchased, however, it needed to be approved by Bondy, so he returned to America to evaluate the farm and approve its purchase. Soon after, the sale was completed.

The Hyde Farmlands property, 1,518 acres, became the Thalhimers' on April 19, 1938. The tax value of the property was $12,372.00, and the real estate tax for the year was $228.89. The purchase price paid by Thalhimer was $15,000.00.[12] The deed filed in the Nottoway County clerk's office was in the name of Annette and William Thalhimer.[13] The initial bank mortgage was for $25,000.00: $15,000.00 for the property and $10,000.00 for machinery and improvements. It is impossible to know Morton's financial commitment, but in all probability he became a "silent partner." On the day that the farm was deeded, Hyde Farmlands legally became Hyde Farmlands, Incorporated.[14]

William B. Thalhimer and a Rescue from Nazi Germany

The search and purchase of the farm was only one of the refugee projects that William and Morton were involved with in the spring of 1938. They had created an extensive network and set of procedures to resettle refugees in Virginia and neighboring states. They comprised the epicenter, the command center for all the resettlement traffic in the mid-Atlantic states. Communications flowed into and out of Richmond.

At the Richmond Jewish Community Council fundraising banquet held at Beth Ahabah Synagogue just after he had purchased the farm, William spoke as the general chairman, while Morton co-chaired the special gifts committee. As toastmaster, William announced that $63,698 had been raised for the general refugee fund and that the sum was the "greatest amount of money per capita raised for this cause in any city in the United States." He stated that he "hope[d] that every $100.00 [would] keep one family together in Poland that otherwise may have died...Jews of the world do not know what the future holds for them."[15] He never mentioned the Hyde Farmlands project.

Now that the farm had been purchased, it awaited the arrival of the refugees from Gross Breesen, but their journey was not going to be immediate or easy.

The manor house at Gross Breesen, Germany, late 1930s. *From the* Circular Letters.

The notification that the farm had actually been purchased was the most welcomed message that Bondy could have hoped for, especially because so many plans to relocate the Gross Breesen community to other countries had fallen through. In a report published on April 28, 1938, he stated:

> *Our project in the U.S.A. is now the closest in keeping with our original plans of a community settlement. By some of our friends, a large farm with everything belonging to it has been put at our disposal in Richmond in the state of Virginia. We are very grateful to them for it. Friedrich Borchardt, who was formerly active at the National Representative Agency of German Jews, is working on this plan in New York and informed us recently that the number of the Gross-Breeseners determined for the Virginia settlement could be increased from 25 to 30. The affidavits have largely been acquired already and we hope that the first group can go across soon.*[16]

The responsibility for a successful mission by the prospective student-settlers who would immigrate to the United States was emphasized to the fullest: "The beginning has to be the basis for everything else, above all the hard and dependable work of the individual and the comradely readiness to help. Now the Gross Breeseners have tasks, for which their whole commitment is worth while!"[17]

The spirits of the students soared. Soon, Ernst Loewensberg, who was already in America, would be the first to settle at Hyde Farmlands and write to describe the farm. After numerous disappointments, everyone was encouraged. There would be, after all, a Virginia Plan.

3.

Bondy's First Consular Meeting

William Thalhimer sent news to Borchardt and Bondy immediately after the Hyde Farmlands deed was issued. On April 28, Bondy sent a packet of information about the Gross Breesen Training Institute to the American consul general in Berlin, Raymond Geist. An appointment between Bondy and Geist was scheduled for mid-July.

As Bondy approached the American Consulate on July 11, he no doubt stopped to take in the entire scene. Directly in front was a helmeted German soldier standing guard, with his rifle at his side. He was surrounded by a fenced booth that elevated him above the street. Questions must have raced through Bondy's mind as he eyed the stone building that held the hopes of his Gross Breeseners and their families: How would the meeting go? Was there any hope? Would the consul general be receptive and sympathetic? Undoubtedly, Bondy had been thoroughly briefed by the Central Committee.

Raymond Geist

Raymond Geist, perhaps more than any other diplomat of the time, was the right man at the right time in the right place—Nazi Germany. He was born in Cleveland, Ohio, in 1885 to American parents, but his grandfather, Philip Geist, was an immigrant from Germany. He fled Germany in the late 1840s, just as William Thalhimer's grandfather had done, to escape the revolution. Philip later joined the Union army in the Civil War and was killed in action. German language and culture and the Quaker religion were ever present in

Raymond's childhood home. He studied at Harvard, where he earned his master's and PhD. His area of concentration was German and Romance philology and medieval literature, and he loved to read and act in amateur Shakespeare productions.

While serving in the navy during World War I, he was the newspaper editor on the ship that carried President Wilson to the Peace Conference in Paris. While in Paris, he was attached to the staff of Admiral Benson. His talents were soon recognized, as he became the chief translator of German for all of the American naval staff. He caught the eye of personnel officers and was selected as the director of the American Relief Administration programs in Europe. He returned to a teaching position at Harvard, but he soon realized that he yearned for the excitement of international diplomatic service. After several posts in South America, Geist joined the staff of the American Consulate in Alexandria from 1923 to 1929. From Egypt, he was transferred to the consulate in Berlin, where he teamed with George Messersmith.[18]

In 1938, when Bondy first met Geist, he was no newcomer to the German scene. He had a firsthand understanding of the rise to power of the National Socialists and the installation of Hitler as the supreme dictator. He was an imposing man with the stature of a fullback—broad shoulders and a thick neck—and his short-cropped dark hair made him look Germanic. He worked as the assistant to George Messersmith, the consul general in Berlin, until he assumed a new post in Vienna in 1934, before the German

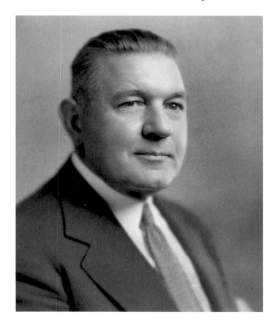

Raymond Geist, consul general, Berlin, Germany, 1939. *Courtesy of the* New York Times *Archives/Redux.*

William B. Thalhimer and a Rescue from Nazi Germany

Anschluss. In 1937, Messersmith returned to the State Department in Washington, D.C., to become the assistant secretary of state under Cordell Hull, with special focus on Europe and Germany. Hull and Messersmith had an excellent working relationship and respected each other personally. While still the consul general in Berlin, Messersmith and Geist became an enormously competent team. Their viewpoints about the Nazi regime were identical. They both had deep-seated animosity toward the Nazis, but they both initially believed that Germany would come to its senses and vote out the new regime. Geist respected his senior officer immensely and patterned his diplomatic style after him, and Messersmith, in turn, saw his younger protégé as superbly capable, intelligent, sensitive and fully committed to the immigration laws as articulated by Congress. In Messersmith's eyes, Geist was a "star pupil who did do his homework."[19]

The transition between Messersmith and Geist was seamless. The styles of the two men may have been different, but their thoroughness and attentiveness to events unfolding in Europe were the same. As did his mentor, Geist wrote highly respected political analyses to the State Department. He was the perfect statesman to be positioned in Germany in the 1930s, for he intuitively knew how "to work the room." He cultivated relationships even with people he did not like or respect. In reality, his ulterior motive was to penetrate the Nazi bureaucracy to gather information. In addition, he needed access to the top officials of various departments in order to expedite strategies of rescue.

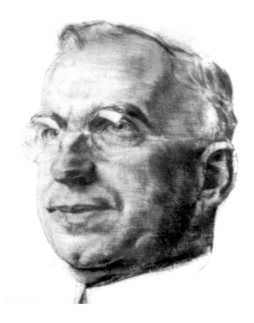

George Messersmith, assistant secretary of state. *Courtesy of the Special Collections, University of Delaware.*

At a large dinner party for Colonel Charles Lindbergh, for example, Geist was asked to translate from English into German the conversation between Lindbergh and Field Marshall Göring. He recounted, "Lindbergh was a little too stupid and dull for the conceited and verbose Göring, who wanted to make a great speech; so I encouraged him and let him talk away to me, which he did for a half hour on end to the amazement of the other guests who looked on while the Field Marshall told what mighty things he could do."[20] Getting information about Nazi activities and intentions was not easy, and the dissemination of that information was even more difficult. Nazi censorship had clamped down on all of the news outlets, so it was through the consulate that most insight and news was filtered and passed on.

Early on, Geist was seriously concerned with the development of the Nazi Youth Program. In a letter to the State Department dated September 15, 1934, he rang the alarm that would play itself out in horrendous ways:

> *It is a significant fact in estimating the present situation in Germany, that into the youth is being inculcated an unprecedented, conscious and deliberate love of militarism and what it stands for. It is one of the amazing things of modern history that the Government of a great power should definitely teach its children to cherish ideas of valor, heroism, self-sacrifice, unrelieved by any of the virtues which modern civilization has come to place above brute force…it is very difficult to foresee how the bellicose spirit here can be restrained and directed into permanent channels of peace towards the end of this present decade.*[21]

Geist understood what was needed to operate successfully within the world of Nazi intrigue. He wined and dined important Nazi officials such as Count Helldorf, who made the final decisions about whether a rich or prominent Jew could receive a passport. He wrote to Messersmith:

> *It has been necessary for me to keep on good relations with this* [Nazi] *crowd, and so I have to entertain them from time to time, otherwise I could have little influence on the gates of the Concentration camps, which now and then I manage to pry open…there is no other way to handle these matters except through personal contact…I hope to get good results where we are pressed to save the lives of various victims. It is a terrible situation and the plight of the Jews in this country is going to get worse.*[22]

William B. Thalhimer and a Rescue from Nazi Germany

The predicament of issuing visas within the immigration quotas preyed on his mind. Geist knew that the number of applications already filed outnumbered the available visas for years to come. He tried to facilitate getting Jews out of the country so they could at least wait for their names to be called in safety:

> *I am hoping to be able to extend this system, particularly for people who are in danger of being taken into the concentration camps. Many of these worthy people are on the verge of suicide, and one cannot close the door on the last ray of hope. I am sure that I have saved a number of people from self-destruction merely by telling them they could come to see me at any time.*[23]

One of the key leaders in the Central Committee was Friedrich Brodnitz. As the entirety of Director Otto Hirsch's "cabinet," he had numerous responsibilities, but one of his most significant was to manage the dissemination of news for the local Jewish press and to provide insider information to the foreign correspondents who feverishly sought information of the Nazi/Jewish situation. The sharing of information was neither easy nor safe. In addition, in 1935, the Nazi government created a special commissioner for the Jewish press to censor and control the various Jewish newspapers and magazines. It became Brodnitz's responsibility to negotiate with the commissioner. The Nazis were extremely sensitive to negative press overseas. They desired to appear modern, respectable and rational, especially since they did not want to jeopardize foreign business dealings. There were a few outstanding investigative journalists covering the German scene who tried to convey the severity and depravity of the Nazi regime: Norman Ebbutt of the *London Times*, Edgar Mowrer of the *Chicago Daily News*, Dorothy Thompson of the *Saturday Evening Post* and Otto Tolischus of the *New York Times*. These people clamored for news and insights and, consequently, were watched closely by the Gestapo.

The passing on of news became increasingly complicated and often was conveyed through the shadowy tactics employed by spies. Tolischus found an ally in Consul General Geist. He confided to Brodnitz that Geist was "an exceptional man; he was a Quaker and for that reason alone a man of deep sympathy with the persecuted people."[24] It was Tolischus who introduced Brodnitz to Geist. He recalled that the meeting of the two was a "heart-warming" event, as he learned of Geist's efforts to aid helpless Jews who had petitioned for American visas. Intensely focused and an effective listener, Geist wanted to glean information about the Jews' situation so that he could

inform the State Department. He provided Brodnitz with a secret place in the consulate to write and dictate long reports that would be transmitted to the authorities in the United States. It was Geist who assisted Brodnitz in obtaining an American visa in 1937 just before the Nazis were to arrest him for being involved in clandestine operations.[25]

Obviously, the Central Committee knew about the character and the activities of Geist very well. He was recognized as a superb troubleshooter, respected by journalists, government people and even by German officials. This information must have been communicated to Bondy before he met with the consul general. There was hope that the students of Gross Breesen would receive a fair and sympathetic hearing from him. Also of immense significance, recognized and articulated often, was the hope that the close relationship that Geist continued to have with Messersmith, now sitting in a powerful position in Washington, would be helpful in acquiring visas. Messersmith, in his own right, had extensive, positive relationships with the powerful Jewish elite of New York and Washington.

The first meeting between the two men who would be instrumental in the Gross Breesen rescue operation went smoothly as they conversed in German. During the conversation, Geist's curiosity must have been piqued when he heard the German name of the American benefactor, William Thalhimer. One can easily imagine that his own German origins and ties were somewhat associated with Thalhimer's. Bondy quickly sensed Geist's desire to help, and Geist recognized Bondy's limitless commitment to care for and help sustain the lives of his students.

Bondy gave Geist more material that described Gross Breesen, and they talked about the students, especially how they were the eclectic ones, chosen within a rigorous admissions process. These were some of the most outstanding young people of the German Jewish community. Most came from middle- to upper- class families in which education and culture were stressed. They were physically vigorous and intellectually bright. Previously they were actively involved in the youth movement, both German and Jewish, before the Nazi takeover.

Bondy explained the workings and curriculum of Gross Breesen, but it was the intangible values, the "Gross Breesen Spirit," that he needed to communicate. In Bondy's mind, it was the values, the hard work and the long hours the students endured that made them worthy candidates for immigration to America. Because of the significance of this initial meeting, Bondy must have second-guessed his effectiveness as he left the consulate, for there was so much riding on a positive exchange. The first meeting with

Geist seemed promising, one of mutual respect, but did he convey the core values forcefully enough? He wondered what would happen now. Would the students receive visas, and how soon could they emigrate and land on America's shores—soon enough to satisfy the schedule of development at Hyde Farmlands?

THE VISA PROCESS BEGINS

Geist read and digested the material that Bondy had presented him and translated the pamphlet into English for the State Department. His July 11 memo to the State Department clearly revealed that he comprehended not only the workings of Gross Breesen but also its mission. There were, however, several items for visa consideration that Geist red-flagged: one, he did not have enough information about Thalhimer or the legal status of the ownership of the farm; two, he thought that there might be conflicts related to the labor contract provisions within the statutes of the immigration law. In accord with Geist's concerns, the State Department sent a copy of his memo to the Labor Department. At this point, Geist did not feel that he could grant visas because the case was more complicated than Bondy and Thalhimer had ever imagined. He did not reject the visa applications outright, but he did start the process of due deliberation by involving the Visa Division of the State Department and the Department of Labor. Gross Breesen was now on the radar screen. It would soon receive attention from some of the highest officials. The predictably slow transmission of information through the tiers of bureaucracy seemed not to be the problem in this case. The seeds for immigration had been planted; how quickly they would grow and blossom was the big question.

4.

IMMIGRATION GRANITE WALLS

William Thalhimer was a man of action. He had "fire in his belly." When he committed himself to a cause or a project, he saw it through to the very end. He was an avid deep-sea fisherman and relished the hunt for the "big one." He knew the capabilities of his tackle and of his own strength and endurance. He was fully aware that setting the hook in a trophy fish was only the beginning of the struggle to land it on the deck of his boat. Now, however, he was fishing in the unfamiliar, deep and turbulent waters of the State Department.

He hoped for swift consular action, because Germany was accelerating its anti-Semitic activities. In addition, one agricultural growing season had already slipped away. He set out to learn more about immigration policies and the machinations of the State Department, the Labor Department and the consuls in Germany. Understanding the rules of engagement grounded his expectations and provided him with a reality check. Like so many other Americans who were running headlong into the granite walls of bureaucracy, he must have felt frustrated and a bit bruised.

Battles over bureaucratic turf are often quietly brutal and prolonged. So it was in the 1930s between the State and Labor Departments. They frequently saw themselves wrestling in a life-or-death arena for their veritable institutional lives. The Labor Department, under the leadership of Roosevelt appointee Francis Perkins, was more attuned to the activist spirit of the New Deal, while many in the State Department clung to the old conservative ways under Hoover. This cantankerous relationship erupted in territorial skirmishes and particularly emerged in the deliberations of visa

matters. The young people of Gross Breesen would be caught in the cross hairs of debate; they would become innocent pawns in a contest between the two giants and within each department.

In the 1930s, immigrants to the United States had to travel an arduous journey; it is a wonder that any completed it. Thalhimer's great-grandfather came to this country in the "first wave" of large German immigration in the early 1840s. Compared to immigration in the 1930s, the 1840s immigration was uncomplicated and unobstructed. William Thalhimer believed the mythic narrative that America was an asylum for refugees. He revered the poet's dream: "Give me your tired, your hungry, your poor…who yearn to breathe free." Through his resettlement activities, however, his idealism was gradually shredded as he began to comprehend the realities of the immigration roadblocks. Those now wanting to immigrate to the United States were part of the "third wave," but the wave really did not exist. It was nothing more than a ripple that lapped on the Atlantic sand flats at low tide. The bulwarks and jetties of governmental policy and the judgments of individual consuls and State Department officials held firm. The hopes and dreams of aspiring immigrants crumbled like sand castles from the relentless undercutting tide of anti-immigrant sentiment. In short, there was no immigration wave at all, but only a trickle.

After the Immigration Act of 1924, the State Department assumed greater executive power relating to the issuance of visas. Beforehand, the Labor Department, working with the Treasury and State Departments, welcomed the immigrants in an "open door" policy. This changed by the 1930s, as all immigration decisions took place at the point of exit rather than the point of entry, and that centered in the offices of the consulates. The consul, most often a State Department career professional on the rise, was the sole determiner of who was issued a visa. Without a visa, there was absolutely no chance of gaining legal immigration status into the United States. Thalhimer turned for help to Congressman David E. Satterfield of Virginia, an old friend who was sympathetic to the immigrants' cause. Because he knew how Washington worked, Satterfield probably warned his friend that putting too much pressure on State Department officials could very easily backfire. Bloated egos burst easily when pricked by incriminating and "pushy" clients. It soon became evident that there were formidable hurdles that had to be transcended before the students could immigrate.

In his refugee resettlement activities with the NCC, Thalhimer worked with immigrants after they landed on American soil, but in the process he learned the visa rules and pitfalls. He was well aware that filling the immigration quotas

was being thwarted by xenophobic nationalism and isolationism. The dire desire to emigrate from Germany was sucked into the tornadic vacuum of a political "perfect storm." American air was toxic with the anti-immigrant and anti-Semitic sentiments published in Henry Ford's *Dearborn Independent* and heard in the radio addresses of Father Coughlin that had 3.5 million listeners. Polls taken in 1936 and again in 1939 revealed that 42.3 percent of the American public "believed that hostility towards Jews stemmed from unfavorable Jewish characteristics. Another poll indicated that Jews ranked second only to Italians as the group considered to be the worst citizens."[26]

Thalhimer had experienced the institutional closed-door policies that prevented Jewish mobility and economic and professional participation. His own son, Charles, faced the college quota placed on the admission of Jewish students at Washington and Lee. Such a quota system existed throughout the country and continued well into the 1950s. No doubt he knew of the anti-Semitic jeers that baseball's Hank Greenberg endured in his rise to fame. He lived in the South, a Jew living in territory patrolled by the Ku Klux Klan and other nativist organizations that tried to define what the "pure American" was. He learned one of the cruelest facts: there was no "refugee" category within the immigration laws. No matter how bad conditions became in a foreign country, no matter how much prejudice, discrimination and violence were perpetrated against a minority, the term "political refugee" did not exist in the immigration law's lexicon at that time.

Because Americans were still traumatized by World War I, there was no stomach for involvement in international affairs that might draw America into another military conflict. It was better to keep one's international political nose clean, and that meant not to utter the loaded word "refugee." In addition, every corner of the economy opposed opening the doors to immigrants, who could potentially compete for scarce jobs. In addition, there was much doubt that the State Department could even respond to the immigration crisis because of its own bureaucracy. This sentiment was best captured in the words of Congressman Emanuel Celler when he accused the department of having a "heartbeat muffled in protocol."[27]

Thalhimer knew that it was the consulates in Germany that could open or close the iron gates of immigration. The ominous immigration statistics spoke for themselves. The biggest hurdle for immigration was the yearly quota of 153,774 individuals worldwide who could possibly enter the United States. When broken down by countries of origin, Germany was allocated approximately 26,000 potential visas. Out of this number, in 1933–34 only 4,392 were admitted. In 1934–35, 5,201 were admitted and in 1935–36,

6,346. There were increases in 1936–37, 10,895, and in 1937–38, 17,199, the year when Thalhimer began the Virginia Project. To summarize, for the years since Hitler assumed the dictatorship, out of the possible 130,000 openings, only 44,033 received visas.[28] Within the visa quotas, the State Department was blocking immigration.

There were three general categories a visa applicant had to fit into: (1) "outside the quota" (professionals and clergymen); (2) "within the quota"; and (3) non-immigration "visitors," whose stay in the country was limited. Furthermore, in all of the immigration laws and policy statements, there was no provision for the issuance of a "group visa." Every application for immigration was an individual case. Contrary to this ironclad restriction, the intention of the founders of Gross Breesen was to transplant the students together as a community or colony. The granting of a group visa was impossible. Thalhimer pondered under what category the students would qualify to receive visas.

The rescue committees clarified one of the biggest obstacles that applicants had to confront. "LPC" ("likely to become a public charge") loomed as the most effective device to restrict immigration. This was the weapon most often used in consular decision making. LPC became lethal, a veritable fire-spouting dragon that stood guard outside of America's gates; tens of thousands of visa applications were torched by LPC. The students at Gross Breesen had no way to counter the consul's LPC scrutiny even if they had affidavits of support.

Furthermore, there were other roadblocks to immigration. Individuals could not come to the United States if they had promises or "contracts" for employment. To the person seeking a visa, that sounded paradoxical. If LPC was concerned with the financial viability of an applicant, and if the applicant had a contract to work in a job or profession that would support him, why not grant a waiver to the LPC? That seemed a rational question, but the Labor Contract Law created its own Catch-22. It was clear and simple: if one had a labor contract, he would not be granted a visa. In addition to the LPC and labor contract provisions, another detail in the law tripped up unsuspecting applicants. Even if one were viewed as worthy of immigration, if his passage were paid for by a sponsoring organization, he would be excluded from receiving a visa. Furthermore, the visa applicant had to satisfy numerous administrative requirements. He had to obtain a German passport, a certificate of health, a personal financial statement, records of personal data and an affidavit presented by a relative or friend in the United States that accounted in detail the assets of the person who signed the affidavit of support.

William B. Thalhimer and a Rescue from Nazi Germany

For the applicant, the most onerous requirement was the procurement of a certificate from the local police attesting to one's good character and conduct. How distressful it was to face interrogation by hostile authorities. Every aspect of the paperwork submitted to the consul had to be meticulously correct, and if it was not, the entire application could be suspended or, even worse, thrown out, and the process would have to start all over again. And all of this transpired under the pressure of a specific time period; if not completed and submitted on time, the applicant lost his place in the "waiting list."

Added to the multiple hoops that visa applicants had to jump through were more intangible snares. The Foreign Service diplomats and the consular staff were, for the most part, holdovers from the Hoover administration. They were, by and large, Republican, conservative and bureaucratic. They were often professionally self-serving and, in their minds, "protecting America," and being ruthlessly efficient meant limiting immigration as much as possible. Some, often in very powerful positions, were anti-Semitic. They often blocked perfectly plausible applications for reasons other than suitability. In their minds, Jews were not worthy candidates for future citizenship. The written immigration laws were restrictive enough, but added to them were the unwritten, unspoken policies that were anti-immigrant and anti-Semitic by nature.

The key person whom Thalhimer had to deal with was Avra Warren, chief of the Visa Division. Not knowing the man's values, he needed to nurture a trusting relationship. It became clear that the entire immigration and visa process was daunting and that rescuing the students from Gross Breesen was going to be extremely difficult. Frustration and anxiety would be handmaidens to any effort to procure visas for the Gross Breeseners. Such complexities! Such difficulties!

5.

THE "VIRGINIA PLAN" BEGINS

The farm was purchased in April 1938, and the State Department had already received its first communication about the Gross Breesen students and the Virginia Plan from Raymond Geist. In June, the first Gross Breesener, Ernst Loewensberg, arrived at Hyde Farmlands. He immigrated to the United States through the urging and help of family members before a Gross Breesen immigration could be arranged. Ernst's older brother, Joseph, had immigrated several years earlier and served as his sponsor. Two letters, written under the light of a kerosene lamp and sent to Gross Breesen, captured his excited observations. As he traveled the six miles from Burkeville to the farm, he was amazed by the dense forests that served as dark backdrops to the green and golden cultivated fields. He was curious about the pipe mailboxes that appeared at the end of the dirt driveways leading to farmhouses. Just as the Thalhimers had driven up the long hard-packed road leading to the white manor house several months earlier, so did Ernst bump along in anticipation. He described the main house:

> *I can only tell you that it is exceptionally suitable for our purpose. Twenty-two rooms are available to us. Some bigger some smaller. They are only waiting for a painter, who can beautify them...On the first floor is a splendid balcony and I can imagine that we will place our musicians there, while we sit below in the grass and listen to them.*[29]

He was expansive in his reporting. There were stables, "called 'barns' in English," and two new muscular workhorses, a breed rare in the South,

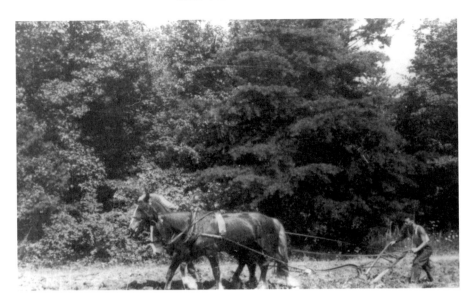

Ernst Loewensberg and his prized workhorses, Hyde Farmlands. *Courtesy of Eva Loew.*

that Thalhimer had purchased with special pride. He wrote about the forest that "contains a source of great wealth in good timber and fertile arable land...There is not going to be a shortage of forest work." He agreed with Bondy that the woodlands reminded him of the Black Forest. Many things were new to him, like riding bareback down to collect the mail at the main road or observing a blacksnake that crawled through his room. He killed it with a coal shovel, and its six-foot skin was presented to an "appreciative" Mr. Thalhimer.

The living conditions were primitive compared to Gross Breesen: no running water in the manor house, no showers and only outhouses. Buckets drawn from the outside well supplied all of the water needed for cooking, washing and watering the animals. He was not alone at Hyde Farmlands, for the previous tenant, R.J. Barron and his family, stayed on to manage the farm and help with any of the transitions. Another tenant family, the Piggs, were friendly and helpful. Because he was a German refugee, an oddity in this quiet community, friends of the Barrons came to visit and introduce themselves as neighbors.[30]

Having a Gross Breesen immigrant living at Hyde Farmlands prompted a visit from influential leaders from New York: Ingrid Warburg, Friedrich Borchardt and Jacob Billikopf from Philadelphia and their host, William

Thalhimer. While touring the farm, their wagon became mired in mud, but Ernst pulled it out with workhorses. He was delighted to be able to converse in German, especially with Ingrid Warburg, a significant leader in American refugee efforts and a member of the famous Warburgs of German financial fame. Billikopf, a nationally recognized social worker, was an eminent leader in refugee resettlement activities along with Thalhimer. Borchardt, of course, was part of the Central Committee in Berlin and the Joint Distribution Committee. Ernst quickly surmised that Hyde Farmlands was more than just a resettlement location for a Gross Breesen colony. It was to become a model for future agricultural refugee settlements in the United States. If the farm succeeded, it would pave the way for other farms of resettled refugees.

Loewensberg's second letter picked up where the first left off. He was establishing a high standard for those who would be eventually settling on the farm and especially focused on the importance of learning English: "In the evening, I have now started to look up words in the dictionary which I hear during the day and...write them down...these words, most of which are derived from practical life."[31] He insightfully suggested that once the Gross Breesen students arrived, there should be a teacher who

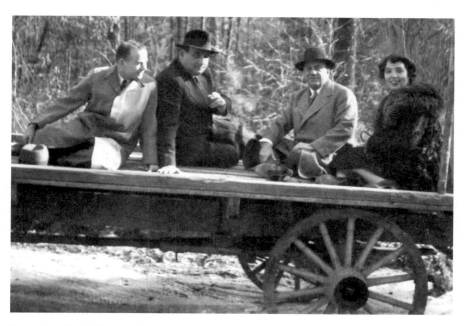

Inspecting Hyde Farmlands, 1938. *Left to right*: Jacob Billikopf, Friedrich Borchardt, William Thalhimer and Ingrid Warburg. *Courtesy of the Virginia Holocaust Museum.*

knew both German and English to work alongside the students so there could be constant language learning integrated into the workday. This immersive approach would have been very effective, but it was never implemented.

Ernst was highly critical, in his own mind, of the care and handling of the horses and mules, compared to the extent of care instituted at Gross Breesen. He convinced Mr. Barron that the horses needed greater hoof attention, and even though he had little training, he was designated as the resident farrier. After supplies were purchased from the blacksmith in nearby Crewe, he nervously began to shave the hooves in preparation for shoeing. It occurred to him that at Gross Breesen he was always under close supervision, but now it was his sole responsibility. Anxious as he was, his first attempt was successful.

Often, Mr. Barron took Ernst to visit neighbors. They were particularly interested in his photographs of Gross Breesen, and they engaged him in light conversation: "How do you like to stay over here in this country?…I hope to see you soon again…I would be glad to see you next week once more." Ernst was impressed by the neighbors' openness. Compared to "serious" Germans, the Americans were so genuinely friendly.

Little details about the people caught his attention. The policeman in Crewe did not wear a uniform, and except for the billy club that stuck out from under his jacket, one would never know that he was an officer. It seemed that everyone chewed gum or tobacco, and when he attended a baseball game, even though he did not know any of the rules, he enjoyed the excitement when a batter made a hit.

On Saturday afternoons, he traveled to town for supplies and some friendly conversation, and on Sundays, William Thalhimer occasionally came to visit. Ernst made a revealing observation about his benefactor: "What I like about him is that he drinks his water with everybody out of the one and same ladle (that is the drinking vessel here)." During one of his visits, Thalhimer recounted a recent trip to New York City, where it was very hot. He described how the city people suffered from the heat and lack of fresh air. He then extolled the virtues of living in Burkeville as compared to New York: "Thalhimer really believed that farmers were fortunate to work with their hands and live on the land, and he hoped that future immigrants would always stay on the land."[32] Ernst noted that whenever Thalhimer visited the farm, local merchants from the nearby towns magically appeared out of nowhere. Everyone wanted to sell him something that would be needed for the activities destined to revitalize

Hyde Farmlands: "I think they lie in wait for him on the way to then follow in his tracks here." Friendly "spies" hid behind every tree.

Ernst had a multifocal perspective. He reveled in the exciting details of his new life at Hyde Farmlands, but he also glanced backward to Gross Breesen. He yearned for the time when more students would join him at their new home. He ended his letters by reminding the awaiting students: "When we are all here, then on such days we will put the farm in order. In accordance with the proven model [Gross Breesen]. We have really had plenty of practice in that. And everyone knows what work he has then to do." With keen anticipation, he concluded one of his letters: "When I write the next report, Haka [Henry Cornes, another Gross Breesen student] will be here!"[33] He was hopeful that the good news about Hyde Farmlands would encourage those who had been selected to immigrate to America.

In the summer of 1938, Thalhimer had engaged a nationally recognized agronomist, Professor Karl Brandt of Stanford University, to analyze and evaluate the soil and its potential for growing crops at Hyde Farmlands. Before his immigration to America in 1933 in protest against the Nazi regime, Brandt, a Gentile, was a highly regarded agriculturist in Germany and headed important departments in the government. He was well known as an outspoken and active partner in the efforts to bring friends and scholars to the United States. Thalhimer had probably heard about him through his associations with refugee organizations. Brandt traveled to Burkeville and conducted a thorough evaluation of the farm. In the 1930s, farmers often depleted their land by not rotating crops annually, and this had been the case at Hyde Farmlands. Luckily, his exhaustive evaluation was never reported to the State Department. No matter, Ernst was not dismayed. He believed with every bit of his fiber that once the other Gross Breeseners arrived, regeneration of the soil would occur because it would become a high priority.[34] Obviously, Ernst's initial optimism was only matched by the spirit of confident challenge shared by those who eagerly read his letters. The stress of waiting for visas, the gate to a new life at Hyde Farmlands, began to weigh on the students. Ernst inadvertently stoked the fires of yearning in his letters when he often included phrases such as "when more people are here" or "I am already waiting for the day when we can introduce that, as well as many other things." Everyone at Gross Breesen was excited by the prospects of the farm, but they were also frustrated, for even though their two-year training program was completed, they could not quickly relocate and put their knowledge and skill to work.

Haka joined Ernst at Hyde Farmlands and was equally enthusiastic to be involved in the rebuilding of the farm and readying it for future arrivals. After touring the property, he made a list of what needed to be accomplished. At Gross Breesen, he was the "head of the building office," so he was right at home planning the sequence of steps needed to put the place back into living and productive order. In his mind, everything that needed to be accomplished was doable.

As the year progressed into early November, Ernst and Haka wrote to their Gross Breesen friends. They were serious in tone and perspective:

> *We wish all Gross-Breeseners success—wherever they may go…to build up anew and to find a new place of work, where they can practice their occupation with complete satisfaction…When we arrived in Gross-Breesen, none of us knew much about agriculture…how much the agricultural training has become the focal point now and how appropriate the attitude is of the individuals towards their work….Nova Gross-Breesen did not become a reality, not as we had imagined it. [Has] a Gross-Breesener become a special type? Who will be able to decide that? But we do believe one thing, that all our people have taken something with them from Gross-Breesen, something has rubbed off on them, to live in a manner like the one in which all of you lead your lives in Gross-Breesen.*[35]

Both expressed their Gross Breesen identity and spirit. Their letter was dated November 9, 1938. The subsequent events in Germany would escalate the need for emigration and begin the demise of the very place that had protected the students for several years.

6.

Visa Considerations

Round One

In 1938, the State Department was being hit by a tidal wave of inquiries and requests for visas. The staffs, both in Washington and Berlin, were frazzled and overworked. Everyone desiring to get out of Germany had a story; everyone had a "connection." Often, personnel felt that they were being stretched in opposite directions by a torture machine reminiscent of the Inquisition. The immigration laws and quotas, the unspoken directives to curtail immigration and the anti-immigrant and anti-Semitic forces steered the consuls in one direction. Pulling in the opposite way, however, was the sympathetic awareness of the worsening condition of hundreds of thousands of Jews and others who begged for rescue. It is a wonder, within this predicament, that the Hyde Farmlands Virginia Plan got any attention at all, and so quickly. The personal relationship that Geist had with Assistant Secretary of State George Messersmith and their shared hatred of the Nazi regime probably hastened the process. Given the snail's pace of how the State Department often moved, it was impressive how quickly it began its deliberations after it received Geist's communication. Some external pressure must have helped to grease the wheels of deliberation.

The State Department had to work closely with the Labor Department in order to evaluate the Gross Breesen applications, especially because Geist requested clarification of the "contract labor laws" as they applied to the visa applications. The first State Department memo revealed a hefty degree of skepticism surrounding the Gross Breesen visas. Richard Flournoy weighed in on the deliberations and did not mask his mistrust of the "disquieting" plan. He was troubled by what seemed to be the establishment of a "colony…a

permanent cooperative on a large scale [where the students] would remain on the farm." He stated: "It appears to me that the Governor and other authorities in the State of Virginia might not welcome the establishment in the State of these colonies, which might be of such a character that they would not fit in with the political and social system in the State."[36]

Flournoy vigorously questioned the political ramifications of the very idea of establishing a colony. He wondered how the students would become Americanized and "fit into" the Virginia social milieu. Was he possibly saying that Jews were not welcomed in Virginia? Overall, his initial response to the visa applications was overtly hostile.

The scrutiny of the visas rested predominantly in the visa office of A.V. Warren. It had been circulated among Jewish organizations that he was not considered friendly to Jewish immigration and that he "invented" roadblocks. George Messersmith, assistant secretary of state, entered into the considerations when he wrote to Frances Perkins, secretary of labor, on behalf of Secretary of State Hull on August 20. Known as a letter-of-the-law guardian in immigration matters, his first inclination was to exclude the Gross Breesen students because of Section 3 of the 1917 Act relating to "contract laborers."[37] He also questioned the viability of the Virginia project and, in addition, raised a moral concern about the advisability of "young men and women, ranging in ages from 18–22 years, living together on a farm…the results of such an enterprise in a moral sense might be most unfortunate."[38] His concern was quite outside of immigration law, but he seemed to be alerting consuls to question the candidates' suitability. Undoubtedly, he also must have been concerned that if the Gross Breeseners were approved as a unit, a precedent for group immigration would be created.

On August 22, Leroy Cohen, Thalhimer's business and family lawyer in Richmond, sent a letter to Avra Warren, chief of the Visa Division, in order to provide a bigger picture of the Hyde Farmlands project and insights into its chief sponsor, William B. Thalhimer. He sent a duplicate memo to the commissioner of immigration, James L. Houghteling. In it, Cohen stated:

> *I think it proper to state that Mr. Thalhimer, the President of Thalhimer Brothers, Incorporated, one of the largest department stores in the South, for two years served as the President of the Richmond Community Fund, an organization of the principal charitable institutions of this city and that he has for many years continuously interested himself in various other charitable and philanthropic enterprises. For references, if such are deemed of importance, any bank in the City of Richmond should be able to furnish you with information.*[39]

William B. Thalhimer and a Rescue from Nazi Germany

Cohen wanted the authorities to know that they were dealing with a man of prominent stature in the Richmond community. He also wanted to allay fears that Thalhimer did not have the financial resources to support such an operation. Leroy Cohen was handpicked to spearhead the delegation that would interact with the State Department. He was a brilliant lawyer, possessing all of the characteristics needed to win over skeptical governmental officials. As a deep, meticulous thinker who demanded excellence in every aspect of his life, he was respected by his peers as a problem-solving genius. His legal mind was a veritable trap; his presence exuded competence and integrity, immediately sensed at any first meeting. Though he was hard-driving, he was also charming and articulate, and even though he was so outstanding, he was never arrogant. This was exactly the kind of man Thalhimer needed. Though he was Jewish, he could travel in the highest echelons of white Protestant America and be respected by it. Of supreme importance, he shared Thalhimer's commitment to rescue Jews. Cohen and Thalhimer forged an awesome team in presenting their case to the State Department.

Leroy Cohen, Thalhimer's chief lawyer. *Courtesy of John Cohen.*

The initial salvo of reticent shots had been fired by three State Department figures: Geist, Flournoy and Messersmith. This was not a promising beginning, but neither were doors slammed shut permanently. Now the legal minds began to churn, and point by point, the visa application process would progress in due time. It was as if State and Labor, along with Thalhimer and Cohen, began a dance that resembled a slow, intricate tango, gliding across the floor, with spurts of sudden twirls, abrupt pauses and turns—and, always, plenty of tension. Warren concluded the first dance with a letter to Leroy Cohen:

> *The American Consul at Berlin has referred to the Department the question of the legal aspects of the proposed immigration of the aliens concerned and it is receiving the consideration of the Department. When a conclusion shall have been reached the Consul at Berlin will be suitably informed in order that he may proceed with his consideration of the individual cases of each of the proposed immigrants.*[40]

In a single paragraph, he summed up the process that was unfolding. There were legal concerns, and even if the State Department and the Labor Department concurred and concluded that the visas could be granted from a legal standpoint, it was still the judgment of Raymond Geist in the Berlin Consulate that would determine the fate of the students, on a person-by-person basis.

7.

STATE/LABOR DELIBERATIONS

Round Two

Much discussion transpired between Thalhimer, Leroy Cohen, Harold Young and the State and Labor Departments during the summer and into autumn. Young, a well-known Washington lawyer, had been the national secretary of the National Retail Dry Goods Association for almost fifteen years. He knew his way around Washington. He was solicited by Thalhimer as soon as Thalhimers Department Store was accepted into the powerful purchasing group the Associated Merchandising Corporation (AMC), member of the National Retail Dry Goods Association. Because the AMC was one of the most influential purchasing conglomerates in the country, the Labor Department would have been impressed by this commercial connection. Young carried clout. Adding Young to the Cohen-Thalhimer team fortified the visa request process. Substantial progress had been made in identifying the sticking points that were being considered by the two governmental agencies. Thalhimer had conversed with the commissioner of immigration, James L. Houghteling, who sent a very important letter to Warren on October 5.

The memo stated that Solicitor of Labor Reilly had "rendered an opinion":

> *Consequently it is my belief that the proposed plan for the immigration of approximately twenty-seven Germans to Hyde Farmlands in Nottoway County, Virginia may be approved as not in contravention with the contract labor law, provided that the plan as finally devised has the following characteristics:*

1. It arranges for the purchase of the farm by the immigrants.
2. It is not conditioned upon the performance of specific labor by the immigrants.
3. It does not furnish the cost of transporting the immigrants to this country.[41]

The issues for deliberation were becoming clear. At this point the consideration of Gross Breesen students owning shares in the farm became crucial. Reilly's stipulation of "ownership" of the farm opened the door for Thalhimer and Cohen to propose that the equity of Hyde Farmlands would come into the ownership of each student through the offering of shares. It's not clear whether the "shares" idea became the response to a requirement presented by the Labor Department or if it was proffered by Cohen and Thalhimer. No matter; the Labor Department had cracked open a door, and Thalhimer pushed it wide open. Owning shares would prove to be highly important in future deliberations.

Another question that needed to be answered was how would the students be classified. After considerable deliberation of the 1924 Immigration Law, Section 6 (A) (1) (B), the commissioner's letter stated: "In view of all these considerations, it is the opinion of the Immigration and Naturalization Service that these immigrants coming in under quota will not be excludable under the contract labor law."[42] This was the first breakthrough. The letter articulated only an "opinion," so more deliberations and legal advisements were going to transpire. The dialogue between State and Labor, and even within each department, progressed with what seemed like endless questions aiming for greater clarification. At this point in the visa deliberations, everyone was not in accord, to say the least.

In order to satisfy the shares arrangement for the students, Hyde Farmlands, Incorporated, had to be spun off into Hyde Farmlands Operating Corporation. In a letter from Thalhimer to Warren dated October 25, perhaps the first hint of uncertainty that the arrangements would not actually bring the Gross Breeseners to Burkeville revealed itself: "Of course, these proposals are all predicated upon the admissions of the proposed immigrants into the United States, as otherwise the present plan would have to be revised or abandoned."[43] It was as if a bureaucratic giant, sculpted out of ice, was beginning to melt, but only slowly. The chiseled, straight edges were becoming softer and rounder.

On October 27, a handwritten note from Richard Flournoy to Warren indicated that Thalhimer was making a very positive impression. The legal adviser wrote: "After having seen and talked with Mr. Thalhimer, I believe that he is acting in good faith in this matter and that his plan is distinctly

philanthropic, rather than commercial." He ended the note by indicating that his first response to the proposal was beginning to change: "I do not feel altogether opposed to Mr. Thalhimer's plan...but [I] still feel that we should be fully informed about it before committing the Department."[44] The absolute need for personal connection and confidence in the integrity of Thalhimer's motivation were essential if the proposal had any chance of being approved by the State Department.

A few days after Flournoy sent his note to Warren, he followed with a letter that summarized a telephone conversation he had with Leroy Cohen.[45] As a very savvy lawyer, Cohen must have thought that the officials at the State Department were asking the same questions in different ways either to uncover some underhanded scheme or just to understand the proposal and convince themselves of its viability. After more back-and-forth questioning, Flournoy concluded positively:

> *I am inclined to think that the Department can accept the assurances of Mr. Thalhimer as sufficient evidence that the refugees in question are not being brought to the United States as contract laborers, although the finding of the facts in the case still rests with the consuls to whom applications for visas are submitted...I may add that since our conference with Messrs. Thalhimer, Cohen and Young last week, I feel much more favorably disposed toward Mr. Thalhimer's plan than I was when the matter was first brought to my attention. As I said before, I am satisfied that Mr. Thalhimer's motives are philanthropic, rather than commercial. I do not believe that the cases of the refugees in question would come within either the spirit or the letter of the contract labor law.[46]*

This vote of confidence in Thalhimer and his team was essential. The memo was sent on November 1. The next communication in regard to the Gross Breesen visas would not appear until November 16. Between these two dates, all hell would break loose in Germany.

8.

GERMANY IN THE FALL OF 1938

In the minds of the students, obtaining visas for immigration to the United States should have been a clear-cut matter—after all, a Virginia farm awaited them, and they had the training to be successful farmers. What the students thought was a simple process was actually looming to be much more complex than ever anticipated. In their minds, the process was dragging on interminably. In a letter to Gross Breeseners, some of whom had already relocated to various places in the world, Bondy revealed his own growing frustration:

> The existing immigration obstacles of the Virginia group have still not been overcome, but just today a letter arrived from Richmond again speaking about an expectation of a decision in the coming week. But it is too vague, as to its arrival, to further delay the mailing of this letter—Hence, as in the first letter, I must write again this time that we hope, reasonably soon, to send you a positive message about the immigration prospects of the group. It is now self-evident that gradually we are becoming impatient, but we are still a lot better off than others, whose emigration is deferred again and again; for we have meaningful and satisfying work and everyone here can still learn plenty.[47]

In a September 29, 1938 letter to Werner Angress, a Gross Breesen refugee living in Holland, Curt Bondy displayed a premonition, general in nature but, in retrospect, extraordinarily relevant and timely. In response to a student's letter that had searched for personal meaning, Bondy rephrased

the question: "How shall we behave in emergency situations, and how can we work on ourselves to cope in such situations?" He went on to say, "I am of the view, that the basis of our attitude and the principles of our conduct in emergency situations cannot be any other than those of our everyday life." In his lengthy reply to Angress, he defined the "mature person."

First, there was the "conscious life." Of supreme significance was the importance of being aware of one's surroundings and influences and one's own responses and thinking. The ability to think under fire was a key concern, to be rational in understanding and in behavior.

The next characteristic of how a mature person should meet an overwhelming challenge is by living a "courageous life": "One can mature from difficulties, become stronger and more powerful, especially if one applies these difficulties as a starting point to increase one's power, to prove oneself against them, and…achieve an intensive lifestyle due to these contests."[48]

The third element was the "intellectual life." Bondy acknowledged that humans are "instinctual" (emotional) beings, but it was the rational or the "intellectual" side of man that must rule.

His extensive reply was not uncharacteristic. Even when he was most preoccupied and busy, he managed to find the time and the will to respond to each student's questions. He listened intently to their concerns and always attempted to respond with sensitivity but also with a firm sense of reality. He had a paternal attitude toward "his boys and girls," for he was the one who had selected them to attend Gross Breesen in the first place and, most often, recognized in them the sparks of intellectual and spiritual fire that he treasured.

Bondy was always urging and nurturing his students to grasp the essence of the "Gross Breesen Spirit" or attitude. He was trying to fortify the youngsters against the realities of a deteriorating situation. Though sheltered from the immediate slashes of the Nazi onslaught to dismember the Jewish community, the students were not naïve. Nazi legislation in 1938 that had stripped the Jews of their livelihoods, property, freedom and dreams had built up a head of steam that was unstoppable. Panic and depression were commonplace. Jews were being imprisoned and killed by the hundreds at the hands of concentration guards. The gleaming, black Nazi steam engine of racial discrimination and persecution pulled along millions of cars filled with willing, screaming Germans. In September 1938, Bondy was instinctively preparing himself and others for the gruesome test lurking just around the corner. He was desperately trying to protect not only the lives of his students but also their very souls.

In Richmond

While various governmental officials considered the Hyde Farmlands proposal, Thalhimer continued to study the developing crisis in Germany. The most accurate and timely source of information continued to be the frequent reports he received from the American Jewish Committee. In 1938, the Nazi regime increased the assault on the Jewish community. As law after law was promulgated by the government, anti-Semitic racism became the behavioral norm for a vast majority of the German populace:

> *Much of German anti-Jewish policy had long since become a matter of routine, which tightened the net of restrictions and added insult to injury. By a decree of July 6, 1938, Jews, with but few exceptions, were prohibited from engaging in occupations of commercial agents and salesmen, real estate brokers, property managers, real estate loan agents, tourist guides, and from serving as advisers on financial or other private affairs. A decree, issued on July 25, barred all Jewish physicians from practice. This was followed by two other decrees, of September 27 and October 31, which terminated the activities of Jewish lawyers. On November 7, all Jewish publications in the Old Reich, with the exception of one allowed to the Cultural League, were prohibited and all Jewish bookshops and publishing firms were ordered to liquidate.*[49]

The August 17 decree compelled all Jews to attach to their Aryan names the Jewish names of "Israel" or "Sarah," and Aryans could not use Jewish names for their own. Nazi anti-Semitism was strangling every vintage of individuality and personal identity.

As the searing summer heat lost its sting and the shadows of autumn elongated in central Virginia, Thalhimer must have sensed his own uneasiness with the shortening of daylight. On the October 26, 1938 radio broadcast of the *New York Herald Tribune*'s eighth annual Forum on Current Problems, President Roosevelt was strong in his warning: "There can be no peace if national policy adopts as a deliberate instrument the dispersion all over the world of millions of helpless and persecuted wanderers with no place to lay their heads."

There was no question to what the president was referring. Certainly, there were refugees who were not Jews, but the plight of this German minority was front and center.

9.

KRISTALLNACHT

November 10, 1938

By 10:35 a.m. Washington time, the State Department was already processing the events that began the day before. A telegram dated November 10, 1938, had been sent to the secretary of state by Ambassador Wilson from Berlin. The contents of the report were bone chilling:

> *In the early hours of this morning systematic breaking of the Jewish owned shop windows throughout the Reich and the burning of the principal synagogues in Berlin was carried out. Observers noted no uniforms of Nazi organizations among the perpetrators of this action. Nevertheless, it is not conceivable that this admirable body of police would have tolerated such infraction of order unless general instructions to that effect had been issued...Although no arrests have been reported in Berlin, the Consulate in Breslau reports arrests of Jews there this morning.*[50]

By November, almost eight months since the farm was purchased, only two Gross Breeseners were in place on the land. At times, Thalhimer was discouraged with the slow progress of the State Department, but those emotions of disappointment paled in comparison to the shear panic that struck him on November 10. The first news of the nationwide Nazi pogrom was announced on the radio, but the emblazoned black headlines of Richmond's two newspapers were what really must have horrified Annette and William.

On November 10, the *Richmond Times-Dispatch* ran a front-page headline: "Goebbels Asks Jew Attack End—Seeks to Restrain Nation-wide Violence

by Nazis." The article went on to quote Propaganda Minister Paul Joseph Goebbels: "The justifiable and understandable indignation of the German people over the cowardly Jewish murder of a German diplomat in Paris has resulted during the past night in extensive demonstrations." The same article stated that Goebbels's appeal was issued at 4:00 p.m., some fourteen hours after violence began in Berlin. Goebbels was playing a cynical public relations game. In fact, it was Goebbels himself who called for the "spontaneous" demonstration. Telephones and teleprinters, the Internet of the time, were used to spread the order. The reports of wholesale destruction of synagogues, Jewish-owned stores, beatings and the arrests of thousands of innocent Jews shocked the sensibilities of most Americans. The first reports of the nationwide pogrom were expanded as hours elapsed into days. An editorial in the *Times-Dispatch* on the thirteenth responded to the gruesome details:

> *The emissaries of sweetness and light who reign over the "New Germany" have shown just how devoted they are to the rights of "minorities," by their behavior during the past few days. If anything more bestial than the sadistic savagery they have manifested, has occurred in Europe in decades, we cannot recall it.*

The devastation was enormous, and the implications of violence on such a scale drove millions to distraction. Who were arrested and who were beaten? Who were now incarcerated in concentration camps? What happened to the people Annette and William had met in Germany in 1930? What happened to the students and staff destined to come to Hyde Farmlands? The news stories written by correspondents stationed in Germany filtered through the static of jumbled reports of terror. The first response of panic escalated into a pervasive nausea of fear. Were the students safe? What would happen next?

THE RAID AT GROSS BREESEN

Gross Breesen did not escape the onslaught of that fateful day. The walls of illusory isolation were smashed just as if they were storefront windows. On November 9, the black-uniformed Gestapo, in several trucks, suddenly descended onto Gross Breesen in the middle of the afternoon. In essence, everyone on the farm was arrested. They were all lined up in the courtyard and answered to roll call. The Gestapo had thorough knowledge of who lived on the training farm; their typewritten lists were always accurate. Every name

was accounted for. Then the segregation of students began. Males eighteen and older were ordered to board the bus that took them to Breslau and then were transported by train to Buchenwald, the notorious concentration camp near the city of Weimar. When the men boarded the bus, no one—not they nor those who remained at Gross Breesen—knew where they were headed. The girls and women were put in a barn, and the younger boys were locked up in a stable with guards stationed at the doors.

Then the infamous Kristallnacht began. Gestapo and local farmers, some of whom had even worked with the students—Gamoth the blacksmith, for one—entered the castle and "vented their 'spontaneous' rage on the furniture.[51] Cupboards were overturned, and the grand piano was hacked to pieces with axes. The Torah scroll was ripped to shreds, and pieces were thrown onto the manure piles near the stables. Furniture was destroyed with sledgehammers, windows were broken, dishes were destroyed and wooden doors were reduced to splinters. The raid ended with a drinking fest that took place in Bondy's room. A few older boys, though eighteen, stayed at the farm overnight, but they were picked up the next day. When they boarded the bus in the morning of the tenth, they gazed at a dozen downcast men already sitting on the bus whose faces and clothing were scabbed with a mixture of dried eggs and blood. The Breeseners did not have to ask the men what kind of cruel humiliation they had endured.[52]

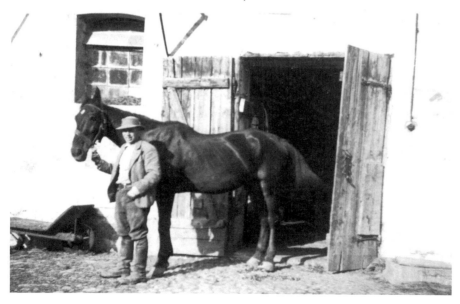

Stable/jail during Kristallnacht pogrom at Gross Breesen, 1938. *From the* Circular Letters.

At that point, especially because the telephone lines had been cut and communication with the outside world had been terminated, the remaining students at Gross Breesen thought that the raid and the detention of the males was an action only against Gross Breesen. There was no knowledge of what had transpired throughout Germany on that afternoon, night and the following day. What the students learned later was that on November 9 and 10 there occurred the most devastating pogrom in modern history: 267 synagogues in Germany were burned down, and those that were too close to neighboring buildings to be set aflame were desecrated and plundered; 36 Jews were murdered, and an equal number were severely wounded; more than 30,000 men, most eighteen to sixty years old, were imprisoned in the Dachau, Buchenwald and Sachsenhausen concentration camps. Kristallnacht was a "systematic public humiliation and abuse of Jews in every city and village in the Third Reich. This was an emotionally significant open ritual of degradation and dehumanization."[53] That the entire country, exactly at the same time, erupted into mayhem was engineered through twentieth-century communication technology.

BUCHENWALD

Transporting the Gross Breeseners to Buchenwald took them through Breslau, where the synagogue near the police station still burned from the night's onslaught. Ernst Cramer, an instructor at Gross Breesen and Bondy's assistant, recalled the events of the day:

> *The whole horrible episode began at the train station, in a tunnel under the tracks. We—several hundred Jews from Silesia—had been transported in a special train to Weimar. With ear-splitting shouts, uniformed guards threw us out of the compartments and drove us through the underpass, beating us indiscriminately with sticks. After a while, we were forced through the deserted square in front of the station into waiting trucks. After a short drive, they beat and chased us again, mockingly, this time through a much too narrow gate, over piles of rocks purposely put there, and into the camp. After having stood at attention for hours on the sodden, muddy assembly grounds, the guards assigned us to five recently built wooden barracks through which the wind blew. A total of 2,000 people lived in each building, none of which had windows or doors, only an opening in the middle. Bunk beds five beds high and less than a foot-and-a-half wide*

stood nailed together. The only way to reach one of these wooden plank beds was by crawling. There were no blankets, sinks or sanitary installations. The latrine was still being dug. Nobody was given any water. Some people lost their minds that first night. I remembered the stand on which people were beaten. I saw before me the gallows, from which a prisoner swung.[54]

Curt Bondy suffered the strain of personal attack and the feelings of powerlessness to safeguard "his boys." He soon gathered his wits, however, and once more resumed his leadership role. Because of his professional training and need to fathom the happenings that he and others were enduring, he observed with keen insight and noted with scrupulous detail the reactions of the inmates in general and of his Gross Breeseners in particular. What he observed and experienced in the camp was forever etched into his memory. He was astonished at the mistreatment that commenced immediately after the arrival at Buchenwald. The aggressive punishment was particularly intense in the first few days of incarceration:

[T]he prisoners had to sit for hours around two whipping racks and watch while various captives were flogged with different kinds of whips. During one of the first nights the storm troopers were permitted to vent their rage freely. Water was distributed in the night after a long period without any beverage. I suppose that a laxative was mixed in the water. The poor chaps who then ran out of the barracks were pitilessly tortured, shot at, strangled, and mistreated in other ways. I cannot guess how many captives died in that horrible night, but it was a considerable number.[55]

Another Gross Breesen student, while standing at attention in the camp yard, was accosted by SS sergeant Zoellner because he had turned around to look at a neighbor. The sergeant, with the sharp edge of the heel of his boot, stomped on the student's foot and ankle. Luckily, the student was wearing his own boots, so the blows did not penetrate. The sergeant kept slamming his boot onto the student's foot, but because his victim did not show signs of pain, the SS officer lost interest, for "it was not fun anymore."[56]

The month spent at Buchenwald was torturously long. Those rounded up on November 9–10 were segregated from the other Buchenwald prisoners and were housed in their own camp, named "Operation-Jews." In all, there were about ten thousand such Jews occupying five barracks, two thousand per barrack. These structures were hastily constructed with wooden planks that did not seal out the wind or cold. Within the special camp, the prisoners

could walk about freely during the day. This allowed the Gross Breeseners to find one another and stick together. Gross Breeseners who were not on campus during the raid and who were rounded up outside of the school were able to join their old friends.

Everyone in the camp had their heads and beards shaved, except for a few rabbis. The twenty Gross Breeseners incarcerated knew one another extremely well, but after each had been shaved, they sometimes did not even recognize one another. Just being able to stay together gave the students and staff a boost of spirit and support. The nights held the greatest terrors. Dogs barked wildly, and screams shot through the darkness. Every day, twenty to thirty prisoners died from sickness, malnutrition or the lack of needed and accustomed medications. Older people were the most vulnerable. The latrine was nothing more than a giant pit with logs stretched across it. Waiting one's turn in a group to use the latrine was agony. Two prisoners actually fell into the pit and drowned in the sewage. No matter where one was in the camp, day and night, inmates were unnerved by the announcements over the blasting loudspeaker. Roll call was a central activity during which absolutely no talking was permitted. The daily chaotic process of just getting out of the barracks took hours.

Bondy observed the total breakdown of civilized behavior:

> *The urge of self-preservation, bestial fear, hunger, and thirst led to a complete transformation of the majority of the prisoners. The ruthless struggle of "each against all" began. No one spoke in ordinary tones, every one screamed. The main thing was to get something to eat and to drink. When food was brought in, an excitement ensued which one can otherwise observe only among animals.* [57]

Prisoners displayed the worst of human behavior. What remained was a "wild, ruthless, and thoroughly senseless struggle for individual survival. Every trace of reason disappeared." Many inmates were driven mad or committed suicide by "severing an artery or running into the electrically charged barbed wire." [58]

Bondy continued to observe the behavior of the Gross Breeseners who were living under inordinate stress but who still managed to congregate together. He soon realized that the students behaved in ways that were completely opposite of the majority of prisoners. They clung together for hope, and they remained devoted to one another's welfare: "From the beginning, they set themselves the goal of bringing their entire group out of the concentration camp without loss of life or breakdown of nerves. They succeeded. Every one from this special group came out alive, without having

suffered serious illness or loss of sanity."[59] In addition to caring for the welfare of the group, the students ministered to other inmates who were suffering.

The terror of Buchenwald began on November 9. That date was of particular significance to the emerging historical narrative of the National Socialists. It was on November 9, 1923, that Hitler led the disastrous Beer Hall Putsch, an attempt to overthrow the Bavarian government. As he spent the next year imprisoned, he memorialized those Nazis who had died in the revolt by transforming them into martyrs. It was in these solitary days that he wrote *Mein Kampf* and seethed with the cancer of anti-Semitism. To add to the humiliation of defeat, the Nazis traced the birth of the hated Weimar Republic to November 9, 1918. All of their pent-up historical frustration and anger was unleashed on November 9, 1938. Kristallnacht became the living metaphor for retribution. The indelible, polished boot print of the Third Reich tattooed the necks of defenseless Jews.

IN BERLIN

Raymond Geist was well aware of the atrocities being committed against the Jews. He immediately telephoned M.J. van Schreven, consul general of the Netherlands, and followed up his telephone conversation on December 16 with a lengthy letter. In it, he laid out the complete and detailed blueprint for the process by which Germans could wait for their American visas while residing outside of Germany. He prefaced the details of a possible arrangement by saying, "Many such persons are under pressure to leave and obviously suffer certain hardships including confinement in concentration camps." He acknowledged the "unusual circumstances, when hardship would be experienced by delaying departure from this country." He asked that the Dutch government admit the refugees for the "period during which [the refugee] has to wait for his American visa, provided that certain assurances be given."

Geist reviewed the requirements for refugees waiting to be admitted to the United States and proposed that the "relatives or friends in the United States [would] transfer to a bank in Holland sufficient funds to maintain [the refugee] adequately for the whole waiting period." In addition to Geist's plan to provide a safe haven for German refugees waiting to receive visas within the German quota, he asked the American consul general in Holland to relinquish the visas of Germans living there and send them to the consulates in Berlin, Hamburg and Stuttgart in order for those visa applicants inside

Germany to rise higher on the waiting list. This did not mean, however, that a visa applicant in Holland would lose his immigration opportunity. It only delayed his receiving a visa in favor of getting those in greater danger out of Germany as quickly as possible.[60]

In America

The details of the raid on Gross Breesen and the situation and destiny of the students and staff were not known by those who labored on their behalf in America. Thalhimer immediately telephoned Avra Warren, the chief of the Visa Division, with whom he had communicated extensively. By now, they had developed a growing relationship of mutual respect. Thalhimer's call was emotional and frantic. He was worried and helpless. His questions must have been asked in rapid fire: Did Warren have any word about the students and staff from Raymond Geist? What would happen to them in a concentration camp? How could the State Department help to get them released?

In immediate retrospect, Thalhimer sent a letter to Warren that alluded to his emotional state of mind in the telephone conversation the day before, and he apologized for his frantic tone.[61] He had gained a broader understanding of the entire situation after he had communicated with the NCC in order to ascertain what had happened and what could be done to hasten an immediate release of the Gross Breesen prisoners. He learned that as soon as the males were incarcerated, the NCC committee, unaware of what Geist had already done, contacted their representatives in Holland in hopes that arrangements could be made to receive the Gross Breeseners as soon as they were released. No one knew how long they would stay at Buchenwald.

In his letter to Warren, Thalhimer mentioned "papers" that everyone hoped would further the chances of the release of the prisoners. Indeed, papers presented by the American Consulate to the Gestapo often facilitated a prisoner's release because the SS considered them as indications that the Jew under consideration would gain immigration status. Thalhimer hoped that Consul Geist could deliver official documents that would indicate that the students would be admitted to the United States under the German quota. He did not know that the State Department could not commit to issuing any kind of provisional papers that might be construed as "guarantees" for visas. Each individual case had to be considered and judged by the consul general

and then follow the accepted procedures. It is interesting that Thalhimer concluded his letter to Warren by saying, "My sincere prayers that this terrible condition will be soon over." Obviously, Thalhimer was shaken to his core, and prayers might have been a natural response, but for Thalhimer praying was not part of his typical response to experience, even when reason fell short. He may have been inviting a sympathetic response from Warren and his religious principles. Sensitive to southern tradition, Thalhimer knew that even though he was Jewish, Christians respected Jews "of faith." He was careful, always, to consider his audience.

Warren's response on November 18 was guarded but reasonable. He stated that Thalhimer's conclusions about the situation were "appropriate" and "sound." His letter, however, was terse, and it must not have been terribly reassuring. The truth be told, State Department officials were masters in letter writing to anxious constituents. The stock form letters were always sympathetic and courteous. Their aim was more to communicate an air of concern to mollify the emotional pleas from American citizens than to indicate actions taken.

Time passed, and it was ascertained in the consulate that the Gross Breesen students were still in custody. Numerous requests for more information, letters and cables were transmitted, but days turned into weeks and into a month. There were no new developments.

IN HOLLAND

The news of the Buchenwald imprisonment stunned Werner Angress severely. He had been corresponding with Bondy on a weekly basis. Because he was living in Holland, he feared that he would be left behind when the time for Gross Breesen immigration to Virginia arrived. Bondy had reassured him to the contrary. As the reality of the Buchenwald incarceration set in, Angress wondered what he could do to help free his friends and his beloved mentor. With his close friend from youth group days, Werner Warmbrunn (Meui), who was enrolled in a Dutch high school, he immediately went to the headquarters of the Jewish Committee in Amsterdam to ask for help. When he arrived there, he was shocked by the chaos of hundreds of refugees pushing their way to talk with an official inside:

> *Many had teary eyes, others ran around wringing their hands on the place in front of the building. You could read the despair in their faces. Everybody*

had a relative or a friend in Germany, who had been arrested that they
wanted to get help for. The only place in Holland that probably could help
was the Jewish Committee.[62]

Werner and Meui managed to gain entrance through the throng and met with two influential leaders, Dr. Rudolf Elk and Gertrude van Tijn. The goal was to procure the necessary documents that would indicate that the Gross Breeseners would be welcomed in Holland and thereby gain their release. A Dutch judge, Mijnheer de Jongh, who knew Bondy well, was contacted in hopes that he might intervene with the Nazi authorities. Communication was dreadfully slow. Angress contacted people in New York and asked them to intercede and provide funds in support of Gross Breeseners, who might be able to settle in the Dutch work/training camp, Wieringer Werkdorf, if they could be released from Buchenwald. He did not know that a plan to relocate prisoners had already been presented by Raymond Geist. After frantic letters and cables from Holland to Germany and the United States, Angress acquired all of the names of those in Buchenwald and those who were selected to immigrate to Virginia. This was accomplished through the help of Fritz Schwarzschild, one of the trustees of Gross Breesen.[63] Affidavits and the required financial support for the Breeseners who would come to Holland, both those scheduled to come to America and those who were destined to settle elsewhere, were secured. The effort to provide sanctuary for the Breeseners was furthered, and amazingly, this was accomplished by a teenager.

In Richmond

Thalhimer's deep anxiety over the fate of the entire Gross Breesen community was shared by his friend, John Stewart Bryan, president of William and Mary College. Thalhimer had contacted him in hopes that he would offer Curt Bondy a professorship at the college. Such a contract would guarantee Bondy's "out of quota" status and release him from Buchenwald. William Thalhimer and John Bryan were friends, but now their relationship took on a whole new dimension. They became partners in the lifesaving business.

Bryan responded immediately and contacted friends in the State Department, which resulted in Bondy's case immediately rising to a high level of attention. Not only was Bryan the president of a prestigious college, he was also a newspaper magnate who published the *Richmond Times-Dispatch*

and the *News Leader*, two of the most prominent newspapers in Virginia. Cables and telegrams crossed the Atlantic from the State Department inquiring about Bondy's whereabouts and his visa application status. A telegram was sent to Geist requesting information from Secretary of State Cordell Hull.[64] Geist responded promptly and informed Warren that Bondy had been imprisoned along with the other Breeseners and that he had not, as yet, registered for a visa at the consulate. He indicated that he was endeavoring to locate Bondy and communicate with him.[65]

Within the communiqués, the State Department clarified that it could not be the agency to offer Bondy the professorship. That had to come from Bryan himself. Eliot Coulter, acting chief of the Visa Department, wrote a lengthy letter to Bryan in order to spell out the implications of offering Bondy a teaching contract,[66] and he indicated that Bondy's visa was assured. One could not have asked for greater attention and cooperation from the State Department. In this case, gaining immigration status into the United States was greatly facilitated through connections with powerful and influential people. "Who you know," an ageless operative, proved to be true once again.

RELEASE FROM BUCHENWALD

In a telegram from Geist dated December 10, news of partial relief was received at the State Department and passed onto Thalhimer and Bryan:

December 10, 9 a.m.

Continuing my November 26, 10 a.m. Curt Bondy with 24 students and additional instructor in Jewish Agricultural School Breslau arrested and placed in Buchenwald concentration camp. All except Bondy other instructor and two students released. Have sent Bondy letter requesting him to call here. He intends to apply for no quota visa.[67]

Three weeks after the nationwide imprisonment of thousands of Jews, inmates other than Gross Breeseners began to be released. The first to be set free were the Jewish veterans who held documents attesting to their having received the "decoration for front-line" duty in the First World War. On December 4, most of the imprisoned Gross Breeseners were released, except for Bondy, Scheier and a few others who were not within the group rounded up in the initial raid. A few days later, Bondy telegrammed an Amsterdam

friend with the much-anticipated news: "Everyone returned healthy from trip. Please inform my brother immediately—Curt Bondy."[68]

The telegram was not exactly accurate, for a few Gross Breeseners were not released until the end of the month. Bondy alluded to the Buchenwald imprisonment as the "trip," a euphemism used not to annoy the Nazi censors. A telegram to the State Department from Geist eased Thalhimer and Bryan's apprehension. Dated December 16, 1938, Consul Geist wrote: "Continuing my December 10, Curt Bondy released from Buchenwald, called today. Told to present proof of professor status last two years in Jewish agricultural school with contract as professor from William and Mary College where he alleges position offered."[69]

Dr. Bryan was informed that the contract for Bondy had been sent through diplomatic pouch to the Berlin Consulate. He was also advised that as soon as the remaining evidence was presented by Professor Bondy, the consul would accord his case every possible consideration and take as prompt action as possible regarding his application for a visa. Bryan responded to Coulter with a letter of appreciation on December 23, 1938.

My dear Mr. Coulter,

You have been very kind in keeping me constantly informed about Professor Curt Bondy and the offer of a professorship at the Richmond Division of the College of William and Mary. I am very glad to know that he was released long enough to communicate with the Consulate General at Berlin, and I trust that our plans will be realized.

Believe me, with all good wishes for Christmas and the New Year.[70]

There were two primary reasons for the release of the Gross Breeseners: the Ministry of Agriculture had been convinced that if the students did not return to the farm work soon, the food production at Gross Breesen would suffer. But of even more importance was that Fritz Schwarzschild and Martin Gerson, both connected to the Gross Breesen Trustee Board, convinced the Gestapo that the students imprisoned had already been selected to immigrate to the United States under the Virginia Plan. For the Gestapo, any indication that Jews would soon emigrate took the highest priority.

The train ride from Buchenwald to Breslau culminated with the Jews of Breslau hosting the students for an overnight stay before they returned to the Gross Breesen campus. On the following morning, the students reported to the Gestapo headquarters to retrieve the items confiscated before they left

for the concentration camp. The efficiency and accuracy of the Gestapo inventory records was astounding. Before the students were released from Buchenwald, each had to sign a statement that he would leave the country posthaste. The document also stated that once the student left Germany, he would be placed under arrest and serve a life sentence in a concentration camp if he returned. There was no equivocation. The next steps for the students were clear; they had to get out of Germany, and soon! Two options seemed possible: one, residing at training centers in Holland, or two, remaining at Gross Breesen until immigrating to Hyde Farmlands in Virginia.

10.

WAITING FOR IMMIGRATION, 1939

Nothing equals the paralyzing anxiety of waiting for one's fate to be sealed. Powerlessness is humankind's silent torturer. For the students at Gross Breesen, their stasis loomed like a toxic fog. One could not control it; one could not elude it.

The first item of business that Bondy attended to after his release from Buchenwald was to write to Gertrude van Tijn. He explained that there were hopeful signs that the Virginia Plan would soon materialize, especially after his discussion with Raymond Geist at the Berlin Consulate. He closed his letter by reiterating his "heartfelt thanks" for the admirable work that the committee continued to do, to house and train students waiting for visas.[71] With the Buchenwald nightmare fresh in his memory, he realized that life at Gross Breesen for the students and himself had been changed forever. In essence, the Gross Breesen that was created in 1936 was now over. The year 1938 had ended with a swirling of furies that hovered over the crushed and splintered stones of Kristallnacht's landslide. All that the students now wanted were chances to build their lives again, to commit themselves to some life goal that was meaningful outside of Germany. A letter to Bondy from one of his students stated it well:

> It has been a long and trying struggle, a year of waiting, a year tumultuous and rough. For you personally the year ended with a blow. You sowed Virginia and reaped Buchenwald. And both are more than names, more than a destination or an experience. They are symbols...Last year we hoped for a year of accomplishments. This time I can really wish us only courage and hope; let that be the spirit in which to enter the New Year.[72]

In 1939, Bondy's full attention turned to facilitate the emigration of the first generation of Gross Breesen students, especially those who had been imprisoned. By Nazi edict, he was not allowed to continue as the headmaster of the institute, so he immediately sought guidance from his old friend, Otto Hirsch, still the director of the Central Jewish Committee in Berlin. He had already received an appointment as a professor, and the State Department had allowed him to take a leave of absence for as long as one and a half years, after which he would lose his "out of quota" professional visa. He decided to stay in Europe and continue to work with organizations aiding emigration activities. Because he had no family of his own to worry about, he was free to volunteer for new posts that were subsidized by the Reichsvertretung, which still gave special attention to non-Zionist students. He reasoned that Hyde Farmlands did not need his leadership as much as the transit camps in Holland and England. Even though the physical Gross Breesen was vanishing for so many of the students who had lived, worked and studied there for two years, social networking continued, with Bondy as the center of the matrix. He was the hub from which spokes extended outward to every student. He was still the center of gravity for the students, and they looked to him for guidance and grounding.

Bondy realized that the original concept to relocate the entire Gross Breesen community to another country as an agricultural colony was impossible, but he still harbored hopes that smaller Gross Breesen enclaves in Virginia and Argentina would materialize. He was, however, a realist. In a letter, he discussed his new vision for the students:

> *I think that there is no sense in mourning for the old Gross Breesen now. Look, that would be the same as if people leaving their youth were to mourn continually for the time, as if their values were irretrievably lost. People who understand how to live know very well that when they grow up, the experiences of their youth represent an important and essential component of their existence as adults. That's the way it is with Gross Breesen, too. Gross Breesen near Obernigk is preparation and a time of youth; the Gross Breeseners in Argentina, in Virginia, in Australia, in Kenya, and perhaps also in Parana should represent real and good adult life and confirmation of it. My friend, isn't that enough for a life's goal, do we have any reason to be sad and lose hope?[273]*

Those students leaving Germany had to broaden their perspectives. The emphasis on being personally self-aware and rational, strengthened

William B. Thalhimer and a Rescue from Nazi Germany

by courage and patience, would serve the students exceedingly well in new and rapidly changing situations. The Gross Breeseners had to maneuver the minefields of the chaos in their lives. They were now fortified with a new and flexible charge. Bondy wrote:

> *Every one of us has to search for his specific task and his specific aim. But to all is the farming vocation, which has to be the real vocation and fulfillment. Equally common is the personal attitude: decent, frank, courageous and helpful, people who want to lead a full and intensive life... In reality, it is as it is, to live, to fulfill the tasks set for everybody, to meaningfully organize every day,* **that** *is our task.*[74]

He was giving his wards the permission to step outside of the Gross Breesen community of their past and enter into the Gross Breesen of their spirit. He was preparing the students to think in terms of individual destinies rather than the vision of a "new Gross Breesen" colony physically located outside of Germany. This shift of perspective must have been painful for him, for there would not be a Gross Breesen home; rather, there would always be a Gross Breesen "attitude" that would allow the students to be home wherever they settled. As Bondy was flying to America via England to visit Hyde Farmlands and converse with Thalhimer, he wrote to his students:

> *I looked out of the window of the aeroplane for long time; it is foggy and already almost dark; I know that below me is water. The aeroplane is turbulent, one has the feeling as if it flew into the unknown; and just as I am writing this, it is clearing, we fly above the clouds—farther away one sees the ocean. And now the thought strikes me, that actually our life is very similar, bleak, uncertain, rays of hope, far-sighted and very cloudy. But as convinced as I am, that in half an hour I will land at the airport in London, as certain am I that, if we only have the will, we are able to lead a meaningful, satisfied life, despite, or perhaps because of all the difficulties, which we have to go through.*[75]

The awareness of being separated from Gross Breesen and having experienced Kristallnacht catapulted the youngsters onto a new plane of personal discernment, for surely circumstances pushed aside any possibility for a lingering adolescence. In a real sense, the students were old for their years. That could be said of the entire generation of German

Jewish teenagers who were forced to skip a crucial stage of development. All were robbed of their later childhood. In Steinbeck's words from *Flight*, "A boy gets to be a man when a man is needed." This was the norm for Gross Breeseners, who struck out in new directions.

The most frustrating part of the waiting period was the perceived slowness of communication between the U.S. governmental departments. Just when there seemed to be closure on a particular issue or question, requests for additional information arose. The paperwork became a nightmare to manage, especially in a world before computers and the instantaneous transmission of information. The manual typewriters, carbon copies on onion skin paper, duplicating machines, letters, cables, telegrams and telephones of those years would drive everyone today to madness. The utter frustration was captured by a student: "It is always a little strange when the grapes are being dangled before one's mouth and one is forbidden to bite into them. For that's the way our American project looks."[76]

The truth be told, Bondy harbored his own fears about the success of the Virginia Plan. In May 1939, he wrote to Julius Seligsohn and dared to admit that "I fear above all that Thalhimer will abandon the project if our people get there another half-year to a year later."[77] To add to this anxiety, the students in Holland and England destined for Hyde Farmlands were notified that their places in the long visa line were set back by ten months for the benefit of those still in Germany.

There were, however, high points of great joy when some of the students finally left Europe for new lives in other countries. Fifteen Gross Breeseners from Germany arrived in Holland on June 11, 1939, and were met by a Gross Breesen contingent already at Werkdorf (Work) Camp. Bondy flew from Berlin to see them off on the ocean liner *Slamat*, of the Rotterdam Lloyd Line, destined for Australia. He received a royal welcome when he stepped off the plane, and surrounded by his students, the excited conversation lasted well into the night. There were no goodbye speeches, though everyone knew the unspoken words: "We are Breeseners, and we have confidence in each other, in our work and in our will." The students had heard those words countless times. As the group stood together on the wharf, one of the students played his accordion, and all sang a song they had learned years earlier while still in the youth movement:

William B. Thalhimer and a Rescue from Nazi Germany

And remember the far away homeland
For the little troop, it prepares itself greatly
To leave the gray bastion.
And nothing holds us any more,
And we are very happy.
Soon sails will flutter towards the East!

As the ocean liner pulled away from the dock, the students on the pier waved their white handkerchiefs in unison following Bondy's instructions: "Up!—Wait!—Down!…Up!—Wait!—Down!" The students on the ship responded with a similarly synchronized handkerchief drill. Because of the waving, both parties were able to spot the signals for a long time until distance blurred the image and made the gestures indistinct. The fellow Gross Breeseners slipped away and turned toward their new lives in Australia.

The departure was so poignant and dramatic that it could have easily been a scene in a movie or a piece of fiction, except that the slow-moving vessel that became obscured by the mist was absolutely real. All of the other well-wishers on the dock had departed, but the students from Gross Breesen remained standing, even after they could no longer discern the waving white flags of their classmates. Bondy turned his attention from the bittersweet ache in his heart to the work at hand, to liberate the rest of the students still in Germany and Holland. For one student, the departure of the other students triggered his own dismay: "Virginia hovers before us like a mirage… it is really only an illusion."[78]

"Root Holds," 1939

The number of Gross Breeseners coming to Hyde Farmlands slowly increased. By the end of January, there was word from Hyde Farmlands that two more students had arrived, Manfred Lindauer and Lu Albersheim, as well as her mother, and that Eva Jacobsohn and Trudi Levin would be joining the rest very shortly. They had immigrated to the United States through means other than the visa negotiations for the students still at Gross Breesen or in Holland and England. Lu's mother was an American citizen who lived in Germany, so the way for their immigration was relatively simple.

Eva's story, however, was more complicated. She traveled from Germany to England and then to the United States en route to Cuba, where her father had been granted a visa. From Cuba, after considerable waiting, Eva, her sister and her mother were admitted to the United States, while her father, a doctor in Germany, with the help of the Quakers, was later granted a visa outside of the regular quota because he qualified as a medical professor. In a letter, Bondy wrote, "[P]eople are waiting with great impatience to go to the USA and to help in the development of the farm. We have reason to hope that this will be soon. They will then be able to prove to all the people who are always committing themselves for us, that their efforts had not been in vain."[79]

The few people living on the farm committed themselves to ready it for new arrivals; optimistically and naïvely, they thought it a foregone conclusion that their friends would arrive soon. At this point, there was nothing glamorous or sophisticated about the farm, except in its boundless potential. Farm life was not easy, and it was downright primitive by comparison to Gross Breesen, but that did not really matter, for it only served to motivate the students. There was talk from the neighbors that electrification was

Passport of Eva Jacobsohn (Loew). Note the "J" for Jew and the "S" for Sarah. *Courtesy of Eva Loew.*

coming to the county. Even though they were excited, there was an equal amount of reticence. After all, this was farm country that had remained pretty much the same for more than a century. Horses and mules did the pulling, and kerosene lamps, wood stoves and bucket wells amply provided the necessities for household comfort. But no matter; modernity's progress was on the march. To those students living on the farm, the importance of electrification was self-evident, for they had lived with it in Germany.

There is a saying for country folk "that a good wind just firms up a young tree's root hold."[80] That was what was transpiring at Hyde Farmlands. The young farmers were gaining "root holds" in the soil of their new lives, much as they had done earlier at Gross Breesen. Generally speaking, they were a serious bunch who had skipped the cushioning period of late adolescence, that period when teenagers are spared making hard decisions. For these youngsters, life had dictated its own terms, without recourse. Now they were farmers, and the harder they worked, the stronger and deeper their roots spread. They had been whipped by the roaring winds of the Nazi storm, but this had not broken them. Determination percolated within their

veins: "They had only to stand in their fields, run their hands through their plantings, and gather in their crops. On the knees of their existence, they rise out of the Virginia soil—these young men and women, collecting their lives in the harvest in their hands."[81]

In 1938 and into the first half of 1939, the production of crops on the farm barely supplied subsistence. The 350 acres of fields had been neglected for many years, but with proper fertilization and crop rotation, there was reason for optimism. The main crop grown had been tobacco, but in 1938, it earned only $400. The sole profitable crop was cucumbers, which earned just $80. All other crops were canned and stored for the needs of the students. In January 1939, a live and material inventory was taken:

> *2 draught horses, 1 mare, who is used purely for breeding, 1 foal, 2 mules, 2 Guernsey heifers, both in calf, 2 Holstein cows, which are good milk cows, several wild goats. 1 new and 1 old lorry* [wagon], *1 new and 1 old tractor, disc-plough for the tractor, 1 disc-harrow, 1 seed drill, harrow, ploughs* [swing ploughs] *hay rake, 1 cart, 1 mower, and sundry implements and tools.*[82]

Ernst Loewensberg husking corn at Hyde Farmlands. *Courtesy of Eva Loew.*

In the world of uncertainty, especially after Kristallnacht, the attention to pragmatic, quantifiable farm matters funneled the attention of all to the future, but what agricultural direction Hyde Farmlands would take was not entirely clear as yet.

Because of this uncertainty, Thalhimer hired a manager to set the farm on a trajectory of productivity and self-sustenance. U.K. Franken was engaged to assume leadership on February 1, 1939. In addition to managing the farm, Thalhimer hoped that his professional status might be a significant factor in the State and Labor Departments' visa deliberations. In a later report of the Blackstone agent of the Cooperative Extension Service in Agriculture and Home Economics, a branch of the Virginia Polytechnic Institute, Franken was praised for his "education, experience, and past record" and because he was "unquestionably well qualified to efficiently manage a project of this kind."[83] He had previously assumed the managerial duties at Belmead, the farm of St. Emma's Military Academy, which was run by Benedictine monks. There he succeeded to increase productivity and create an efficient and self-sustaining operation.

Thalhimer's hiring of a manager demonstrated his serious long-term commitment to the development of Hyde Farmlands. Franken settled in quickly and by the middle of February had evaluated the young people already at work. In an article that appeared in the *Crewe Chronicle*, on February 17, 1939, entitled "Hyde Farmlands Manager Optimistic Over Work Outlined For Year," it was reported that Franken "was very optimistic over the spirit of cooperation that the young German boys are showing towards the program of the farm work outlined for the year 1939. These youngsters are fast becoming oriented, and in the short space of time that they have been located here, they have become 'good neighbors.'"

Franken's initial inclination was to raise dairy cattle, for he saw a profitable market in the selling of cow manure for fertilizer, which was desperately needed to regenerate local depleted tobacco fields. In the late 1930s, the Agricultural Extension Service agents in Virginia were emphasizing the need for reclaiming "tired" soil through revitalizing with natural fertilizers. In addition, because of its prime location near population centers, everyone believed that if the farm could produce prime products with an eye to the calendar's most opportune sales periods, its success could be guaranteed.[84]

There were numerous reasons for a positive attitude: a farm manager was on hand; plans to build new infrastructure buildings were being considered; the poultry and dairy production was increasing; grain and garden produce was expanding; and the manor house was being refurbished to house

additional students. Despite the generally positive outlook, however, there were still two reasons for a valid sense of uneasiness: one, the students still living in Germany needed to emigrate soon, for their own personal safety; and two, more hands were desperately needed on the farm. Time was of the essence on both accounts.

The letters sent to Gross Breesen from Hyde Farmlands were treasured. Haka's reports were centered on building matters, while Ernst described more of the daily chores and work schedule. Irwin Scheier, the school's agriculture instructor, selected topics from the letters and integrated them into his curriculum. He viewed the letters as "teachable moments" because he could link topics to future applicability. In addition to their being pragmatic, the letters were essential to keeping alive the hopes of those on the list to immigrate to Virginia.

By the middle of 1939, there were seven Gross Breeseners living and working on Hyde Farmlands. Their days were long, but the rewards of seeing daily progress were bountiful. The farm tasks soothed their minds with a consciousness that focused on the present and pointed toward the future. This was crucial for their psychological and spiritual well-being. As farmers

A water break at Hyde Farmlands. *Courtesy of Eva Loew.*

all over the world have known for thousands of years, the soil is always being prepared for the next planting. Seeds are ordered with the certainty that they will eventually root and flower. Calves will be born. Chicks will hatch. Truly, the students had faith in life's promise. Farming, by its very nature, is futuristic.

The group created an effective division of labor: Rolf Falkenstein specialized in the development of poultry; Trudi looked after the pigs; Eva was the dairy person; Ernst and Manfred managed the teams and plowing; Haka drove the truck and focused on administrative concerns; Howard Irvin operated the tractor; and Lu was an all-around contributor. The work ethic of Gross Breesen was demonstrated in the attitude that the students attached to their daily chores. In addition to the students, Lu's mother, known to all as "Mrs. A.," made sure that the students stayed "in line" and were learning American ways. All in all, the Gross Breeseners were making a fine impression on everyone who visited the farm or who came in contact with them in the community. Thalhimer was very proud of the progress that was being made, and he acknowledged his delight when he visited the farm: "I like them all and would take everyone of them into my family."[85] The relationship with Franken developed positively with a fair give and take, even though Franken's constant refrain was, "That's not how we do things in America." Mrs. Franken and the six children were well liked, and one of the children, "Scotty," became a farm mascot. The tenant farmers, the Piggs, were friendly and very helpful. Overall, the farm community had settled into an amenable and well-functioning body.

Perhaps the greatest difference between Gross Breesen and Hyde Farmlands was felt by the young women. With the crossing of the Atlantic, some of the traditional German roles of the girls were left behind. In Gross Breesen, the girls were mainly involved in the activities of the house: preparing meals, housecleaning, mending, darning and doing laundry and some light gardening, but at Hyde Farmlands their responsibilities broadened. This new expansion of roles fostered pride and accelerated individual growth. Household responsibilities were augmented by different activities. Eva triumphantly wrote in May 1939: "So, now the whole cattle raising is in my hands. That sounds very arrogant, however, for it consists only of two cows, one heifer and one calf."[86] In addition, she fell in love with gardening. Her knowledge was growing quicker than the plants she tended or the dairy she managed. From two cows, the dairy grew to six. Milking twice a day was a constant exercise in learning and experimenting.

She rigorously studied the bulletins and newsletters published by the Virginia Cooperative Service; her cherished bible was the revised 1938 *Dairy Production Manual* by R.G. Connelly, Extension Dairy husbandman, published

by Virginia Polytech Institute. The table of contents was mouthwatering: "Feeding and Managing Dairy Cattle"; "Rations For Dairy Cattle"; and "General Dairy Herd Management." Eva learned what were the best feeding protocol and milking techniques. Hand-milking, in particular, was not a mechanical science but rather an art; each cow responded to a different touch. The best milking technique was always a source of friendly, competitive discussion in the *Circular Letters*, which served as a "snail-mail" version of the modern Internet chat room. The raw milk was bottled and used by the students and Franken's family.

Because of her proficient English, Eva became the main source people turned to for information and translations. She learned English when she was sent to a boarding school in England in the mid-1930s, after Hitler took power. Though her experience there was lonely and often frustrating, her English speaking and writing skills improved greatly and served to be ultimately significant as she contributed to the new life at Hyde Farmlands. She was the one who purchased the seed and grain in Burkeville and Richmond, where she negotiated with the Southern States countermen. Her

Eva Jacobsohn (Loew) feeding
her cow, Hyde Farmlands.
Courtesy of Eva Loew.

astute questions and observations revealed an extensive knowledge and a probing mind. No doubt some of her questions must have stumped the clerks. Even though she was one of the very few females in the warehouses, she was never intimidated by that man's world, and she quickly won the respect of the salesmen. She knew what was needed on the farm and calculated the quantities exactly. The seeds, grain and other needs were always "charged to Thalhimer's account." She enthusiastically commented on her new roles:

> *I am much more involved in the work here and also in the farm, than it was the case in Breesen. The reason is probably that I get much closer to everything and through that know more and have a much better overall view. For instance, I am already able to do the harnessing almost on my own and generally it* [is] *quite different to do the work. One does know why it is and what for. If it were my own land, I would not work and feel differently. I am really happy and satisfied doing it, and I only still miss the Virginia-people* [those selected to come to Virginia who have not arrived] *then everything would be complete.*[87]

Trudi echoed Eva's observations. She was energized by viewing herself as living "the life of a settler," realizing that everything one did was done independently: "The thing that I like so much here is the independence. We do the work which we think to be right, every single one has the responsibility, it is one's own fault if it does not turn out. Everything is almost as if it were their own household, like a large family."[88]

Planning for large group meals was a major logistical concern for the women at Gross Breesen, but at Hyde Farmlands, with smaller numbers, the planning and preparation were not so complicated. In addition, much of the canned food was purchased wholesale through the nearby Piedmont Sanitarium in Burkeville, and the garden produced ample quantities of fruits and vegetables for canning. In the summer of 1939, twenty-seven different vegetables were listed in the diary of one of the students. Despite the rather poor conditions of the soil, Hyde Farmlands was turning into a modest "truck farm."

The students ate in the kitchen. Cold cereal and toast composed the breakfast, while the break in the middle of the day afforded the biggest meal. Mealtime was announced by the ringing of the large bell in the tower that stood in the backyard, just outside of the kitchen. Lunch consisted primarily of vegetables: cabbage, potatoes, tomatoes, sweet corn, string beans, beets, carrots and onions. Homegrown beans became a staple. Supper usually consisted of sandwiches.

To supplement their own produce, Franken's old position at Belmead (later known as St. Emmas's Military Academy) offered additional canning

opportunities. Four students—Ernst, Howard, Eva and Lu—went to the boarding school when the students there were on vacation. The surplus vegetables from the school's gardens were donated for canning. First, the Hyde Farmlanders worked in the field picking beans, red and yellow beets and carrots. Then they prepared the vegetables for canning under the supervision of the kitchen staff, who were experts in using the newest canning techniques and equipment. They stayed on campus for several days and were fascinated by the institution, which was run by five Benedictine monks under the leadership of Father Strittmatter. Belmead, a secondary military boarding school that offered a completely subsidized education, maintained extremely high standards for its primarily black enrollment. The curriculum of the school combined military discipline and drill along with a classical education that was also supplemented by practical skills such as carpentry and farming. The Hyde Farmlanders were impressed by how intelligent and openly friendly the Belmead students were, and they were struck by the school's sense of high purpose that emanated from the students and their instructors. Discipline was understood as "courtesy, decency" and a general respect for the community. In many ways, the refugees saw the principles of Gross Breesen at work at Belmead.[89]

Ernst Loewensberg boiling the clothes at Hyde Farmlands. *Courtesy of Eva Loew.*

The loudest complaint in the kitchen of Hyde Farmlands arose from the merciless attacks by flies that were countered by covering the food and then spraying with Flit insecticide. The flies were a nuisance, but nothing compared to the "stinging monsters" that lay in wait in the fields. These were the notorious Virginia chiggers that inflicted on their victims spasms of itching and subsequent scratching. The baking was done in the wood stove, and consequently it was difficult to keep the heat constant. As did cooks throughout the country, the girls learned to measure the baking temperature by exposing their thermometer elbows to the heat of the oven.

Mrs. Franken was very helpful in teaching the girls the "American way" of preparing food. Meat was scarce, but when available, stew was the main dish, with lots of bread to soak up the gravy. Coffee was an expensive, prized luxury and was not served regularly. The water tank that was attached to the cooking stove provided hot water for cleanup. The new life on the Virginia farm was more primitive than in Germany, but the young men and women shared the workload in a balanced fashion. The women were rescued from the tedium of only doing household chores, for the males were willing to share household responsibilities. The daily routines were labor intensive. Water was drawn from the well, and the rusty bucket chain stained the hands orange and scratched the skin. Clothes were boiled clean outside in large metal tubs. Wood was constantly cut, split and carried to feed the kitchen stove, the wood stoves and the steam heat boiler in the basement. The outhouses, one for the women and one for the men, were cold in the winter and "nasty" in the hot months, and at night, when one was alone, they were downright scary. The minor injuries that often occurred in farm work were tended to by Eva, who had extensive first-aid training from her father. In her Berlin youth, she had considered becoming a doctor.

THE WOODS ARE BURNING!

Emblazoned in memory were the events of April 10, 1939. In the height of the forest fire season, the day was hot and very windy. The unusually warm and dry spring resulted in vegetables already sprouting:

> The boys wanted to burn a field so that they could disc it. But as the wind changed suddenly, and it was rather warm and dry, the woods started burning. I was just coming out to fetch Howard, when Manfred came and shouted, "Run. The woods are burning." We ran home and everybody

rushed out, but it was already too late. We were only nine people, and the fire was burning in a long line through the woods. We started putting it out, beating it with the branches of the pine trees, but it did not do much good. Then we started clearing a path, where the fire should stop. But it went over and we made about three more paths without much positive results. Even plowing did not do much good. The fire stopped at the furrow for a moment, and at the next blow of the wind, it went over. Luckily the ground was rather wet underneath those dry leaves and the trees did not start burning. If they would have started in that wind, it would have been nearly impossible to stop it. After a while, help came. And those people brought the right tools which we did not have. The help was the CCC boys. They made a path about twenty yards off the fire and cleared it of dry leaves and twigs and set another fire. As the two fires met, they had to go out because nothing was left for burning. We very quickly had the fire under control and put it out. Late in the evening, we went out again and put out the smoldering spots. There were quite a lot of them. We mostly covered them with soil. They set the fire on Monday. In Germany, Easter Monday is a holiday; they felt the fire went out of control because they were not supposed to be working.[90]

Luckily, there were two Civilian Conservation Corps camps in the vicinity of Hyde Farmlands, Camp Pershing and Camp Gallion. Each provided extensive training and experience in fighting forest fires, especially developing the famous "back-fire" technique. Firefighting trucks stood in readiness and were equipped with hand tools and Indian pumps. There were several fire lookout towers in the area, and because the terrain was relatively flat, smoke from a fire was quickly spotted. On April 10, when the fire raged out of control, the fire unit from Camp Pershing appeared on the scene in what must have seemed to the students as a miracle. They were in the vicinity cutting forest roads and building small dams. These were the men later chronicled in CCC history: "The heroic exploits of the company in forest fire fighting are legend over a wide section of the state."[91] If it had not been for the CCC men of Camp Pershing, disaster would have wiped out the woodlands of Hyde Farmlands and perhaps destroyed the entire farm.

The spring months were spent preparing for the transplanting of hotbed seedlings. Wheat was fertilized, and a variety of cabbages were planted along with Brussels sprouts, mustard, parsley and lavender. Lespedeza, which in good years often yielded three crops within a single growing season, had already been sown. The new calf was growing right before their eyes, and tiny horns could be detected. The young farmers had learned their lessons well from the Cooperative

Historic marker of the site of the Civilian Conservation Corps' Camp Pershing, Burkeville, Virginia. *Photo by Robert Gillette.*

Extension Service and Mr. Franken and put their suggestions into practice. Even the pigs, which were now being fed boiled potatoes and the remains of the kitchen scraps, flourished. Eva's daily work diary was so extensive that one wonders if she had intended to create her own agricultural encyclopedia.

Even though tobacco was no longer a profitable cash crop, it still needed to be planted to bolster earnings. Gross Breesen did not teach tobacco farming, so everyone had to learn the intricacies of growing the Virginia crop from the very beginning. Mr. Franken was helpful, but other neighboring tobacco farmers willingly shared their generations-old knowledge. In particular, Mr. Pigg and his daughter, Mary, were most instructive. They were tenant farmers and also housed the girls in their home. The entire complicated process impressed the students. For the first time, they were farming a truly American plant in American soil.

Because tobacco farming was so different from anything they had experienced in Germany, they had to learn a whole new culture. The boys had fantasies of growing their own tobacco and sitting back in their comfortable chairs pipe smoking on the veranda. As the season began, no one had any idea of how difficult tobacco farming was. By the time the harvest was complete, most vowed never to grow tobacco again, for the work never ended. It began with harvesting tobacco seeds in February and lasted into the curing stage in autumn. Tending to the plants was an endless,

backbreaking job. Picking off the sucker branches and the green tobacco worms was not only monotonous, but it often occurred on extremely humid days after a rain, when everyone became soaked from the moisture still on the plants mixed with the salty sweat that cascaded down their brows. To these natives of a temperate clime, the humidity and heat resembled the jungle climate of the Amazon.

To add to the misery of bending over for long hours, the young farmers soon learned that the thick gum that mature plants exuded was a scourge. It took several washings to remove the green stain tattoos. As the plants matured, the students learned how to use several types of tools dedicated only for tobacco work.[92] The intensity of labor was beyond the faintest imagination and felt interminable. Tobacco leaves were bundled on long sticks and then hung on the barn's rafters. Controlled fires in stoves and pits were set to reduce the humidity and cure the leaves. This required that each person had to take a night watch in order to feed the fire, manage the ventilation and safeguard the crop. With such a difficult growing regimen, it was no wonder that some lost all desire to smoke again.

All of this work seemed monumental for only seven people. In addition to raising tobacco, there were countless chores to support the gardens, the orchards, the chickens, the dairy, the forestry management and the household. The young students had boundless energy, but their work stretched on without respite. Each workday ended in exhausted workers collapsing into deep sleep. During this phase of the farm's development, the small group worked seamlessly, each assuming responsibility for a specific task. However, they

Tobacco harvesting, Hyde Farmlands. *Courtesy of Eva Loew.*

desperately needed more hands if the farm was going to prosper and expand. Adding to the enormous labor, because the students were not seasoned farmers, every task took longer and needed greater effort.

Chicken farming started at a modest pace. The boys converted small sheds and renovated tobacco barns for poultry production. They soon learned that chicken farming was fragile, for an entire flock could be wiped out from a single mistake in feeding and care. More than one thousand chicks arrived in cardboard parcel post boxes at the end of March and were immediately placed in the brooder house, a converted tobacco barn. The chicks needed to be kept in a constant environment of ninety-seven degrees, which was accomplished by using kerosene heaters and erecting tiny fences to keep the chicks close to the heat source. The students were especially concerned that if the temperature dropped, there was the danger that the chicks would bundle on top of one another for warmth and suffocate many in the process. In addition to keeping the chicks warm and well ventilated, the young farmers learned to feed them with the measured dry mash that provided the nutritional needs of the rapidly growing birds.

By the beginning of the summer of 1939, the modern age had arrived at Hyde Farmland. Thalhimer, at considerable expense, contracted a company to erect a water tower that held two thousand gallons in its wooden reservoir. The newly installed electricity powered the pump that replenished the stored

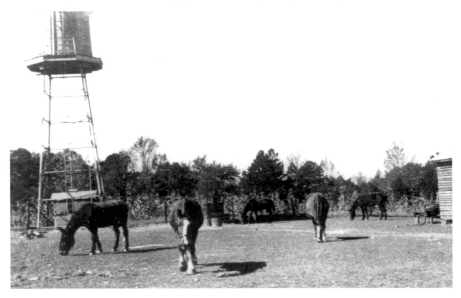

The water tower at Hyde Farmlands. *Courtesy of Eva Loew.*

water that was gravity fed to the manor house. If there was an electrical outage, the tower's capacity could supply the needs of the farm for several days. Bathrooms and showers were installed, and electric lights replaced the kerosene lamps. The manor house already had centralized steam heat, but now, with the addition of household electricity, the modern world truly arrived, and everyone was downright giddy. Even one of the outhouses was electrified, and Thalhimer promised the girls an electric mangle that would save hours of ironing. It was as if the young people had come in from a long, bone-chilling camping trip and suddenly taken residence in a luxury hotel. Everyone's spirits soared, and Thalhimer must have beamed with satisfaction. When Bondy came to visit the farm in the summer of 1939, he wrote:

> *This is really quite something, what these few people have achieved there so far. For everybody who is coming now, it will already be much easier, but I do not know whether one should be envious of them, or the people who in the first place had to arrange everything. When I was there this time, fly-gauze was already in front of the windows, the plumbing was in order, there were even several splendid showers in the basement, water closets, refrigerator and clean rooms. There was no snake in my room and no rats were running up and down the chimneys. In the community room stand comfortable armchairs, a perfect kitchen etc. The house is in a really clean state and is only waiting for*

The Oliver tractor at Hyde Farmlands. *Courtesy of Eva Loew.*

95

Hermann Kiwi to arrive soon to start his work…In recent days I have spoken a lot with influential people about Hyde Farmlands, and it was astonishing how serious this project is taken, how closely this attempt is observed and much of great importance depends on the success of Hyde Farmlands…Very much depends really on each single one, that this attempt succeeds.[93]

Bondy touched on a very significant topic. Certainly, Hyde Farmlands was to be a refuge and opportunity for new beginnings for the Gross Breeseners, but it was also to become an experiment for refugee resettlement that could be replicated elsewhere in the country. In the late 1930s, it was conceived that many Jewish refugees would be coming to the United States from Europe in the years ahead. If Jews could be resettled outside of the cities in rural areas, immigration officials would look kindly on the development. The image of Jews working on the land would be welcomed by all.

The men were totally engaged in tilling and preparing the fields for planting. The horses and mules pulled the plows that disced the soil, rather than using the prized Oliver tractor. Its versatility was admired, but it was used primarily as a source of belted power for the buzz saw. Always the farmers faced the need to develop ways to improve the planting beds and reduce the scourge of erosion. They must have cheered when Eva read aloud a poem from the *Extension News* written by the Tennessee Valley Authority:

*Hordes of gullies now remind us
We should build our lands to stay,
And, departing, leave behind us
Fields that have not washed away;
On the land that's had our toil,
They'll not have to ask the question
"Here's the farm, but where's the Soil?"*

The reports from Hyde Farmlands were welcomed by the Gross Breeseners everywhere, and everyone marveled at the amount of work that had been accomplished by so few people. They were also intrigued by their benefactor, William Thalhimer, who had created a haven and who visited the farm on the weekends, along with his sons. He often brought along community members and store employees to meet the students and to learn about the farm. He was always a welcomed and honored guest. He struck the students to be a down-to-earth man who had a genuine concern for them, and even though he was a city person, he had an abiding love for the land and what it stood for.

Visa Deliberations After Kristallnacht

The open, festering wound of Kristallnacht would never be cleansed of its psychological infection. Hundreds of thousands of Jews would forever sleep fitfully for the rest of their lives. Kristallnacht was the precursor to the Holocaust; both of these onslaughts cemented themselves into humanity's consciousness forever. The November pogrom revealed the possibility of the unimaginable. For the rest of the world, it was a revelation of the potential evil that flowed through the veins of the Nazi soul, though much of the world remained nothing more than a spectator of the horror.

Kristallnacht only partially broke the State Department's visa logjam. For the first time in a decade, America opened its immigration doors to at least fill the allotted spaces from the combined German and Austrian quotas. Immigration began to flow from a mere trickle to a very small stream, but it never swelled into a river of hope. The glacier of American indifference and hostility toward immigration melted only on the fringes. Even if time allowed, because the quota remained the same from year to year, it would have taken at least ten more years to enable all German Jews to procure visas. Of course, in retrospect, time ran out.

Those engaged in the deliberations regarding visas for the Gross Breeseners felt the urgency of making decisions that related to the young men from Gross Breesen, but no matter how serious the situation became, no matter how sympathetic officers might have been to the plight of German Jews, the State Department operated according to the immigration laws on the books. Only Congress could change the laws governing the quotas to allow for more immigrants to enter the country. This did not happen. To be fair to history, however, at this point, few could have even imagined the Holocaust.

On November 16, just a week after Kristallnacht, Raymond Geist received a lengthy memorandum from Assistant Secretary of State George Messersmith. The communiqué recounted the history of the deliberations thus far. First and foremost, following strict protocol, Messersmith underscored the most salient feature of all visa considerations: the decision to grant a visa rested solely with the final judgment of the consul. He then reiterated the issues that had been brought to the table by both the State and Labor Departments. He summarized the current status: (1) Thalhimer had purchased a 1,500-acre farm in the name of Hyde Farmlands Incorporated; (2) he then formed another corporation, Hyde Farmlands Operating Corporation, that would purchase the land from Hyde Farmlands Incorporated; (3) the immigrant students would be given shares in the operating corporation, and the profits from the farm would eventually buy the farm from Hyde Farmlands Incorporated.

The assistant secretary offered his understanding of the conclusions agreed upon by State and Labor:

> *It is not believed, however, that the contract labor clause was intended to preclude an alien from immigrating into the United States to perform labor upon his own land, or upon the land in which he has an interest. In the case of an alien who is coming to the United States to engage in the occupation of farming upon his own land, or upon land in which he is to have an interest, there should be no agreement with any other person or concern for the alien's employment as a laborer, although there may be an agreement regarding the purchase of the land or an interest therein by the immigrant either before or after his arrival in the United States. The aliens in this case must satisfy you that they do not intend to engage in work on such land until they shall have become the shareholders in the operating corporation, and until the operation corporation purchases the land, before the contract labor clause may be considered as inapplicable to their cases.*[94]

Messersmith, understanding the general pressure that his friend was under, tried to be of help by clarifying the facts in the case. He anticipated that Geist would raise his own questions in order to inform his final ruling. In addition, it was obvious that he was not pushing Geist to make a determination one way or another. In addition to discussing the relevance of the "contract labor" restriction, he focused on the extremely significant LPC issue. Would the Gross Breeseners be able to support themselves until they became owners of the farm, and even after, would the farm be able to support them? He suggested that Geist needed to investigate more thoroughly Thalhimer's willingness to support the entire project.

The third issue that Geist had to be clear about was the matter of who was paying for the passage of the Gross Breesen students to the United States.

The memorandum sent on November 16, 1938, was not responded to until March 1, 1939. This delay indicated the enormous amount of visa cases the consulate was considering. In his letter, the consul general attached a lengthy memorandum written by the three vice-consuls—Halleck Rose, Carl Norden and Cyrus Follmer—selected to review the Gross Breesen/Hyde Farmlands file. Before the individual applicants could be called to appear at the consulate, the vice-consuls had significant questions that needed to be discussed by the State Department. For sure, final decisions about the granting of visas were to be delayed once more, but the cases now were high on the list of considerations. This delay and the reasons for it were not known by Thalhimer or Bondy.

Even before the vice-consuls met to discuss the Gross Breesen case, Geist articulated his concerns. He understood the initial conclusions of the State/Labor deliberations regarding satisfying the "contract labor provisions" of the law, but he stated that he had not received any evidence that the title of Hyde Farmlands Incorporated had been transferred to Hyde Farmlands Operating Corporation. He needed at least a certificate from a Virginia attorney that would attest to the transaction.[95] This detailed documentation was necessary to advance the visa process. Again, more delays.

The meeting of the three vice-consuls began with a reading of the report from Dr. Bondy and Mr. Scheier that summarized the Gross Breesen institutional workings and the certification program. The report concluded: "It might be added that the selection of the people for Virginia was made with special care, and there is no doubt that they will prove successful."[96]

Concerning the satisfaction of the contract labor law, there was general agreement that the case had not been made that the students would receive shares and that "evidence" for such an arrangement was "lacking." Furthermore, there was no accounting as to the value of the individual shares. Each student had an affidavit of support from someone outside of the farm project, but this did not strengthen the application because each affidavit was not in any way connected to Hyde Farmlands. In short, the consuls had no evidence from William Thalhimer that would clarify the "productive capacity" of the land or make an accounting of how each student could derive sufficient income.

In addition, the issue of contract labor again was raised. Seligsohn, the chief Gross Breesen negotiator, and Bondy were contacted to tell them where the deliberations stood and that more documentation was required

from Thalhimer. The agony of delay was exasperating. Vice-Consul Rose turned the attention of the committee to what was probably the most crucial concern. He articulated the very essence of the entire visa matter:

> *Each of the applicants should be made to clearly state the reason for his going to the United States. If the compelling reason is to work for the Hyde Farmlands Operating Corporation, I believe he would be contract labor. If the main compelling reasons are the present conditions in Germany, I think he would not be contract labor.*[97]

In Rose's mind, ascertaining the "main compelling reason for the applicant's immigration" was paramount. Rose, the leader of the committee, proceeded to sum up the state of affairs succinctly:

> *Contract labor provisions of the law are intended primarily to prevent the importation of foreign laborers by the American employers to the detriment of American labor. The immigration of these agricultural students, however, would not appear to be detrimental to American labor for the reason that the object in setting up the philanthropic enterprise to which they are destined in the United States was primarily to cause their removal from present conditions, particularly affecting the race to which they belong in Germany. Obviously, had these conditions not existed, the enterprise would not have been established and the question of importing foreign laborers would not have come into the matter. There would seem to be no reasonable doubt in respect to the compelling reasons for the migration of these agriculturists. Their desire to leave the country where they are now as quickly as possible is probably not motivated by a special desire to accept employment in the United States, either skilled or unskilled.*[98]

He had zeroed in on the key consideration: why were the students emigrating from Germany. In one paragraph, loud and clear, he cut through all the red tape and all the legal considerations finally to put the entire visa case into its proper perspective.

On March 16, the consulate received a telegram from Secretary of State Dulles. The case had climbed up the ladder of the State Department bureaucracy. In it, the secretary relayed the message that "Mr. Thalhimer [was] experiencing considerable loss on account of [the] delay of the consideration of these cases." Thalhimer requested that Dr. Julius Seligsohn visit the consulate on March 20. The secretary of state requested that the consulate "cable a report as

to the status of these applications." Obviously, friendly pressure for action was mounting from the United States. It was already one year since the first contact regarding the Virginia Plan was received by the State Department from Geist and Thalhimer and his legal advisers.

A letter from the Labor Department to A.V. Warren, chief of the Visa Department of the State Department, took issue with some of the requests for information made by the consulate in Germany. Solicitor of Labor Gerald D. Reilly wrote:

> *[I]t occurs to me that the sponsors of the project might be asked to submit evidence of its feasibility, but the indispensability of such evidence is subject to doubt. The letter of Mr. Geist indicates that it is necessary in order to establish a "preference status" for the immigrants.* [99]

Reilly dismissed the concern over the students qualifying for agricultural preference being tied to the financial feasibility of the project. He continued his letter and diplomatically revealed some frustration with the drawn-out process: "The minutes of the Board Meeting of the Vice-Consuls in Berlin concurs in the view of this Department, as expressed in our letter to you of October 5, 1938, that these immigrants are not contract laborers." (That was nearly eight months earlier!) The agricultural preference issue was quickly resolved by the State Department when it was agreed that a diploma or a certificate from an institute of agricultural education was not sufficient to earn the category of "first preference, agricultural." Each candidate for immigration needed to be interviewed and tested by the proper authority so designated by the consulate.

William Thalhimer, along with his son, William Jr., Leroy Cohen and Howard Young, visited the Visa Department on April 5, one year since Thalhimer purchased the farm. The visa officer explained where the process stood. All of the participants in the decision of granting visas were coming into accord, but Thalhimer needed to provide additional information for the Berlin Consulate before it could complete its examination of the visa applications.

The first item of information that needed to be provided was an evaluation of the feasibility of Hyde Farmlands' productive/financial success. The Cooperative Extension Service agents became the evaluators of the program of work and development of the farm prepared by the farm's manager, U.K. Franken. On April 22, G.R. Mathews, the county agricultural agent, wrote a report that supported the feasibility of Hyde Farmlands' success. Mathews concluded his evaluation: "We know that

Mr. Thalhimer is a reliable and successful business man and that he is greatly interested in this project and that he is financially able to do the things indicated in the enclosed program of work."[100]

Mathews alluded to a mortgage payment plan that was extremely generous. The interest rate that Hyde Farmlands Operation Corporation was to pay for the mortgage to Hyde Farmlands Incorporated was 3 percent. Astoundingly, that interest payment would not begin until December 1, 1944. The initial principal payment of $250 per year would not begin until December 1941. This extraordinarily liberal repayment arrangement allowed the farm to get on its feet and develop without the strain of immediate financial indebtedness. This kind of generosity on Thalhimer's part was boundless, but he also needed and received the most favorable terms negotiated with the mortgage lender, the Central National Bank of Richmond.

William H. Schwarzschild, "Mr. W.H.," owned the bank and was intimately involved with the finances of Thalhimer's Department Store and family affairs. Thalhimer, Schwarzschild and Morton Thalhimer composed a formidable financial team. On April 27, 1939, the final deed for the ownership of Hyde Farmlands was transferred from Hyde Farmlands Incorporated to Hyde Farmlands Operating Corporation. Leroy Cohen became the principal trustee, Sara J. Rosenberg assumed the position of secretary of the corporation and fourteen Gross Breesen students were named shareholders: Werner Angress, Rudi Caplan, Ernst Cramer, Friedel Dzubas, Manfred Gottschalk, Klaus Herman, Herbert Kirchroth, Isidor Kirchroth, Hermann Kiwi, Walter Mielzinger, Ludwig Rfoshlich, Gerd Tworoger, Hans Bacharach and Ernst Ludwig Heimann. Others would be added to the list in the near future. Those who were already on the farm did not receive official shares because the list was developed for the immediate use by the State Department as it related to visas matters. No shares were given to women, even though Gross Breesen women were part of the farming community.

On April 22, 1939, U.K. Franken wrote an exhaustive memorandum to dispel the doubts of the vice-consuls regarding LPC. Anyone reading Franken's report would have been impressed with its thoroughness and the potential earning power of the farm. His estimated financial statement indicated that after expenses the farm would earn $20,559 in the year of full production.

On April 28, 1939, William Thalhimer wrote to A.M. Warren advising him that the information requested to answer the questions of the vice-consuls in Berlin had been sent. He also stated that the students would be issued their shares when they "are in person at Hyde Farmlands." As he signed the letter, he no doubt thought that the process was nearing completion and that

the deliberations were coming to a positive conclusion. The very next week, however, another snag stalled the progress.

The momentum toward the granting of visas was dramatically halted by Robert Alexander, technical adviser to the Visa Department. In a letter to Avra Warren, he blew a piercing police whistle. He did not equivocate; his tone was hostile when he portrayed the entire farm project as a "scheme." He pointed out that the contract labor law made no provisions "in favor of immigrants who are coming to the United States to work for philanthropic enterprises." He postured that there was an underlying profit-making motive for Hyde Farmlands to earn money in order to purchase a mortgage. In addition, the farm's products were to be sold on the open, competitive market as opposed to raising crops solely to sustain the immigrant farmers. Furthermore, Alexander questioned the likelihood that the students, once they arrived in New York, "would ever venture to Burkeville to settle on the farm." The letter advised that the entire matter should be reviewed by the legal adviser's office for their opinion. Alexander wanted the yearlong deliberation to start all over again.[101]

K.M. Knight, State Department legal adviser, responded to Alexander's request to evaluate the legalities of the Hyde Farmlands plan with a lengthy seven-page memorandum. He supported Alexander's conclusion that all of the points of contention were valid and needed to be determined by the vice-consuls. In particular, he urged further clarification regarding the nature of the payment to the students for "labor." In addition, he asked what the status of the students would be if the mortgage note could not be repaid when the principal was due:

> *The inability to pay the note would apparently divest the Operating Corporation of title to the lands, thereby divesting the aliens of whatever interest they had in the lands. It is for this reason that it is believed the immigrants should have guarantees of support, adequate to satisfy the requirement of the public charge clause, separate and apart from those issuing from Mr. Thalhimer's plan.*[102]

At this point in the development of the plan, legal counsel observed that Hyde Farmlands Incorporated maintained supervision and control over Hyde Farmlands Operating Corporation. This arrangement did not give the latter any autonomy. Knight concluded his evaluation by stating that the matters he questioned "should be clarified in order to adequately cover the many ramifications of this case for the purpose of instructing the American Consulate General in Berlin."

When Knight used the words "ramifications of this case," he hit the nail on the head. What started out in Thalhimer's mind as a simple, straightforward process to acquire visas turned into an international summit. This was now May 11, 1939, thirteen months after the first State Department contact by Thalhimer, and the deliberations had not as yet been concluded. Fifteen months, which must have seemed like an eternity, had elapsed since the Gross Breeseners were notified that the Virginia Plan was going to be a reality. Under the tightening of the Nazi vise, each day of uncertainty was progressively more painful.

On May 16, 1939, Richard Flournoy, a chief legal adviser in the State Department, weighed in on the discussion. He did support Knight's question about the value of the individual share given to each student, but he differed with him when it came to insisting that Thalhimer put up individual bonds for each student in addition to the shares:

> *After all, the immigration law itself does not require any alien to show positively, beyond the shadow of a doubt, that he would not become a public charge, if he should enter the United States. The law only requires that aliens should not be admitted if, in view of all the facts and circumstances, it appears that they are "likely" to become public charges.*[103]

In his mind, a letter from Thalhimer stating that if the farm project failed financially he would take measures to prevent the young men from becoming a charge on the public would suffice. Certainly, the intent was to emphasize Thalhimer's responsibility in the public charge matter. His last recommendation was a crucial one. He suggested that Thalhimer and his associates be invited to the State Department for a face-to-face meeting during which the concerns could be aired and countered. He also recommended that a representative from the Department of Labor be present at the meeting. This enormously important meeting was scheduled for May 23, 1939, at 2:30 p.m., and it could have been a deal-breaker. The future of the Gross Breeseners rested on the outcome.

Robert Alexander wrote a memorandum for the files on the day of the meeting. The conference included William Thalhimer, Leroy Cohen, Harold Young, Solicitor of Labor Reilly, Assistant Legal Adviser of the State Department Flournoy, Chief of the Visa Division Warren and Technical Adviser in the State Department Alexander.

The consensus of the group countered the issues raised by Alexander, and the last few details had to be hammered out. First, it was agreed that

the students would not receive their individual shares until they arrived in Richmond, Virginia, and before they actually took their place on the farm. And then came the clinching agreement. Alexander, in somewhat of an about-face, wrote:

> *With reference to the public charge clause, Mr. Thalhimer said he would be willing to guarantee that the aliens would not become charges upon the public. He is prepared to invest enough money in the co-operative farming venture to make it earn a livelihood for the aliens, but in the event it should for any reason prove to be a failure he would see that the aliens do not become charges upon the public. Inasmuch as Mr. Thalhimer is a responsible citizen and merchant in Richmond and is an officer on the resettlement committee for Jewish refugees in the United States, it was agreed that his assurance of support would be sufficient to meet the requirements of the law in each particular alien's case, although some of the aliens may have affidavits of support from other persons on which to fall back in the event of the failure of the farming project.*[104]

After over a year of exhaustive deliberations, it all came down to a verbal promise by William Thalhimer to finalize the visa decision. His integrity won the confidence and trust of the State Department. In addition, he waived any claim of charging interest on the note assumed by Hyde Farmlands Operating Corporation.

The hard-fought battle to scale the walls of the State and Labor Departments was finally won. In his letter to A.V. Warren, Thalhimer wrote on May 25, 1939: "Under those conditions, I hope you will find it possible to do everything to speed up the conclusion of this case." On June 22, 1939, George Messersmith summarized the deliberations of the State and Labor Departments and responded to the questions and concerns that the vice-consuls had raised in their March 1, 1939 dispatch. He wrote that the students "should not be regarded as subject to exclusion under the contract labor clause in Section 3 of the Immigration Act of February 5, 1917. It is understood that the Solicitor of the Department of Labor concurs in the conclusion just mentioned."[105]

He dismissed the charge of LPC and instructed the consulate to examine each student for agricultural preference status. He explained that even if a student did not qualify for an agricultural preference within the quota, he should not be penalized or lose his place on the visa waiting list. Messersmith requested that the department be informed of the actions taken on the

applications so that the department could communicate with the interested parties without having to route questions to Berlin. Hyde Farmlands had now earned a priority status.

Curt Bondy, who was in the United States at the time, received a cable from Julius Seligsohn telling of the positive decisions of the consuls in Berlin. Jubilant, he wrote to Warren: "I hope that there won't be any further difficulties for the boys in Germany as well as for the boys already in other countries [Holland and England]. I want to thank you again for all your kindness and helpfulness in this matter."[106]

Leroy Cohen wrote to Warren on July 28, 1939, to inform him that there were seven boys living in Holland who should be added to the list of those coming from Germany. Warren acknowledged the request and informed Cohen that those in Holland needed to contact the consulate in Rotterdam, where they would receive visas. He forewarned Cohen that the officials in the consulate would not know of the cases and that there would "necessarily be some delay before the consular officer in charge at Rotterdam may obtain from the Embassy at Berlin the information necessary to pass properly upon their cases."[107] No doubt, Thalhimer was relieved that, finally, his plan stood an excellent chance to succeed. There were still hurdles to be crossed before the students actually planted their feet on Hyde Farmlands soil, but these were minor compared to the long, torturous process that was ending. Ahead, each student had to be interviewed and approved; each had to be examined for agricultural preference status; each had to be booked for passage; and finally, each had to leave Germany and Holland before the Nazi war machine made emigration impossible. The race against time seemed even more perilous.

13.

JOURNEY TO HYDE FARMLANDS, 1939–1940

Preparing to depart from Gross Breesen aroused a complex array of emotions. The students were leaving not only their home of the last three years but also their homeland, the place of their birth where their families still lived. They hated the Nazis and harbored disdain for the general German populace who participated in such horrendous treatment of minorities, but they still deeply loved the German culture they once knew. Ernst Cramer, Bondy's principal assistant and a most admired counselor, looked back on the founding of Gross Breesen and wondered what would happen to the place in the years to come. His heart was full, for he could not quite believe, after so many months of waiting, that he and his students were finally emigrating from Germany to their new home and new beginnings in Virginia. There was packing to be done and families to contact, and there would be difficult goodbyes to those younger students who now resided at the training institute and staff members who would remain. In an entry in the *Circular Letters* at the end of July 1939, he wrote: "Accept a last greeting now from us Virginians [those who were on the list] from the old Gross Breesen. In the next Circular we, as well, will be able to report from our work abroad. Hopefully the people from Holland and England will also be in Hyde Farmlands already."

The transatlantic liner, *Hamburg*, carried the students from Germany and stopped in England on its way to America. The Gross Breeseners living in England met to greet the ship and were anxious to spot their friends. With the ship's band playing, yells of recognition rang out. The reunion had a liberating air to it, for it was the first time that Gross Breeseners could greet one another in freedom.

The journey to Hyde Farmlands was different for each immigrant. Some came as part of a small group, and others traveled alone. The way across the Atlantic was part exodus, part exile and part adventure. Emotions of worrisome reluctance and a longing for home whirled with joy, excitement and personal relief. Added to the uncertainty of being a refugee, the young men harbored the natural self-doubts and mood swings of any adolescent. All realized that momentous events were happening in their lives, and they were confused by the melding of fear and exuberance. On their voyage, the students were surrounded by German and Austrian emigrants, many of whom spoke only German. These older people were depressed, for they were immigrating to a country that they would never quite comprehend, speaking a language they would never master. They would be homeless forever.

When the young immigrants docked in the United States, they were excited and uneasy at the same time. Their greatest apprehension was that there would not be someone to meet them at the time of disembarking, someone who could speak both German and English to help negotiate the initial landing in America. To their thankful relief, the immigrants were always met by people who were dedicated to taking the newcomers under their wings and providing a secure first encounter. The refugee committee members considered the arrival experience to be crucial and took their role very seriously; of course, New York City was an impressive doorway to the students' new lives.

Not every student's journey to America, however, was without disruption. One such student who was living in Holland was Werner Angress. Misunderstandings and miscues could have easily resulted in his losing the opportunity to immigrate altogether. Though the events of the crossing, in hindsight, seem comical, they could have been tragic.

Angress left a Holland that was growing uneasy. Even though it was neutral, everyone was convinced that Germany was poised for imminent invasion. In the last week of September 1939, he was called to appear at the consulate in Rotterdam. Sent from the Berlin Consulate, his name appeared on the list of Gross Breesen students who were earmarked for Virginia. The initial meeting disclosed that LPC was a concern, for it was deemed that Angress's affidavit was not financially viable. His original sponsor, Samuel Trepp, a cousin of his father, worked as a building engineer at the famous Bergdorf-Goodman in New York. The LPC question was quickly resolved when the Joint Distribution Committee procured an affidavit from Lewis L. Strauss, co-owner of the prestigious New York bank Kuhn, Loeb and Company. With such a prominent sponsor, the officials at the consulate were duly impressed, and the visa was assured.

William B. Thalhimer and a Rescue from Nazi Germany

After he passed the physical examination on October 3, he waited several more weeks before the Dutch ship SS *Veendam* was readied for the voyage from Antwerp. The *Veendam*, which coincidentally also carried George Landecker in 1940, flew the flag of Holland and was always well lit in order to be easily identified by German submarines. As was every passenger ship in the late 1930s, it was filled beyond normal capacity. In every cabin where two would ordinarily sleep, now there were four. Werner was in a unique situation because he knew Mr. Langenberg, the head chef of the *Veendam* and the supervisor of the personnel of the three different kitchens on board. By chance, the Angress family had rented rooms at Langenberg's home in Amsterdam.

The incident that could have proven disastrous occurred on October 30. The ship sailed to Southampton, where British naval and immigration officers proceeded to inspect the papers of the passengers on board. One name on the ship's manifest raised questions. Unbeknownst to Werner, for over an hour officials were looking for him to examine his passport. A passenger friend informed him that he was being hunted throughout the ship, and he immediately presented himself to the authorities and tried to answer their questions in his broken English. Angress was registered as a German living in Holland. A Dutch crewman overheard the interrogation and explained that because Werner had lived and worked at Werkdorf in Wieringerwaard, he had to be a Jewish refugee. They were satisfied that he was not an enemy spy, and the *Veendam* continued its Atlantic voyage. Finally docking at Hoboken, New Jersey, Werner was met by relatives and friends from the Joint Distribution Committee and spent several exciting days in New York.[108]

After staying with relatives or friends for a few days in New York, the Gross Breeseners boarded a Greyhound bus for the eight-dollar overnight trip to Richmond, Virginia. From bus windows, as they peered at the changing landscapes passing by, they began to fathom the immensity and complexity of the United States. Cities, with dense neighborhoods that often dramatically contrasted one from the other, bordered skyscrapers, offices and stores, but the scenes of run-down ghettos of poor blacks and whites surprised everyone. The countryside outside of the cities stretched far and wide, flat and hilly. At times, the ocean could be glimpsed, as were trains that bordered the highways.

As the bus drew closer to Richmond, the anticipation of meeting William Thalhimer became intense. What would he be like? Would he be welcoming? Because the bus arrived at the bus station early in the morning, the meeting at Thalhimer's Department Store had to wait until the store opened. Angress wrote of his first encounter with Thalhimer:

Thalhimer Department Store, Richmond, Virginia, 1938. *Courtesy of the Thalhimer Family Archives.*

At nine o'clock on the dot I went into the department store and told a young saleswoman that I wanted to see Mr. Thalhimer. First she stared at me as if I were some kind of creature from a fairy tale, and then she began to giggle and apparently told one of her colleagues—I understood barely a word of her Southern English—that this boy wanted to see the "big boss." Finally I found someone who took my request seriously and took me on the elevator up to the top floor to the office of the owner of the department store. Mr. Thalhimer, a short man in his fifties, greeted me in a very friendly manner with the ever-present American smile ("keep smiling," as Europeans say) and introduced me to his secretaries as one of the young refugees who was on his way to Hyde Farmlands. I liked his informality. He spoke to me alone in his office briefly, announced that he would soon visit the farm and then sent me back to the bus station, where I was to catch the bus to Burkeville, a small town near Hyde Farmlands, where I would be picked up.[109]

The bus ride from Richmond to Burkeville seemed familiar, for the students had memorized the descriptions of the trip in the letters from Ernst Loewensberg. The remembered images now coincided with what appeared in the framed picture windows of the bus. There were gentle hills of green pastures, dense forests, vegetable gardens, tobacco and hay fields and, everywhere, dirt roads. After the Richmond bus pulled into the Burkeville station, the riders were met

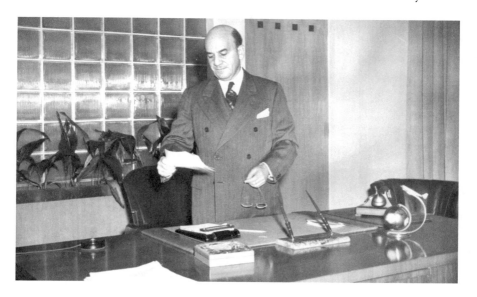

William B. Thalhimer often met immigrants in his office at the department store. *Courtesy of the Thalhimer Family Archives.*

by equally excited Hyde Farmlanders. The meeting was joyous and intense, and after heartfelt hugs and back-slapping, the immigrants rode the six-mile last lap of their long journey in the red farm truck to their new home.

The drive south from Burkeville was filled with anticipation, and as the truck maneuvered Old Plank Road, the major road leading north–south for centuries, the students may have caught a fleeting glimpse of two roadside monuments located near the bridge that crossed the Little Nottoway River. The metal sign was erected by the Virginia Conservation and Development Commission in 1935 to commemorate the establishment and building on the very site of the second Baptist church south of the James River in 1769. Next to the sign, the words engraved on a granite monument read, in part: "Nottoway Baptist Church…Built on Land given by John Fowlkes, constituted December 10, 1769."

Unrecognized by the students, the irony of history was astounding. The John Fowlkes mentioned on the monument was the independent, public-spirited man who gave land for the erection of Nottoway Baptist Meetinghouse. This gesture was noteworthy because at that time of religious prejudice, by law one could only contribute to the Established Church of England. Fowlkes defied the law and acted out of his own sense of justice.[110] He dared to extend an audacious hand to those who needed help. Hyde Farmlands was the very land that Fowlkes purchased, and now, hundreds of years later, it was opening its

Left: Memorial monument of the Nottoway Baptist Church, located on Plank Road, Burkeville, Virginia. *Photo by Robert Gillette.*

Below: The red farm truck at Hyde Farmlands. *Courtesy of Eva Loew.*

heart to new immigrants, fulfilling the long line of generosity that began in the 1700s. It can be safely assumed that Fowlkes would have approved of the efforts of its most recent owner, William B. Thalhimer.

The flatbed farm truck bumped its way up the long gravel road and stopped in the backyard of the manor house. A beep of the horn announced each new arrival. As the travelers jumped down from the running board onto Virginia soil, joyful screams of welcome and reunion turned the heads of nearby, curious farm animals. For most, the long journey from Gross Breesen seemed to be over, but for others, the journey did not feel complete; for them, the farm would be a way station to the future.

14.

BLEAK NEWS FROM EUROPE

German and European news was more easily accessed in the United States than when the students were still at Gross Breesen. The German propaganda agencies were masters in deception and staying on message in the battle to win the minds and hearts of the German people. Consequently, newspapers and radio programs were censored and controlled. Thalhimer made sure that the daily *Richmond Times-Dispatch* was delivered to the farm's rural mailbox, where someone on horseback picked up the mail. After mealtimes, reading the newspaper became an important part of each day, as was listening to the news reports on the radio. English-German dictionaries were always close by.

The students were not the only ones preoccupied with the war clouds of impending catastrophe. William Thalhimer was consumed by reports that he was receiving from the various rescue and resettlement agencies and committees. When he read the same newspaper articles that the Hyde Farmlanders did, he must have wondered how the students were reacting to the deteriorating international circumstances. With each ominous development, he grew more nervous; all of the students on the Virginia list were not safe.

A front-page Associated Press story in the *Times-Dispatch* by Louis Lochner on August 17 underscored the obvious: Germany was going to return the free city of Danzig to the Reich: "Germany had put finishing touches to 'preparedness' measures, which may go into history as the most stupendous of their kind, and today stands ready for any emergency the future may hold."

The scars of racism and dislocation from their homeland and families had grayed the students with premature, adult pessimism. Most were politically

savvy and understood "ready for any emergency" to mean that the German army was going to strike with massive force. The extent of the military buildup that took place between 1933 and 1939 could not be readily judged from the rural isolation of Gross Breesen, but all knew that Breslau was a major railroad hub, a prime launching point for attack on the eastern border. For Hitler's Germany, territorial expansion was inevitable. Now it was only a guessing game as to when it would attack Poland. Maps of the German/Polish border were published in the newspaper to indicate the areas that would be the military flash points. The caption of the political cartoon that appeared in the paper on the eighteenth captured the mood of the free world: "How Much Longer Can He [Europe] Hold His Breath?"

The most vigorous discussion among the students centered on two topics: one, would Russia stand by and watch its neighbor fall to Germany, and two, would England and France come to Poland's defense? Most believed that Danzig and the Polish Corridor were never prizes in themselves. The big question was the most worrisome: if Hitler attacked to his east, would he do the same to his west? How could little countries like Holland, Belgium and Luxembourg resist a German invasion, and could France and England halt Hitler's domination of Europe? Above all was the most terrifying question: if war broke out in Europe, what would that mean for the emigration of Gross Breeseners still on the farm and those who were temporarily safe in Holland?

The weeks before September 1, 1939, were filled with newspaper articles that reflected the worldwide tension. August 20: "Europeans Fear Crisis Will Break this Week; Hungary Split on Ties"; "Nazis Continue Warfare on Poland, Attempt to Crack Nerves of Europe." August 21: "250,000 Fully Armed German Troops Massed on Slovakia's Border"; "Poland's Pact With Britain Near Signing"; "Italians See War in Few Days"; "Reds Ratify No-War Pact With Germany." August 26: "French Army Will Get Brunt of First Action"; "Germany's Moves Indicate Zero Hour Approaching"; "German Reich Makes Its Final Military Preparations to 'Deal with' Poland."

Some of the more ambitious students read the respected column of Dorothy Thompson. One of her articles discussed *The Revolution of Nihilism*, written by Hermann Rauschning, a Nazi social philosopher and mouthpiece of the National Socialists. In it, he prophesied the collapse of the entire world order by social and military revolution: "The future of Germany does not lie in colonies of German peasants but in large-scale collective farming with the labor of alien races. The new German is to be a ruler, a soldier and an administrator, like the ancient Romans."[111]

William B. Thalhimer and a Rescue from Nazi Germany

A Nazi revolution that would dominate the entire world was not a fantasy; it was a call to arms. This same Rauschning would be discussed by Thalhimer in one of his Sunday visits to the farm later in the fall of 1940. Finally, the headline that everyone was expecting appeared, on September 1: "POLISH CITIES BOMBED...FIGHTING IN DANZIG REPORTED." As Thalhimer read the ominous reports, he grew more distressed over the immigration prospects for the Gross Breeseners selected for the Virginia Plan who had not yet arrived. On September 8, 1939, he received a bulletin from the National Refugee Service that discussed the cessation of immigration to the United States from French, Polish and British ports until Americans were evacuated from European countries. Americans in Europe were in a frenzy to return to the United States, so passage on the transatlantic liners was thoroughly booked. After Americans were evacuated, it was believed that the volume of immigration to the United States would not substantially increase.[112] If it were difficult for Americans, who possessed passports and money, to find passage, how much more so for immigrants? Thalhimer had done all he could to fulfill his promise to Bondy. He could only hope that the remaining young men selected for the Virginia Plan would receive visas and arrive safely. He had become emotionally attached to all of the Gross Breeseners.

Much had transpired in such a short period since the most recent Gross Breesen people had arrived at Hyde Farmlands. By summer's end, most of the "first generation" of Gross Breeseners, those who arrived in 1936, had already emigrated from Germany, but Bondy and others were still living in Holland and England. What would become of them?

HYDE FARMLANDS EXPANDS,

1939–1940

By late summer, life at Hyde Farmlands had settled into a comfortable rhythm. The immense manor house accommodated most of the students, but more living space was needed. The slave quarters to the rear of the house had been used to store corn, grain and feed, but now it was transformed into bedrooms. It was cleaned and furnished, but even though it had been converted from a granary, rats, acting out of memory, still visited their old hangout. That did not deter the new human residents. Other buildings were modified to house students, and the tenant farmer's second floor was converted into a girls' dormitory.

The dense forest that surrounded the cleared fields veiled a tortuous topography. Severe gullies folded into themselves and eventually descended to a flowing creek that tumbled over an alluring waterfall. This spot became a favorite for cooling off in the intense, hot months of summer. A dirt road that extended westward to the creek gradually leveled onto a flat, bedrock shelf that extended several inches under the creek stream. The yellow stone base that reflected the sun was extremely smooth, shaped by thousands of years of flowing water. The road literally submerged for thirty feet and reappeared on the other side. The creek was perfectly passable except when there were turbulent flash floods that tainted the water with the brownish red of eroded sediment. The severe Virginia rainstorms cut deep into the stream beds, unearthing stones and creating broad sandbanks where the stream slowed in its serpentine pathway.

The spotting of abundant animal life was frequently a topic of discussion at the dinner table as the students tried to identify the fauna and flora that was indigenous to Virginia. Their list was long: brilliant red cardinals; pileated

The creek sandbank at Hyde Farmlands. *Photo by Robert Gillette.*

woodpeckers; huge, soaring vultures; hawks; wild turkeys; hummingbirds; raccoons; foxes; deer; possum; and even an occasional bobcat and bear. The large blacksnakes, often found on farms and especially where there are chicken eggs and rodents, unnerved the uninitiated Europeans. They learned to be cautious when uncovering logs in the woods or stacked pieces at the woodpile in order to avoid poisonous copperheads or rattlesnakes. For many, the new environment was a romantic playground in which to act out childhood fantasies in the manner of the beloved Tom Sawyer. In fact, Werner Angress changed his first name to Tom in honor of his boyhood fictional hero. In Sawyerlike exuberance, he sneaked out in the night and rode the unsaddled workhorses in the moonlight.

Despite the worry over what was happening in Europe, and despite the complexities of moving to a new country and being totally absorbed with hard physical work, some students still possessed a sense of adventure and play that sustained them. There were signs that the students were settling into the normal Virginia farming life; some acquired pets or even hunting rifles. Living for much of their teenage years manacled by the Nazi regime, they yearned for the fun of just being teenagers once again.

The improved living conditions at Hyde Farmlands had positive effects on the morale of the students. Amenities such as an expanded library, a radio, a phonograph and even a piano served as ways to relax after a hard day's work.

A fun break at Hyde Farmlands. On the seesaw are Curt Bondy and Manfred Lindauer. Lu Albersheim, Eva Jacobsohn and Henry Cornes look on. *Courtesy of Eva Loew.*

Without notifying his wife, which resulted in much consternation, Thalhimer had the piano moved from his home in Richmond. Now there was muslin screening to keep out the flies, and no longer were there blacksnakes or rats in the manor house. In many ways, the conditions of Gross Breesen had been improved upon. Thalhimer did not skimp on providing the farm with what it needed in terms of comfort for its residents or machinery and supplies for the farm's productivity. The bills accumulated rapidly, and behind the scenes Morton Thalhimer kept a close eye on the financial books.

RESPONDING TO THE BUSINESS PLAN

Soon after the arrival of additional students in November, William Thalhimer visited the farm and held a community meeting. As he articulated his vision for Hyde Farmlands, the young men and women listened intently to their benefactor's business plan. With the advice of Franken and the Extension Service staff, Thalhimer encouraged the students to develop poultry production as quickly as possible. The decision to emphasize chicken farming grew out of necessity as well as opportunity: the soil on the farm

was not fertile enough, as yet, for large-scale truck farming. Thalhimer admitted that he had purchased the farm in the winter, the worst time to buy agricultural property, because he was committed to get the students out of Germany as soon as possible. Realizing a profit from poultry farming was more realistic than any other kind of farming, for it could be done independent of suboptimal growing conditions. In addition, there were large population centers not far from Burkeville ready to purchase quality chickens and eggs. Up to this point, chickens were raised in existing farm shelters on the property, some of which were makeshift transformations of tobacco barns. The small number of chickens raised in this manner was sufficient for the needs of the students, but with the determination greatly to expand chicken production, new facilities had to be constructed.

Thalhimer continued to discuss his more expansive concept for Hyde Farmlands. In addition to focusing on chicken production, he pointed out that workers would be needed for limited vegetable and tobacco farms, orchards, a dairy, pig production, lumbering and continued infrastructure and building projects. He envisioned the establishment of smaller, privately owned satellite farms that would benefit from the centralized buying power of the parent corporation. The advantages of purchasing collectively would be enhanced by the pooled marketing of products. In addition, the prospect of a shared labor force that could be assembled and mobilized quickly would result in an effective harvesting team that would reduce crop wastage. No doubt this concept of an agricultural cooperative was modeled after the practice of the pooled purchasing power that Thalhimer utilized in his department store with the Associated Merchandising Corporation.

Thalhimer conceived the farm as part of a larger refugee resettlement program. It would become a model that could be replicated by other refugee farming cooperatives nationwide. Eventually, he hoped that the experienced farmers of Hyde Farmlands would become instructors and mentors for other refugees coming to America. Generally, the students were pleased with the vision for Hyde Farmlands, for it included many of the goals that Gross Breesen sought to accomplish.[113] However, everyone acknowledged that by the end of the 1939 growing season, the long-term schedule for the development of the farm was at least two years behind schedule. This meant that financial solvency was woefully delayed.

In order to develop the poultry operation, two types of buildings had to be constructed: one, log sheds to accommodate one hundred laying hens each, and two, a brooder house that could be environmentally controlled. The procurement of chicks to build a chicken population was done in April and

May, so new structures had to be completed during the winter of 1939–40. Rolf Falkenstein volunteered to become the "chicken man." There were to be three products of the poultry enterprise: (1) egg production for Hyde Farmlands consumption and also for sale to the public; (2) fully grown chickens for meat consumption; and (3) the raising of chicks that would be sold as potential egg layers or as breeders. The Extension Service agents stressed early on that because Hyde Farmlands was going to become a large commercial venture, the chicken houses and equipment had to conform to strict rules of cleanliness. In order to keep the areas clean and insulated from frost, concrete floors were required. The chicken waste products, which were high in nitrogen, would be used for fertilizing the tobacco plants, which literally sucked nitrogen from the soil.

More hands were needed to expand the needed infrastructure of the farm, so the news that more boys from Gross Breesen would soon arrive energized everyone: "Every day fresh thinking comes up, new plans emerge, the discussion again and again about the 6 newcomers, until one day the red truck roars along highway 49 to welcome boys in Burkeville."[114]

CONSTRUCTION

The first item of business was to develop plans for building the poultry sheds that would satisfy the requirements of the Extension Service agents. It was decided to construct the new chicken houses on a gentle hilltop east of the manor house to take advantage of the southern exposure and optimal drainage. Keeping the chicken houses dry and well ventilated was essential. A backdrop of trees provided shelter from northwesterly winds, which were always the coldest in winter.

Hermann Kiwi, a trained cabinetmaker and instructor of structural carpentry at Gross Breesen, became the project manager. At the recommendation of the local farm agents, he studied two essential sources: Plan No. 360, *Plans Of Farm Buildings For Southern States*, and *Poultry Houses and Fixtures*, a most useful resource also published by the U.S. Department of Agriculture. After dinner, the various plans and illustrations were spread out on the dining table and studied, and one particular photograph of a log chicken house caught the students' attention. In its caption, the author stated that the "birds found their log cabin quarters highly comfortable, notwithstanding the severe winters of that mountain state." After asking where Wyoming was and how cold it became in the winter there, the

Harvesting timber for the chicken house construction. At the two-man saw are Manfred Lindauer and George Landecker. *Courtesy of Eva Loew.*

students were confident that they could build such a substantial shelter, especially when the article boasted that log shelters would "last a lifetime." In addition to the positive prediction made by the author, the students felt comfortable building a structure that resembled those made in Germany. The entire construction project was daunting, especially as the harvesting of the raw materials and the construction itself would be accomplished without major machinery.

Because Hyde Farmlands possessed a huge supply of trees for lumbering, the cost of materials was radically reduced. The manual labor of cutting the trees and extracting them from the woods was intense. Two-man saws whined through the groves of soft pine used for walls and structural support beams. The workmen soon learned that how skilled one became with the file to sharpen the saw's teeth determined how easily the trees could be cut down. The rhythmic sounds of *chunk* and *thud* echoed with each axe blow that severed limbs from the trunks. In addition, roadways were cleared to allow the horse team to pull the logs from the woods to the Oliver-powered buzz saw.

Driving the horses was difficult and often dangerous work, for dragging the logs proceeded with fits of forward thrusts and sudden braking, the result of being snagged on rocks and stumps. The horses at Hyde Farmlands were not trained logging horses that could snake their way through dense forests. They were accustomed to plowing open fields and unobstructed terrain.

William B. Thalhimer and a Rescue from Nazi Germany

Hauling logs for the chicken house construction. *Courtesy of Eva Loew.*

Trained logging teams, on the other hand, knew exactly what to do without a driver. This was not the case at Hyde Farmlands, for the person handling the reins had to learn along with his team. Needless to say, the learning curve for the horses and the driver was frustratingly slow.

Once the logs were deposited near the buzz saw, they were lifted by hand onto the cutting platform and sawed to the desired lengths. The saw screamed and trembled as it tore through the bark and heartwood. The large, exposed circular blade with razor-sharp teeth was a scary piece of equipment, seemingly alive and ravenous. Sawdust collected in large piles at the saw's base was used elsewhere on the farm. Each log was placed on a sawhorse, and men using drawknives exposed the shiny, moist, yellow-brown pulp. Because none of the students had experience in using a drawknife, they quickly learned that there was a proven method that needed to be mastered; shaping the logs required finesse and skill. First they learned how to sharpen their drawknives; next they learned that patient technique was more effective than trying to overpower the logs. The knife was placed at an angle, and after each short pulling, it was backed off and then pulled again to gain momentum. Forward progress entailed backward motion. This technique harbored a broader life lesson—forward progress often entails stepping backward—but it was not readily absorbed by youthful consciousness.

Soon, the peeling of the pine bark became a natural, efficient stroking. Their mastering another skill was just one more step to self-sufficiency and personal confidence. This kind of orderly and incremental achievement was exactly what Bondy had tried to provide at Gross Breesen. The logs were

The chicken houses under construction. *Courtesy of Eva Loew.*

stacked off the ground in different lengths to season briefly before their ends were V-notched in the typical German configuration. This kind of fitting of end logs was found in countless structures in the Shenandoah Valley to the west of the Piedmont plains of Burkeville.

If the young immigrants had traveled west beyond the Blue Ridge Mountains, they would have felt right at home among the farmers of German ancestry. Their barns and sheds looked exactly like the buildings at Gross Breesen. As the students observed the growing piles of logs, they realized how fortunate they were to have such large quantities of raw materials on hand that could provide such durable walls and framing. The building plans envisioned chicken houses built with the logs stacked horizontally, but whether horizontal or vertical, the logs needed to be chinked with mortar to seal out the wind and rain.

WORKING WITH CONCRETE AND CINDER BLOCKS

Concrete floors had to be poured before the framing could begin. The students mixed the cement with sawdust, which greatly reduced the amount of cement needed and also provided considerable insulation. In addition to the sawdust produced by the buzz saw, local lumber mills freely supplied additional needs. The cement, mixed in a gas-driven machine, was transported to the sites and poured over a thick layer of crushed stone.

The laying houses required removable roosts, shelves or boxes for the egg-laying, feeding troughs, watering apparatus, windows for proper ventilation and a heat source that could keep the birds comfortable. Though the students had been instructed in the raising of chickens at Gross Breesen, this new venture far exceeded their rudimentary education. Instructional materials were constantly supplied by enthusiastic Extension Service agents, whose advice was meticulously followed.

In addition to the log houses, a cinder block brooder building had to be constructed. The making of cinder blocks was completely new to the students. Mr. Franken purchased a manually operated cinderblock machine, the then famous Sears and Roebuck Wizard, which was featured in the *Sears Catalogue*. As a matter of fact, at the time, the *Sears Catalogue* was the most widely read "book" in America. The students gawked at this odd-looking contraption, but it had earned an outstanding reputation for efficiency and durability. The raw materials for the creation of the gray, rough-textured cinder blocks had to be gathered locally. Sand was

The popular Sears Wizard cinder block maker. *From the* Sears Catalogue.

Above: Ken Herman and Harvey Newton making cinder blocks. *Courtesy of Eva Loew.*

Right: A finished cinder block. Thousands more to go. *Courtesy of Eva Loew.*

dug and hauled from the nearby creek beds and shoveled onto the farm truck. This part of the operation was supervised by George Landecker. He scoured the creek banks and floors by dragging a three-foot by three-foot iron scoop pulled by a team of mules. He positioned the scoop by manipulating two wooden handles, much like the handles of the small cultivator plow used in the truck garden. The mules, Lu and Rowdy, obeyed his commands as they dragged the scoop onto the bank of the creek, where it was dumped. Even though Landecker was warned that one of the mules had kicked and killed a man, he loved them and was convinced that they worked harder and more efficiently than horses. Others disagreed, and verbal debates of mule lovers and horse lovers erupted, resembling a scene from *Fiddler on the Roof*: "Horse—Mule, Horse—Mule!"

The heavy, wet sand was shoveled onto the flatbed truck that transported the sand to the mixing site. Cinders were collected from the furnaces of the Piedmont Sanitarium in nearby Burkeville. The ingredients of sand, cement, cinders and water were mixed in wheelbarrows and shoveled into the Wizard. Klaus Herman became the chief coordinator of this phase of the construction job, but others took their turn hand-mixing the cement. After the cement solidified, the block was slipped from the machine to dry. Each block had two holes stamped into it, which provided excellent air pocket insulation. The newly formed blocks were arranged in rows, but

The brooder house under construction. *Courtesy of Eva Loew.*

A finished chicken house. *Courtesy of Eva Loew.*

they became objects of scorn for the horses. For some diabolical reason, when they came in from the woods or the fields, they loved to trample the slow-drying blocks for fun. Understandably, frustration among the block makers reigned supreme. Immediate measures to fence the blocks out of harm's way were taken so that the horses could no longer exercise their block disdain. Just like the harvesting of logs, the making of cinder blocks required extensive manual labor, but the raw materials were readily on hand, and the expense of building with finished materials was avoided.

The building of the ten chicken houses occupied the attention and energy of everyone. As the first structure took form, there was wholesale jubilation. The building of permanent structures, where there was none before, buoyed the spirits of the newly arrived refugees. This was a new kind of work that had significant meaning. Before, at Gross Breesen and at Hyde Farmlands, structures were refurbished, but now the students were not just improving what was preexistent. Starting from scratch and out of their own hard labor, they had planned and constructed substantial buildings. The sense of new beginnings was palpable. Hyde Farmlands was becoming their own new home, their own future. Pride of accomplishment was a welcomed tonic for these displaced persons.

News from Europe

As the spring of 1940 advanced, the prediction that the war would push westward and devour the free nations of Europe fulfilled itself when Germany invaded Norway in April. Around the table at breakfast, lunch and dinner, newspaper articles and maps of the worsening situation were studied and discussed. Thalhimer, in Richmond, worried about how his wards would be taking the bad news. He was receiving constant updates from the American Jewish Committee and personal letters from his old friends and coworkers in the National Rescue Service (NRS). At times, he felt torn between various activities that all needed his attention and action. As the national chairperson for the Resettlement of Refugees in America, he traveled widely to coordinate activities and urge community involvement. He was constantly briefed about the developing circumstances that affected refugees.

Everyone had their sights set on western Europe. Hitler had attacked to his east, and England and France, honoring their treaty with Poland, declared war on Germany. And now Norway came under siege. The students predicted that Hitler would attack Holland, Belgium and France. Within the precarious predictions of expanded war, the students tried to keep family ties alive. Letters were written to family and friends still living in Europe, and whenever a letter was received, they were read over and over again to be sure not to miss or misunderstand a single word. The letters were the lifelines that kept hope alive.

Amid heavy hearts, the comics became the most sought-after sections of the paper. As if to soothe the jittery minds of an entire nation, the Sunday edition included an enormous, expanded section of cartoons. The list contained a comic-lovers paradise: *Charlie Chan, Micky Finn, Henry, Bringing Up Father, The Lone Ranger, Katzenjammer Kids, Smiling Jack, Little Orphan Annie, Skippy, King of the Royal Mountain, Flash Gordon, The Phantom, Blondie, Joe Palooka, Dixie Dugan* and, by far the favorite, *The Little King.* The illustrations enhanced the captions, which proved to be an aid in the students' efforts to learn new English words.

NEIGHBORS AND HELPERS

Hyde Farmlands was surrounded by dense forests that blocked views of the surrounding farms and roads. The farm was separated from the outside world and self-contained, and because everyone spoke German, it could have easily been mistaken for a farm in Germany. Its isolation was more than physical—cultural barriers fenced in the students as well. A student wrote: "Our new homeland, America, remained completely strange to us at the beginning. For oddly, we were once again living on a sort of island, as we had been a few years before. But this time our surroundings, Virginia and beyond, were not hostile, they were just unknown to us."[115]

Not speaking English was the greatest barrier to acculturation. There was a marked difference between those Gross Breeseners who had lived in the United States before coming to the farm and those newly arrived students who had little facility with the spoken language. When visitors and neighbors came to meet the refugees, the more recent, self-conscious arrivals retreated into the shadows not to embarrass themselves trying to converse. Their feelings of linguistic inferiority undermined opportunities for cultural exchange and learning about American ways.

From the very beginning, the neighbors were curious, friendly and helpful. They were hardworking farmers who shared their practical knowledge, their songs and music and, above all, their watermelon treats. Watermelon, chilled in a fast-moving stream or an ice-filled container, delighted the immigrants, especially on particularly hot Sunday afternoons. The students marveled at how far a native could spit a pit or shoot it in the air from the pinching pressure exerted between the thumb and a finger.

Laughter was easy when the students tried to master this seemingly simple form of farm sport. Sunday was the day for visiting, a time of rest from the never-ceasing chores that tied all farmers to a work schedule that could rarely be manipulated for personal pleasure. These were modest farmers whose entertainment revolved around socializing.

THE HAMLINS

One farmer, who lived adjacent to Hyde Farmlands just north of the Little Nottoway River that served as a boundary between the two farms, was particularly enchanted by the arrival of Jewish refugees. Thomas Holmes Hamlin was in his glory because, out of nowhere, Jews had settled on the "lowlands" right next to his farm. He and his wife, Mary, were observant Christedelphians, a small and unique Christian sect that differed from the Baptists who populated the area.

Holmes was a devout follower of the Christedelphian theology that was grounded in the Hebrew Bible, the Old Testament, and rejected the New Testament's Trinitarian doctrine. He believed that the Jews were God's "Chosen People" and that the messiah would come through them. He was an ardent Zionist, supported the Jewish National Fund and treasured the Holy Land sand that his nephew, John Lea, brought him from his frequent trips to Palestine. The Hamlins read the articles in the *Christedelphian Advocate* that came monthly to their home, especially the current events section, "Sign of the Times." Here, they had followed detailed accounts of what was happening to the Jews in Europe all through the 1930s. The family felt a strong bond with the young Jews who had suffered the Nazi onslaught.

Marrying later in life, the couple had one son, Richard, who was just ten years old when refugees began to arrive at Hyde Farmlands. The Hamlins knew the sting of being estranged from the community, of being a minority. Even though the family had occupied the farm since the 1840s, they remained outsiders in the eyes of the townspeople, for their religious beliefs were so contrary to the mainstream theology of local congregations. Young Richard challenged his friends' beliefs in such topics as sin, heaven, hell and even a savior. Even though they were considered a bit weird, they did not encounter harsh treatment because of their longevity in Burkeville and the strength of their personalities. The arrival of Jews fleeing persecution and settling right next door was, to Holmes, "providential." It was as if the messiah had landed

at his doorstep. He loved to talk with his new neighbors and immediately formed a bond with the young people, his adopted Jewish family.

Holmes walked the three miles from his home to Hyde Farmlands by jumping the winding Little Nottoway River. His small farm was typical of others in the area. He raised cows, pigs and a large vegetable garden mainly for home consumption. To earn extra money, he raised turkeys and tobacco, with the help of black tenant farmers who lived on the farm. He knew farming well, and he enthusiastically shared his knowledge with the newcomers. It wasn't long before the Hamlins invited the students to their home for Saturday or Sunday night dinners.

It was at the Hamlins that the Hyde Farmlanders celebrated their first Thanksgiving. The atmosphere at mealtime was charged with spirited goodwill. Joking and laughter were as much an important part of the dinners as was the delicious food that Mary Hamlin prepared. The boys, especially, ate with gusto, and Mrs. Hamlin was so pleased that the girls helped in the kitchen and cleaned up without being asked. After dinner, everyone congregated in the large living room around the piano and sang German songs that often dated back to youth group days. Ernst Cramer stood out as the jokester and general master of ceremonies, telling stories and leading the singing.

Richard adored the young men and women, and even though he was only ten, he recognized how handsome and wholesome the boys were and how beautiful the girls appeared. He remembered how enthused his father was to talk woodworking with Hermann Kiwi, the cabinetmaker, or chat with Ilse Lehmann, who was the resident doctor at Hyde Farmlands. Eva captured Holmes's heart with her love and expertise with the dairy cows. In fact, he gave Eva her very own bull calf. He spoke to the boys about the opportunities in farming, especially during the lean times of the Depression. He singled out George Landecker as one who had the natural spirit and inclination to become a farmer. George became one of his favorites as he urged him to consider farming seriously as his life's work. He often told him that even though one probably would not become rich, he could earn a good living as a farmer and his family would never go hungry. Because he felt great sorrow for the students who had to flee their country and leave their families, he felt a responsibility to be a substitute father. Furthermore, because Burkeville was in the middle of KKK country, he saw himself as a buffer between a potentially hostile community and the students. The Hamlins were too dominant of a Burkeville fixture to fuss with. What a strike of good fortune for the youngsters to have been placed in the cradling arms of the Hamlins.

Later, in the 1940s, when Curt Bondy was teaching psychology at the Richmond Professional Institute (a division of William and Mary College), Richard Hamlin found himself knocking on the professor's door just after he had moved from Burkeville to Richmond. As was the case, Bondy interviewed each student prior to being accepted into his class. Richard's interview began with Bondy asking him his name, and when he responded, Bondy hesitated and inquired, "Hamlin, from Burkeville?" With a nod, both smiled, and Richard was immediately accepted into the class even though his high school transcript was not stellar.[116]

Piedmont Sanitarium

Piedmont Sanitarium was a friendly neighbor right from the beginning. This tuberculosis rehabilitation institution served black patients, the first of its kind in the entire nation. It was located in Burkeville just six miles from the farm. It occupied a three-hundred-acre campus that was originally chosen because of its proximity to the railroad hub in central Virginia and the largest black population in the state. In the late 1930s, there were 150 patients, but in 1940, the capacity was greatly increased with a building program that modernized the facility. An extensive staff responded to all of the patients' needs, including teachers and an occupational therapist. There were art rooms, a chapel and an auditorium for movies and larger gatherings.

In addition to the regular professional nursing staff, there was a school of nursing. This was a unique program, as it was the first school of nursing specializing in the treatment of tuberculosis for black women in the country. Piedmont was a pioneer institution right from the very beginning. For example, ex-patients were often employed and trained in various aspects of care-giving because it was believed that these individuals, who had "gone through the cure," would be ultrasensitive to the needs of the patients and the therapies prescribed. In addition, because everyone at Piedmont received routine screenings, it was one way to keep recovered patients clean of the disease.

The staff at Piedmont was composed of good-hearted people who responded to the health needs of the black community. They were pioneers in stepping over the line that separated whites from blacks. It was this kind of empathy for the disenfranchised that motivated them to open their hearts to the refugees at Hyde Farmlands. One woman in particular, Mrs. Pauline Burton, was instrumental in creating this close relationship. Mrs. Burton was an administrator's administrator. She ran the office with precision and

demanded high efficiency from everyone else. She had her finger on the procurement of foodstuffs for the hospital, so it wasn't long after she learned about the refugees that she contracted them to provide vegetables from their gardens. She fell in love with the young immigrants and admired their work ethic and sense of purpose, and she visited the students when she could. She once told a visitor, "One would not find such a group anywhere in the U.S.A."[117] She arranged for the cinders from the Piedmont furnaces to be available for use in making blocks for the brooder house.

Burton also paved the way for Ilse Lehmann to work with the patients while she studied for the medical boards that later certified her to assume full medical duties at Piedmont, where she later lived. Ilse was prevented from practicing medicine in Nazi Germany and became the house doctor at Gross Breesen and, later, at Hyde Farmlands. She was first employed in the medical records department and worked alongside Dr. Charles Scott. Because of her German training, she incessantly hounded her coworkers to keep accurate records. Despite her intensity, she was loved by all, for she was never too tired or too busy not to put the patients first; she "knew no skin color." Rather comically, with her heavy German accent, she learned and spoke the black southern idiom and used it proficiently with the patients. After she established herself as a physician at Piedmont, she often cared for the local families of Piedmont employees who lived in Crewe and Burkeville.[118]

17.

NEARBY TOWNS

The Hyde Farmlanders occasionally journeyed to the nearby towns of Burkeville, Crewe and Blackstone in the back of the red farm truck. Crewe was the closest town and offered just about anything the students could want or need. There were two movie houses, the Crewe and the Star; several ice cream bars, including Indian Oak Farm; a homemade ice cream dairy; a pool parlor ("off-limits to girls"); and clothing, drugstores and hardware stores. Turner's Drug Store was the favorite ice cream and soft drink counter. Wile's Ice House, where one could have a watermelon cooled, supplied cakes of ice to farmers, townspeople and the railroads. Watching the enclosed ice wagon pull out of the yard for deliveries of stacks of blocks, dripping a trail of melting ice on the hot roads, always drew a smile from an onlooker.

In the 1930s, Crewe was a thriving miniature city that boasted six automobile agencies. It was a planned community that revolved around the railroads and emerged as the major hub for central Virginia. The most popular attraction of the railroad yard was the railroad turnaround building, the "roundhouse." Because the steam locomotives could not go in reverse, they rolled onto a huge turntable that rotated the engines in order to face them in the direction from which they came, be it Lynchburg to the west or Danville and destinations to the south.

The Hyde Farmlanders loved to travel to Crewe for a movie and an ice cream cone, though they questioned the segregated division of the town. There were two Jewish clothing merchants in town, the Machts and the Beckers. The Machts, who affixed a mezuzah to their front door, invited the students to their

home for weekend and holiday meals. On a Saturday, the town teemed with people doing their weekly shopping. It was also the day to socialize, especially between the young women and the young men from the nearby CCC camp. Some of those ice cream dates developed into eventual marriages.

It was in Crewe where the Hyde Farmlanders saw the epic movie *Gone With the Wind*. The movie was so long that it took two consecutive days and a return trip to view it. The film impressed the newcomers, so much so that Tom Angress read the book with the help of an English dictionary. This was the first English novel he had ever read, and it launched his earnest endeavor to master his adopted language. A particular song, "Marching Through Georgia," captured his imagination, and he memorized the tune. It was the singing of this song at a social mixer with female students from Blackstone that so threatened their southern sensibilities that they protested vociferously.

A RUMOR

One local rumor illustrated the national fear that "fifth column" Nazis were infiltrating the United States. People knew about Hyde Farmlands; they had seen the not-too-inconspicuous red farm truck rumbling down the road on its way to Crewe or Burkeville, with young people seated on its flatbed. A rumor spread that the young farmers at Hyde Farmlands were actually German spies. One woman exclaimed to her neighbor that the students had to be Nazis because one of them had red hair. Her statement: "Have you ever seen a redheaded Jew?"[119]

As the threat of being drawn into the next world war became more certain, greater suspicion and fear surfaced, and not only on the local scene. The State Department aggressively restricted immigration from Germany. This change in immigration policy would become a significant factor in the future of Hyde Farmlands.

18.

ENCOUNTERS WITH A NEW RACISM

The students of Gross Breesen were victimized by radical racism. The Nazis transformed religious anti-Semitism into a more virulent strain. Preserving the purity of Aryan blood became the ultimate goal of Nazi propaganda, education, persecution and law. Jew-hatred pervaded every aspect of German life. On German soil, the students knew what to expect, but when they immigrated to the United States, they were not prepared for the encounter with another form of racism—the prejudice, discrimination, segregation and violence against black Americans. For some, the first encounter with this American racism occurred as soon as they rode the bus that entered Virginia.

Isidor Kirshrot, a Gross Breesen latecomer to Hyde Farmlands after a refugee stay in England, recounted his first experience with American racial discrimination. When he was returning to Hyde Farmlands after spending an exciting two-week trip in Washington, D.C., as the guest of the International Student Club, and meeting Mrs. Eleanor Roosevelt at the White House, the bus stopped half way over the bridge spanning the Potomac River before it entered Virginia. The bus driver announced, "All niggers to the rear." The bus did not move until all of the black passengers took their new seats. This was a shock that brought back horrid memories of Nazi Germany. Perplexed and hurt, Isi contemplated the meaning of this occurrence. How could this be accepted in America, the "home of the free." He realized suddenly that this was not the home for all to be free.[120]

Learning how to live in the South was the topic of one of the talks that William Thalhimer gave to the Hyde Farmlanders. On a Sunday afternoon, the students were assembled on the shaded lawn in front of the porch where

Thalhimer sat. Speaking in a light southern accent, he clearly wanted to help the students learn the mores of the South, for he did not want them to get into any trouble from the locals for not knowing how to act toward black people. He wanted to explain "how it was." In his address, he referred to the blacks as "negrahs." He discussed a hypothetical instance that exemplified the response that he urged all the students to adopt: If one were driving the farm truck and saw a black person hitchhiking, he could stop to pick him up, but the "negrah" could not sit up front in the cab of the truck. He would have to sit outside on the flatbed. He continued by pointing out that the white students should address a black man by his first name or by calling him "uncle" and should never use the term "mister" or use his last name, even if he knew it.

This kind of subordination targeted against black people was puzzling. How could a Jew, an American Jew, a person who rallied against German racism and who had rescued the students from Gross Breesen, endorse this kind of segregation and lack of human respect? Thalhimer was a pragmatist when it came to race relations in the South. In this, he reflected the norm of Jews living in the South in the 1930s. He was not a racist, but he was not going to lead a crusade during these precarious times. In Richmond, Thalhimer's Department Store did sell to black customers, though they were not served in the store's cafeteria until years later. Progress against the contagion of racism in America would have to evolve slowly. In truth, Thalhimer spoke to the students to safeguard both the immigrants and black Americans. If the Klan caught a white man sitting next to a black man in the cab, both could have suffered injury or worse.

Tom Angress was particularly troubled by the discrimination of the times. His first face-to-face encounter with a black man occurred in a log chicken laying house just before Hyde Farmlands closed for good. He wrote:

> It was my first personal encounter with a "negrah." Several days long we sat facing each other in one of the henhouses and cleaned eggs for shipment. After he had noticed that I behaved towards him differently than he was used to from Whites, and after I, in broken English, had told him something of my past, he gained confidence and told me something about his own life. He was an older man, the son or grandson of a slave, and from his very carefully formulated report I could get an idea of what it meant for someone like him and his family to live in a Southern state in the USA…and I, a Jew who had emigrated from Germany, was quietly ashamed to be a white person.[121]

Being the victims of prejudice and racism left the Gross Breesen students sensitive to racial inequality for the rest of their lives.

19.

A COMMUNITY IN TRANSITION, 1940

The latter part of 1939 and well into 1940 was a critical time for Hyde Farmlands. The few who were already in the United States and first to arrive on the farm in the summer of 1938 anxiously awaited the arrival of those who came in the beginning of 1939. In turn, those seven worked hard and made progress, but they also looked forward to new arrivals in order to accelerate the farm's productivity. By September, 1939, Ernst Cramer and six others had settled into their new home. Those on the Virginia Plan immigrant list from Holland and England arrived in the fall and into the winter. With the increased students came new opportunities, but complications also accompanied that growth. Whenever old friends who have been separated by time and circumstance reunite, trying to replicate what once was is impossible.

Everyone now had changed and lived in different situations. Those earlier farmers, who had literally resurrected the farm and worked to the bone to prepare it for the newcomers, encountered behavior and habits in the newly arrived that were not suited to the new setting. For those coming from Holland and England, a different set of experiences governed their thinking because they had been living neither in the United States nor in Germany. The leadership roles that existed at Gross Breesen were not automatically transferred to the Hyde Farmlands scene. Moreover, there were a few refugees living on the farm who had never lived at Gross Breesen. Added to the convergence of these factions was the fact that Bondy, who would have eased the blending of the immigrants, was not yet in the United States.

In the background stood William Thalhimer, who had his own vision of Hyde Farmlands as part of a larger refugee resettlement strategy. It was inevitable that

some friction between the groups and with Franken would emerge. In reality, Hyde Farmlands now comprised a heterogeneous group of refugees, each journeying to Burkeville on differing paths. Every student was now older than he was when he entered Gross Breesen beginning in 1936. The ensuing years catapulted the adolescents into manhood and womanhood. Their perspectives on the future and their place in it radically changed, as did their relationships to authority and their emerging senses of autonomy. In their late teens and early twenties, the young men and women were more individualistic compared to their group identity fostered by the youth group experience.

For every student, no matter how and when he or she arrived at Hyde Farmlands, the reality of the crisis of Nazi domination and its implications sunk in as never before. Every day, news of the war fatigued the students with worry for family and friends. While events in the homeland and beyond whirled out of control, the students felt the sickening despair of ineffectual stasis. They could do nothing to prevent the catastrophic events that began to wear down life's enthusiasms. They could do little to outrun the invisible enemies who stalked them or silence the desperate voices that called to them in their imagination. Deep, personal questions nagged them. In his own way, each student asked the proverbial questions: Who am I? Where am I going? And, more specifically, how can I just sit by and watch tragedy unfold?

Such existential considerations were replaced momentarily on January 24, 1940. Virginia was buffeted by the biggest blizzard since 1899. Twenty

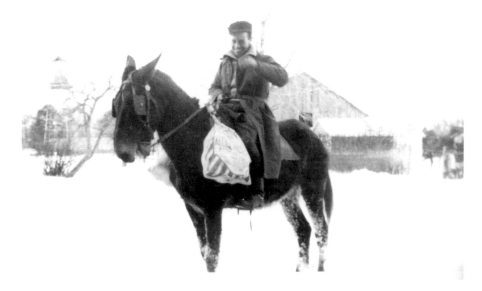

Ernst Loewensberg rides for supplies in the blizzard of 1940. *Courtesy of Eva Loew.*

inches of snow blew into drifts as high as twenty feet. Along with the entire state that came to a standstill for more than a week, the students were totally isolated. The muffled silence of the snow-covered farm soothed the hearts and minds of the young immigrants. The events of human history—twisted, contorted and noisily clamoring for daily attention—were silenced in a larger perspective. The sharp realities of their lives were softened by the graceful swirls of the rounded snow mounds that covered everything, including barns and sheds. The power of nature reigned supreme. For the students, the blizzard was a respite from everything. After shoveling paths and tunnels through the drifts to attend to the animals, they were liberated to play snow games. Coming inside to the warmth of the manor house invited a cherished sleepiness that aroused childhood memories. Germany and family were so far away and long ago. The joy of being snowbound mixed with a melancholy of vanished images from the past.

The drifts of the blizzard began to melt, but patches of snow on northern hillsides and in the shade of farm buildings reluctantly resisted the warming southern sun. As the young farmers resumed their chores, the signs of approaching spring and the hanging on of winter must have caught their attention. Duality, in the farmyard and in their mind's perspective, governed everything. The turmoil of the times and the self was calmed by youthful hope, but no matter how optimistic the young people were, a cloud of questions hovered over the homestead: 1) Would the farm be able to become self-supporting and accommodate the increased size of the refugee community? 2) Could each individual envision himself as a farmer, on this farm, far into the future? 3) What obligation did each refugee owe William Thalhimer, who brought him to the farm and made promises to the State Department? 4) What responsibility did students have to the original vision of Gross Breesen, to Curt Bondy and to those who relied on their success? These were serious concerns that had to be wrestled with, but even though all of the questions were highly significant, the economic one was probably the most pragmatic and immediate. Could the farm support so many people, and how long would Thalhimer be willing and able to subsidize the entire enterprise? Some raised the crucial question—could the Hyde Farmlands bubble burst?

A VISIT BY WILLIAM THALHIMER

The students remembered a visit from Thalhimer on a Sunday afternoon in the autumn of 1939. He wanted to explore two topics: one, why he became

involved in the Hyde Farmlands project, and two, discuss some of his thoughts about the future lives of the students. The students were amazed at how similar his thoughts were to those of Curt Bondy. He emphasized his belief that life on a farm was superior to that of the city and that the values of hard work and integrity were grounded to the agricultural domain. He explained how he selected and purchased the farm "out of the idea to save lives." He was convinced that Jews could become farmers, and he hoped that other refugees would follow the example set at Hyde Farmlands, for it was on the farm that people could live "a simpler and happier life…to make them have a natural life again, to make them think again and to give them ideals." He admitted that even though he was not a Zionist, he admired the spirit of the young Jewish pioneers in Palestine:

> [They realize that] *unless they sacrifice now their comforts, their sleep and many things they had before, they will never be able to get anything built up. They know they are working less for themselves than for future generations. This is the right pioneer spirit. And this is the very spirit I should like for you to have.*[122]

Thalhimer wanted to reinforce the idea that everyone at Hyde Farmlands was a pioneer and that others were depending on them, especially the "oppressed, imprisoned and interned in Europe" who yearned to come to this country.

William Thalhimer was a complicated blend of an urban, pragmatic businessman and a country idealist. As an adolescent, he had worked on a farm owned by a doctor during the summer. His love of farm life never dissipated. His remarks to the students echoed the words that he had written to Annette in a love letter, even before they were married, dating back to 1912. Thalhimer's core values had not changed:

> *Still you will always find out in later life that it takes trials and crises to test the mettle of a man or woman. Some fall before it and some survive—but in any event, it shows the real person…For I know happiness—like material success is not handed you in a neatly tied, ready-made package—it comes and comes only through hard work—long hard work and applied intelligence.*[123]

STAYING ON THE FARM

The question of staying on the farm came to a head when one of the students, Friedel Dzubas, and his wife, who immigrated under the Hyde

Farmlands plan, decided to leave the farm and live in New York City to pursue his career as an artist. With this prospect, everyone felt that their fragile community had been weakened, raising questions that were ultimately personal. In the back of their minds, all realized that the success of the farm could directly affect the lives of those Gross Breeseners who still might be able to immigrate.

A person's departure from Hyde Farmlands was particularly distressing for Thalhimer, for he had put his integrity on the line to the State Department. It was explicit that the issuing of the visas depended on the students traveling directly to Hyde Farmlands and "staying on the land." In addition to Thalhimer, many students felt that they, too, were being abandoned by the one who left, but they also harbored conflicting uncertainties about their own intentions.

A.M. Warren, chief of the Visa Division, with whom Thalhimer, Cohen and Young had been negotiating for more than a year regarding the visas, wrote to Harold Young about Dzubas's departure from Hyde Farmlands:

> *Since the aliens actually did proceed to the Hyde Farmlands, but thereafter found that the farm work was not suitable to them, I do not see that there is any action the Government may take to compel them to return to Hyde Farmlands...but in the case of a person who immigrates into the United States for the avowed purpose of proceeding to Hyde Farmlands and who fails to carry out such an intention in good faith, a serious question arises as to whether the immigration visa with which the alien entered the United States may not have been obtained by fraud and misrepresentation. In such a case, of course, the Government may be in a position to take suitable action to correct a condition resulting from such a breach of faith.*[124]

The Dzubas case did not, in itself, cause any negative ramifications in the endeavor to ensure the continued immigration of Gross Breeseners, but elsewhere in the letter, the serious matter of students staying on the farm was addressed. It was this concern that so troubled Thalhimer. Warren stated that people leaving the farm "would result in undermining the whole project."[125] The perspective of the individual Gross Breesener was narrower than that of Thalhimer's. He knew that the creation of the farm and the granting of visas were inseparably connected and that any breach in the model could have negative ramifications for future immigrants. In his mind, the students did have a moral obligation to work and develop the farm. He was upset over the departure of a student because he grasped the larger significance of the entire Hyde Farmlands project.

There were other reasons that Thalhimer had to communicate with the State Department about activities of some of the students that took them off campus. In a letter written to Richard W. Flournoy of the State Department, he informed him that several of the young men were enlisting in the army and that others were working as carpenters at Camp Lee in the expansion of the training facility and returning to the farm at night. At that point, there was a shortage of skilled carpenters, and the Hyde Farmlanders were, by now, experienced and competent.[126] Thalhimer was a man of his word. In no way did he want to compromise the goodwill and the trust he had cultivated. He felt that it was his obligation to inform the State and Labor Departments of any activities or changes to their original agreement.

Thalhimer's letter only strengthened the State Department's impression of his genuine desire to rescue and provide a new life for the refugees. Warren was an early skeptic, but now, after several years of getting to know Thalhimer, Cohen and Young, he was a convert. He was impressed by the ceaseless endeavors to save German Jews from Hitler.

The Gross Breesen vision and spirit shared much of the community-building aspects of Zionism, but it did not ring with the clarion call of the Halutzim, the pioneers. The original goal was to create communities outside of Germany, but their success was highly questionable. Even if the principles of Gross Breesen and the very best of German and Jewish culture were maintained, the transplanted communities would forever be islands in foreign lands, encircled by encroaching cultures. What would be the long-term goal of such a social entity? How long could such an enclave support its own culture? That vision was ultimately unsustainable.

In addition, as the Hyde Farmlanders settled down and realized that it was a distinct possibility that if the war in Europe expanded, and the borders consequently closed, continued emigration from Germany and other European countries would be halted. The question of defining a new Gross Breesen mission became progressively challenging. The prospect of creating one's own future crept into the consciousness of the students, especially because Bondy constantly urged the development of personal independence. Furthermore, the American culture that surrounded the farm was not a hostile one. It may have been foreign to the students, but it did not exclude them from integrating into it. In short, the longer the students were living in the United States, the greater was the tug to join the "American dream."

Within the context of all of this uncertainty and confusion, the relationship between Thalhimer's handpicked farm manager, U.K. Franken, and the students became strained. At times, he was highly appreciated and respected,

especially by those students who had settled the farm earlier, because he had much expertise in developing a farm plan and introduced the refugees to the American ways of farming. As the farm population increased, however, he began to assume a greater self-appointed role as a guardian of moral virtue. He was a traditional Catholic and made sure that the young men and women living in proximity "behaved" properly. He became more adamant in his "rules of the house." In many ways, he really did not understand the rather complex situation into which the refugees had been thrust, nor did he fully internalize the life experience of the young adults. To be fair to him, however, he found himself now in a new situation. The social fabric of the place had changed into a much more complicated entity. Friction began to intensify, and factions developed over the question of leadership. After a period of contention, which often centered on the person and role of the farm manager, the community stabilized as it assumed greater self-determination, but Franken's days as the manager were numbered.

By the spring of 1940, the log chicken houses had been successfully constructed. They were so sturdy and well built that everyone agreed with those who visited the farm that they would last a lifetime. In addition, the brooder houses were completed, as were the portable pullet houses. With all of this building, the students had evolved into experienced construction workers. They had taken building plans, modified them for their own purposes, prepared raw materials from the local property and created structures of prominence. The chicken business, which encompassed all of the facets of poultry farming, was about to become a major moneymaker. It was apparent that Hyde Farmlands had grown into one of the most modern chicken farms in central Virginia, setting a standard for the future.

In addition to the huge advances in improving the infrastructure and the addition of electricity and a centralized water supply, the young farmers tackled one of the most serious farm deficiencies by enriching the soil of the fields. Needed terracing was accomplished by contracting a Caterpillar tractor that graded the hillsides. At this time, in Virginia and throughout the nation, there was a coordinated effort by the Extension Service and the Department of Agriculture to address the gigantic problem of soil erosion and depletion.

No matter how much progress was made and how well individuals became more accustomed to their new lives in America, a mist of tentative anxiety settled on the manor house every morning. The horrific world of war was being waged across the ocean. May 1940 promised to be a good planting season, but world events dampened the anticipation of a full harvest in the coming months.

THE LARGER WAR IN EUROPE, 1940

The newspaper continued to be the major source of information. In April 1940, Norway was invaded; the very existence of the free nations of western Europe was in doubt. Around the table at breakfast, lunch and dinner, newspaper articles and maps of the worsening situation were studied and discussed. The reports from Europe were troublesome, but as soon as Holland came into play, a greater sense of urgency erupted because Bondy was still in Holland, as were other Gross Breeseners. The headlines of the *Times-Dispatch* articles on May 8 were worrisome: "Communications Suspended by Netherlands During Night; Dutch Forces on War Footing"; "Germans Reported Moving on Holland." On May 9: "France Anxious Over Reports of Nazi Invasion of Holland." On May 10: "NAZIS INVADE HOLLAND." On May 11: "Armies Are Hurled Through Lowlands in Hitler's Path"; "Biggest Battle of All Time Impends on 200-mile Front; Nazis Bomb 18 French Towns"; "British Land to Aid Defense of Netherlands."

Those who had emigrated from Holland just a few months earlier struggled to comprehend their luck in immigrating when they did. Tragically, not all of the Gross Breesen students who were living in transit camps in Holland got out in time. They were trapped. Everyone worried that Bondy might be caught in the maelstrom that slammed into western Europe. They did not know if he had evacuated from Amsterdam in time to flee south into France. Tom Angress's family was living in Amsterdam when the invasion

"Blitzkrieg," cartoon by Fred O. Seibel, May 11, 1940. *Courtesy of the* Richmond Times-Dispatch.

commenced, and not hearing anything from them was troubling. At the end of every one of his diary entries between May 10 and June 24, he wrote: "No news"…"Nothing else"…"Still no news"…"When will I get mail from my parents? I could go crazy!"…"Apparently we only get little mail now because Germany supposedly has increased censorship."[127]

Ten days after the German invasion of Holland, Hyde Farmlands was hit by a severe rainstorm accompanied by thunder and lightning. Tom went out at night into the storm and walked in the whirling winds. The sky was slashed by the bolts of lightning that illuminated the fields. The chaos of the storm mirrored the unbridled pain that he felt: "It was horrendous, glow worms, lightning and rain. Fantastic. No news from Europe. War situation unclear, apparently more German advances in the heart of France. The Germans? The Nazis! But, unfortunately also the Germans."[128]

How could the German professional military, which he had romanticized in his youth and for which he still harbored a trace of admiration, be turned into Nazi barbarians? The feelings of helplessness, accompanied by shame and guilt, drove the young people into quiet anguish. The raging storm of the natural world that night reflected the affairs of man, as if a grand Shakespearean tragedy descended on Burkeville.

BONDY'S STORY

On May 9, Bondy was in Brussels working on plans for two hundred young people to immigrate to San Domingo.[129] There he heard the first bombs dropped on Brussels as the invasion began. When he tried to return to Amsterdam, he found that all of the northbound trains had stopped running, so he traveled south. The train never reached Paris; he was stuck for three days and three nights without being allowed to disembark.

Eventually he made his way to the small town of Revel, which was located near Toulouse in the south of France. He was placed in an internment camp, but he was released several days later because he held a San Domingo passport. He may have wanted to get to Bordeaux, where there was an extensive immigration network developed by Aristides de Sousa Mendes, an official in the Portuguese Consulate who helped refugees escape to Portugal and then on to north Africa, South America and the United States. Because Bondy's professor's visa status had expired, he needed new papers. He made his way to Lisbon by the end of July, where he received a new American "non-quota" visa through the help of the Joint Distribution Committee. From

Portugal, on August 10, he sailed for America. When the Hyde Farmlanders learned that Bondy had arrived in New York on August 21, they were elated, and his arrival at the farm was anticipated with joy and relief.

After a welcoming celebration of gratitude that Bondy had rejoined his beloved students, it became evident that "Herr Professor" was not quite the same. He had toiled for years working with friendly and hostile bureaucracies, trying to spring loose young people who yearned to immigrate. His own escape and internments, at Buchenwald and in France, had sapped his energy; he was a tired man. He harbored his own uncertainties. He questioned if he could start anew as a professor with such a heavy accent and with such a traditional Germanic teaching style. He had traveled so far from the days of the inception of Gross Breesen to this Hyde Farmlands satellite. In his own eyes, he had not fulfilled the promise to parents that he would keep their children safe and sound. Circumstances had overrun the original plans, but nevertheless, he still felt responsible. He was, by no means, a broken man, but he had lost some of the aura of self-assured leadership, the spirit that had inspired and molded his young Gross Breesen wards. No matter how tired he was, however, he still urged his students:

> *Don't forget your task. Don't forget all our people in Europe who are in such terrible situations and don't forget how important it is for us to fulfill our own special task, everyone in his own place…It is difficult to say how it will go on with this farm. We have not given up our plan to bring over other people from Gross Breesen and young agricultural refugees who are now in other countries… But more than before, I am convinced that what we began at Gross Breesen and what we are realizing now anywhere in the world is quite right.*[130]

For those Gross Breeseners living at Hyde Farmlands, the days now seemed more complete: their treasured "Bo" was among them. He divided his time between Richmond, where he began teaching psychology at the Richmond Professional Institute, a branch of William and Mary College, and the farm. As he rested from the ordeal of escape and adjusted to his new life in America, he slowly revitalized and assumed the "old Bondy" mannerisms. He turned to his writing, which helped him come to terms with the new world order and his place in it. At the manor house, as he tried to concentrate at his desk, noises and voices from under his window constantly interrupted him:

> *At least four girls' voices can be heard, "Why didn't you bring the tomatoes, when I did tell you especially?"—"The peas cannot be used*

at all, you should have picked them yesterday"... "Were you in the house with these filthy shoes? Can't you boys have a little consideration?"... The porch door bangs shut, the carping goes on inside the house and Bondy who was on the verge to call down "Herrschaften" ["Hey you!"] turned again to his book....Now from some place or another resounds also the deep drone of Red's tractor. Though Bondy is not sure whether it might not be Ernst Cramer with the red truck. But even before he has found out, the bell down below rings the first time for the meal and now he energetically draws together his eyebrows, turns his sight towards the book and for the last ten minutes acquaints himself intently with the "Crime and Twin Studies."[131]

It was difficult for Bondy to find uninterrupted periods of time for writing. He was outwardly annoyed, but in truth he relished the normal noises of a busy farm. He loved having his "boys and girls" around him.

The consideration of a new form of community governance at Hyde Farmlands continued to percolate. From a small group of individuals who worked harmoniously there grew a larger community of about thirty that needed a more organized polity, and herein problems resurfaced. Two factions emerged. One was the more recent Gross Breesen arrivals who still looked for leadership from their assistant director, Ernst Cramer, and their beloved Curt Bondy. A second faction rallied around Martin Sobotker, a forty-year-old refugee who came from New York with his wife. Sobotker had been a significant leader in the youth movement, and he was also involved with the creation of Gross Breesen. Institutional loyalties, which have a life of their own, began to play a role in disunity.

Thalhimer's vision for the farm began to be tested. He envisioned a place that could welcome, nurture and train Jewish refugees to become American farmers. The social dynamics of mixing several groups of refugees, who came to this country out of differing experiences, was more complicated than initially considered. The Gross Breeseners saw Hyde Farmlands as their Virginia Plan, inherently tied to the mission, vision and leadership of Gross Breesen. Thalhimer, on the other hand, though responding to the hopes and dreams of those who created and nurtured the agricultural institute in Germany, underestimated the implications of transplanting an entire community to the United States and mixing it with "outsiders."

The NCC, stationed in New York, lobbied Thalhimer, who willingly accepted refugees who were not from Gross Breesen. Rather than having the existing community members sponsor a new candidate and screen him

through a Gross Breesen filter, Thalhimer and others looked on the refugees from Germany as being generically homogeneous in identity and aspiration.

One person, Howard Irvin, proved to be one who fit Thalhimer's vision. He was not a Gross Breesen graduate, but he fit in well. While working in New York City, he met Ingrid Warburg, who introduced him to the possibility of joining the Hyde Farmlands community. He was a trained mechanic in Germany and had already studied engineering. Warburg could spot the potential in people and promised Irvin that she would win him a scholarship to engineering school if he committed to the farm. She was acutely aware that the development of the farm was falling behind schedule because of the visa delays. He did and became the chief mechanic and driver of the Oliver tractor from 1938 to 1939. Warburg fulfilled her promise, and Irvin entered a prestigious engineering school in September 1939.

Not all of the people, however, who were sent by the NCC to Burkeville worked out well. Herein was the conflict. Thalhimer wanted to fulfill his promise to Bondy to develop a Gross Breesen community in America, but he also desired to put into practice a strategy for refugee resettlement that could serve as a paradigm for agricultural settlements elsewhere in the country. Furthermore, he was anxious to have the Virginia farm become financially self-supporting, especially when the schedule for its development had been stalled by the snail's pace of negotiations and deliberations within the State Department.

The conflict between two internal farm factions dampened the enthusiasm for the future development of the community. There were continuous, heated discussions on how the farm should be governed. Thalhimer wanted the members to embrace the ownership of the farm in principle and in practice, but in reality, complete self-determination had not as yet developed because the enterprise was dependent on outside sources of support. Uncertainty about the future integrity of the farm and individual personal plans plagued the students.

Eventually, Thalhimer was convinced that Ernst Cramer should assume the overall leadership of Hyde Farmlands and that George Landecker should become the farm's manager. Reducing the overhead by eliminating the cost of a farm manager tipped the scales, and Franken was dismissed in 1940. In the meantime, Thalhimer remained involved with critical national resettlement matters throughout the country. In Burkeville, he continued to be a vital part of the farming community, even though he visited the farm less and less. Closer to home, he still had major responsibilities at the department store, in the Richmond community and as a husband and father. Lurking in the shadows was the insidious presence of a weakening heart. Sleepless nights became more the rule than the exception. His health suffered.

1941

A Fateful Year

As 1940 progressed, life on the farm became more productive and promising and less tumultuous. Ernst Cramer, the overall administrator, and George Landecker, the farm manager, worked well together. They boasted:

> *Our chickens are outstanding. They have the reputation of being one of the best flocks in the State. We have Barred Rocks. They are gray sprinkled birds. We sell the eggs to a hatchery. However they are just selected eggs, the standard size and weight, without any defect, so they can be successfully hatched. We have a lot of other eggs too and sell these as ordinary eggs. To make good use of our brooder houses, we have raised a batch of broilers, too.*[132]

The initial plan to develop chicken farming on a large scale was developing well. The farm showed signs of standing on sound financial footing.

The shorter days of the winter of 1940–41 forced the activities inside. There was more time for leisure activities, especially after supper. Reading newspapers, magazines and books became a favorite pastime in the small library. Letter writing and English study balanced the thoughtful discussions of farm issues and current events. There was time for pipe smoking and, on occasion, savoring of a good cup of coffee or tea. Listening to the radio and the phonograph and playing the piano afforded opportunities for quiet reflection. Life had grown very civilized.

Some had already been on the farm for two and a half years; they were the ones who saw the greatest changes in the makeup of the community and

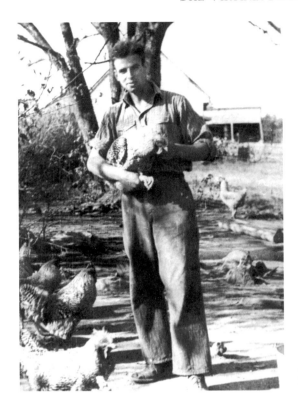

Ernst Cramer, farm director.
Courtesy of Eva Loew.

its physical properties. All in all, life at Hyde Farmlands was settling into normalcy, a positive calm with a good deal of satisfaction and hope. There were still questions of the farm's future and of an individual's future life plans, but there was not the frenzy of arguments of the previous months. Looming over all of the progress and achievement, however, was the anguish of knowing that with Europe's borders being sealed and the fear of a "fifth column" operating within America's shores, any hope for continued immigration was dashed. Worrying about family and friends never ceased.

For the first time, an edition of the *Circular Letters*, which was sent to Gross Breeseners all over the world, originated from Hyde Farmlands. Increasingly, this communication vehicle became the means through which old relationships were maintained. It served as the artery through which the lifeblood of Gross Breesen flowed. For those living in isolation elsewhere in the world, it became the rope that connected refugees to the anchor of Bondy and a memory of happier times. Having it originate from Burkeville meant that Hyde Farmlands was becoming more secure and permanent. Having it written in English heralded a new era for the

students. English was now the language of the present and the future, for most Gross Breeseners were living in Australia, the United States, England and Kenya.

Everything seemed to be developing on a relatively even keel when the lives of the students were suddenly turned upside down. Word had been communicated to Bondy that William Thalhimer had been stricken once again with heart disease. He was hospitalized, but with a lengthy recuperation, it was hoped that he would bring himself back to strength. In addition to the Hyde Farmlanders, the news of his condition shocked many in the Richmond and national communities. He had always been a man of boundless energy and commitment, the torchbearer for active volunteerism. Those who so respected and relied on him for his leadership in refugee resettlement matters felt an urgent sense of uneasiness. Letters of concern poured in from all over the country.

CLOSING HYDE FARMLANDS

As much as it pained Thalhimer, he had to face reality. In December 1940, he had to remind himself that facts could never be blurred by unrealizable dreams, no matter how much one yearned for them to materialize. In this important way, he mirrored Bondy's urging to be self-conscious and aware. With the clear-sighted help of Morton, he realized that the farm could not be self-sustaining for quite some time, if ever, for it could not support the number of people it now housed. He reluctantly acknowledged that future immigration to Hyde Farmlands was doubtful, for events in the world obliterated any long-range planning in America. The hard facts of finances and political realities did not leave much room for alternative decisions. Conversations with Morton and Leroy Cohen pointed in the direction of closing the farm.

Thalhimer hated the idea of disappointing the young refugees who had come to depend on him. He struggled with how he would communicate his decision with Curt Bondy, the man he came to respect. In addition, he had enormous reticence because he had worked so hard to cultivate trust with members of the State Department. He wondered if those officials would regret their support of the immigration of the Gross Breesen boys and the establishment of the farm. He feared that the State Department would now look on him as one who had "used the system." He called A.M. Warren, not knowing what his reaction would be to the prospect of the immigrants no longer staying on the farm. Warren's written response to Thalhimer revealed his deepest admiration. He opened his letter by an uncharacteristic greeting

when writing about State Department business: "My dear Mr. Thalhimer." Warren had full confidence in the integrity of Thalhimer's motivation. He wrote:

> *There certainly can be no legitimate criticism of you and your good faith and generosity in the matter. I realize how disappointing such a turn of events would be to you. You have been so magnanimous about the whole thing that I should regret any disappointment which may come to you... With kindest regards always, I am sincerely yours.*[133]

Thalhimer's overarching goal was for the young people at Hyde Farmlands to "remain on the land" and to continue to become American farmers. He asked Warren to write a letter that would communicate the seriousness of the intended goal of placing refugees on farms permanently. He hoped that a letter from the State Department would apply pressure on the young people to establish themselves in the field of agriculture. The request was never implemented, much to Warren's credit.

By February 17, 1941, the decision to close Hyde Farmlands had already been sealed. In the absence of the ailing William, Morton Thalhimer and Leroy Cohen paid a visit to A.M. Warren in the Visa Division. Both men had been the behind-the-scenes keepers of the purse throughout the existence of the farm. The two disclosed that the key reason for closing the farm was financial. A detailed accounting of the farm from its inception on April 19, 1938, through January 31, 1941, was presented to Warren and discussed. The document revealed that the monetary commitment of Thalhimer had been enormous. The two Richmond men were anxious to hear what Warren had to say because he was so involved with the entire process of acquiring visas. They, like William, were afraid that the State Department would look on the closing of the farm as a breach of promise, a rupture in a relationship of personal integrity. Their anxiety was greatly allayed after their conference with Warren.

In a letter to Warren sent one day after their meeting, Morton Thalhimer wrote:

> *Dear Mr. Warren,*
>
> *On behalf of William Thalhimer and myself, I wish to thank you very sincerely for the time you gave to Mr. Leroy Cohen and myself on Monday, February 17th. We both appreciated the opportunity of talking to you and explaining to you the problems which confront us on Hyde Farmlands.*

You may be assured that both William Thalhimer and I will continue our supervision of these people after they leave the farm and also, if you will allow us to do so, after they become American Citizens. We shall always do our best to guide them, give them the best advice, and whenever necessary proper financial assistance.

I am enclosing herewith a copy of the financial statement of the farm through January 31, 1941.[134]

Morton received a letter from Warren a few days later. It would be the last entry in the State Department records that dealt with Hyde Farmlands:

Dear Mr. Thalhimer,

Thank you so much for your letter of February 19th and its enclosure of a financial statement of Hyde Farmlands, Incorporated.

I have read the statement with much interest and look forward to seeing you again when next you have occasion to visit Washington.

Sincerely,
A.M. Warren[135]

The closing of the farm was responded to in the State Department with boundless sensitivity and appreciation for what the creators and supporters of Hyde Farmlands had initially set out to accomplish. The respect for the integrity of all was never tarnished. Contrary to so many stories about the brusque and sometimes hostile responses to immigrant and refugee matters, everyone involved with the Hyde Farmlands project was ultimately caring. Here was one glowing instance when Jewish immigrants were treated humanely and with respect.

THE YOUNG PEOPLE HEAR THE NEWS

On the evening of February 12, at a meeting with Curt Bondy, the possibility of closing Hyde Farmlands was discussed. Bondy did not avoid the facts: sooner or later, in all probability, the farm would be dissolved, and the young men and women would soon be contemplating their next moves. In a way, this news was not so dramatic. Most harbored doubts that Hyde Farmlands would last forever, and to be truthful, most had entertained thoughts of

leaving and getting on with their lives, sooner or later. On February 14, Bondy informed the group that he had spoken with Morton Thalhimer, who had made the final decision to break up the farm immediately, and that William Thalhimer was very sick.

Tom Angress wrote in his diary, "The group, and me too, acted in a strange way. With lots of resentful remarks and some anxiety."[136] Angress probably projected his own uneasiness onto his fellow students more than how most actually thought. There seemed to be a lack of emotional response overall, for the pervasive attitude was one of acceptance and a desire to "move on." To add to the unnerving news, on the next day, the entire farm community was shocked by the chopping accident of George Landecker, who cut his hand severely. He was treated at the hospital in Richmond, and luckily, no permanent damage was done.

On the sixteenth, Morton Thalhimer drove down from Richmond to talk with the students. The bearer of bad news is always the one who is branded the villain. In the case of Morton, that was an unfair assessment. He was straightforward, to be sure, but he had to be: the farm was to be dissolved. Everyone was rather subdued and went to their rooms early. Over the next few days, Bondy called the students together for talks, as he had done so many times over the past five years.

The students were not left dangling in midair. At the urging of Thalhimer, before his hospitalization, Bondy had traveled to Philadelphia and Washington to confer with Quaker committees, who had been so helpful in the past in refugee matters; he was successful in obtaining job positions for several of the students. Morton Thalhimer again returned to the farm with the news of agricultural employment possibilities through his expansive connections from his refugee resettlement activities of the previous years. One of the positions he offered was to work on the farm-estate of Virginia's ex-governor and U.S. senator, Harry Flood Byrd. This indicated the kind of circles in which the Thalhimers traveled. He also counseled some to consider joining the army in order to gain U.S. citizenship. Several students followed his advice. On February 27, the farm's doctor, "Doktorin" Ilse Lehmann, enjoyed a going away party as she assumed a new home and position at Piedmont Sanitarium in Burkeville. Later in the evening, Bondy talked about unconscious reactions, hopefully helping the students to become more aware of their own reactions to the closing of Hyde Farmlands and the prospect of beginning a new life somewhere else.

People began to prepare for departing the farm that they had called home. The fact that there was no panic spoke well for the personality training they

had experienced at Gross Breesen. Bondy had always stressed the need for rational understanding of a situation and an acceptance of that which could not be changed. The "Gross Breesen Spirit" kicked into high gear and launched the students onto the next trajectory of their lives. Packing was not complicated, for most had few possessions. The books in the library were divided among the students who wanted certain volumes, and the piano, which brought music and a touch of the old Gross Breesen atmosphere, remained in the house for Franken's use, for he was buying the farm.

Moving, which entails sifting through one's belongings and deciding what to throw away and what to keep, is always complicated. The gleaning process is more than just sifting through possessions. Emotions run high when considering which item to keep or discard. The fondling of an object drifts off into nostalgia. Some of the students' meager possessions had been brought over from Germany, Holland or England. Memories of transit and dislocation mingled with flashbacks of more recent events at Hyde Farmlands. Photographs that had been stuffed into a drawer were gently pasted into a scrapbook. Diaries were safely tucked away. People departed at different times, depending on the arrangements with their new employers.

The last entry into the Angress trilogy of short essays describing Hyde Farmlands vividly captured the last days that students resided on the farm. Many had already left, and just a few stayed on to clean up. Resignation and a bit of melancholy colored the scene:

> In front of the large house at the back porch stands the "red truck" and a boy is filling it up…The [truck's] load is full, now it goes to the garbage dump…The "Red one" rattles a bit! Well, tomorrow it will be sold, that doesn't matter any more. So, here is the garbage dump. Actually, it has not altered much since the beginning of Hyde Farmlands. It has grown somewhat larger, but the basic look has remained. So, now to drive onto the heap backwards and down with the rubbish. Piece after piece flies…the old iron, the empty food cans and semi-solid butter milk tubs. Now and then the boy hesitates when something familiar comes to hand. But only a moment, then it flies downwards too. There, Otto's arch supports, Prinz's hat, one of Martin's old shoes, Inge's dress belt. Whatever it might be, it all meets again down below, mercilessly. Peacefully united lie the small possessions of so many boys and girls, and the garbage dump does not ask, whether their owners would have been pleased if they had been thrown together in the same way as their belongings now. As the last item, one single sock follows

Packing up Hyde Farmlands in 1941: Tom Angress, on the truck, and Manfred Lindauer. *Courtesy of Eva Loew.*

marked 158. Surely a Werkdorfer!...Today is the last day, tomorrow he already sleeps elsewhere and nonetheless it was "a home."

Inside it is empty. Only bits of paper and scraps of dust are lying on the floor. No furniture any more, no pictures. The walls look bare and ugly now, everything is so dusty and dirty. One can tell that for several days no girl has been in the house...Room after room is gone through, the few remaining items are put aside and then the place is swept. "Farewell celebration!"...the boy sweeps from the window towards the door. Only in the center, he carefully sweeps around a pile of hand luggage. It's his own...Actually, it was a beautiful dream! But now it is finished! How does one frequently say? I see, of course. Finality![137]

By April, all of the Hyde Farmlanders had found new homes. Many were working in general agriculture, poultry, cattle and dairy management. A few found positions as gardeners, carpenters, cabinetmakers, plumbers and domestic helpers, and another began training as a masseuse. Others began their studies, either completing high school or beginning college. One remained at Hyde Farmlands to work for the new owner, the ex-manager,

U.K. Franken. The largest Hyde Farmlander group—Prinz, Ruth, George and Eva—lived and worked at Carson College, an orphanage not far from Philadelphia. The institution was located on forty-five beautiful, rolling acres that included a farm and a dairy. The girls served as assistants to the housemothers and had direct contact as counselors with the seventy-five girls who lived on campus. The men worked in agricultural and maintenance jobs. The training and experience that all four received at Gross Breesen and at Hyde Farmlands, in addition to their admired work ethic and maturity level, made them immediate successes and revered members of the adult staff. It was at Carson that George Landecker met Jesse, his future wife.[138]

The dust had not even settled from the cleaning and departure from Hyde Farmlands when a new era in the lives of the young men and women commenced. There were no crippling effects from the most recent dislocation. The morale of the students was generally optimistic, though it was always darkly colored by the fear of continued and growing threats to their families and friends in Germany. The desire to get on with their new lives did not diminish their keen sense of community connection. In fact, this group consciousness and responsibility would continue to grow and develop in new ways.

21.

AFTER HYDE FARMLANDS

W hen the students left Gross Breesen or other transit locations, they anticipated coming together with old friends and fulfilling a "task," a vision of community building at Hyde Farmlands. Now, the moves that the students were making took them to places where they might be alone. Launching outward was intimidating, but the students were now older, and the prospect of exploring new horizons with independence was exhilarating. For the first time, individuals would be taking full responsibility for their own lives. The Hyde Farmlanders were not novices in making new beginnings, and for most, the next steps in their lives were accepted and welcomed with a bittersweet confidence.

The Gross Breesen/Hyde Farmlands experiences would become even more significant in the years to come. While they were living at Hyde Farmlands, they were always living in the present, fulfilling the chores of working on a farm. They thought about the future of the farming community and their individual places in it, but now with its closing, each had to look forward in a new way. Making decisions that would determine the next directions in their lives called on a deeper self-consciousness. They soon realized that their past would never die, that their suffering the onslaught of Nazi persecution and subsequent immigration would always be with them. They were mature enough to begin the lifelong task of making sense of what had been. They began to ask the crucial questions of individual experience: What did all this mean to me, and how did it influence what I am doing in my life, now? Being homeless, they began to realize that the only home they would ever have would be within themselves.

The *Circular Letters* became the vehicle through which the young people clarified their own thinking. For the students, Bondy's influence did not subside. He continued to offer guidance to those with whom he had lived and loved. Letters continually arrived at his postbox at West Franklin Street in Richmond, and no matter how busy or tired he was, he always responded to each individual. He was trusted beyond question to keep in confidence questions and thoughts that were too personal to be revealed. He never broke that trust. In the *Circular Letters*, he would summarize important questions and thoughts in order to share topics that he felt would be relevant to all the readers.

Bondy's new mission began immediately after Hyde Farmlands closed. As always, he helped put events into perspective:

> *The individuals will now have to prove themselves in the life out there, they have to learn a lot yet, have to master the language better and have to try much harder to enter in the American lifestyle. The task, which we had set ourselves, to do the groundwork for further Jewish young people from Europe who wanted to become farmers, cannot at present be continued...Perhaps no other common task arises any more...We will have to shape our life, each one by himself.*[139]

In truth, many of the young people who originally came to Gross Breesen in 1936 did not come because they were totally convinced at that time that they wanted to become farmers. As teenagers, how could they honestly know what they wanted to do for the rest of their lives? They came because they had to, because they had no other choice in their constricted world. Emigration from Germany was the first matter of concern, always. So, now, if individuals moved in directions other than farming, it would come as no surprise to Bondy or to anyone else.

The announcement of Dr. Otto Hirsch's death galvanized the students' increasing fear for their own families and friends. For Bondy, he had lost a dear friend. The students had met Dr. Hirsch at Gross Breesen, but they never really knew much about him. During the tumultuous times of upheaval, he commanded a moral and administrative authority within the Jewish community, and he gave his life by remaining even when he could have left Germany. In Mauthausen, he was tortured to death. Bondy tried to put his life into perspective:

> *Perhaps you do not know how much he contributed towards the establishment of Gross Breesen and was concerned about the fate of our*

people. He was only rarely in Gross Breesen, but he really felt to be one, who belonged to it. I am just remembering how we, at the end of 1935, met Martin Buber…how passionately Hirsch discussed with us the plan of an agricultural training farm, for those people who were not Zionists. Did you know that he could have emigrated long ago, and that only his incredible strong sense of duty kept him in Germany? As the president of the National Representative Agency of German Jews, he had enormous achievements to his credit. He died for his task in the truest sense of the word. And that is more than a hero's death on the battlefield! If we said repeatedly, quite seriously, that our dead comrades have to live on through us and through our work, so today I am saying it far more urgently, pleadingly, indeed imploringly for Otto Hirsch. We have to continue his task and to keep on living with his attitude and with his spirit. That means with the most profound and most pressing seriousness…Begin a good New Year, prepare yourselves for greater tasks…That is my hearty wish for all of you this evening. Bo.[140]

Hans George Hirsch, the son of Otto Hirsch, had lived and worked briefly at Hyde Farmlands in 1938. At that time, being older than the other students and determining that he could not totally commit himself to a long-term stay on the farm, he decided to leave. He needed the freedom of decision and movement in his search for a new identity in America. For him, America meant freedom to choose one's own path and be able to work at its achievement. By the autumn of 1941, he had completed his bachelor's degree in agriculture at the University of Minnesota and was working at the university while engaged in graduate studies.

William Thalhimer kept in close communication with Bondy, even as he was recuperating:

I feel like a father towards all the boys and girls formerly at Hyde Farmlands and will always be ready to give them whatever counsel and advice they may need. As time goes on, questions will always arise and I know you will feel free to call on me. The different boys and girls have been writing to me and they all seem to be very happy[141]

The first Hyde Farmlands reunion was held in October 1941. It would not be the last. Ten Hyde Farmlanders, who were living in Virginia, gathered in Burkeville and visited the farm. It was so different and so very quiet. Bondy wrote, "We felt a little bit queer being out there as visitors; and we dreamed

of old times, sitting on the porch and looking at the park. But I do not want to talk to you about old times."[142]

Hyde Farmlands was closed, but the people who had tended to its growth were free to begin new lives elsewhere. At the same time, in Germany, Gross Breesen was also closed, but not amid new beginnings for its students. Within a short period of time, the school's population shrank from 110 to 38. It soon died altogether by order of the Gestapo, and the students were placed into forced labor camps. The person who wrote the last free entry into the *Circular Letters* from Gross Breesen was Klaus Freund, who in October 1941 miraculously received a visa and immigrated to the United States.

Almost all of the remaining students and staff at Gross Breesen perished at the hands of the Nazis.

Now that the students no longer lived within the security of a community, Bondy recognized the need for each individual to face reality on its own terms. Living as a German Jewish immigrant in America was difficult. He did not mince words:

> *We are not able to alter the external circumstances under which we have to live. We are not able to alter fundamentally suspicion of strangers, the economic and political conditions, hate of Germans and anti-Semitism… No one is politically more powerless than the immigrant. Nor is there any point in wanting to minimize the actual difficulties by saying, "this is really not so bad, it only appears that way, etc." That is nonsense and with this, one does not help anybody. On the contrary, we have to make ourselves aware of our general and special situation with complete clarity, have to comprehend what it means to be uprooted, isolated and alien, i.e. to be an immigrant.*

He urged the students to be prepared to counter the difficulties ahead by being aware of the dangers: "There is no other way, and if one does not have this clarity, one will again and again react to every fresh attack against oneself or generally against Jews and aliens with depression, despondency and desperation."[143]

He did not devalue or underestimate the hardships endured by refugees, but he urged for a certain type of human response: "[That if people] endure great hardship and suffer much misfortune, [they] either become purposeless and perish or actually grow, because of all the difficulties, [people can] become deeper and emerge as greater and stronger personalities from these times."[144]

Bondy believed that misfortune was like a treatment, a chemotherapy of the spirit—it would either cure or kill, but unlike the fight against a physical disease, one could exert enough spiritual will to survive. This was tough talk. This was tough love. This was what the students had experienced years before in Germany.

Bondy closed his letter with words that would resonate throughout the lives of the students and even their offspring: "REMAIN GROSS BREESENERS."[145]

22.

THE WAR YEARS AND AFTER

E very Hyde Farmlander who could enlisted in the war effort following the
attack on Pearl Harbor in December 1941. At first, there was a reticence
on the part of draft boards to accept alien volunteers from Germany, but that
changed as the entire country began to mobilize. It was soon realized that
German-speaking recruits would be of immense importance for intelligence
gathering and communication with German POWs and active forces.

Several Gross Breeseners were selected to study at the Military Training
Center at Camp Ritchie in Maryland, part of the Army Specialized
Training Program, and became known as the Ritchie Boys. Even Bondy
tried to get into the fight to defeat the Nazis, but he was three years over the
enlistment age, and the sons of William and Morton Thalhimer enlisted
in the military. Gross Breeseners from all over the world volunteered for
the fight, from Brazil to Australia to Kenya. There was no ambiguity
about why they were fighting. They knew the Nazi regime firsthand, but
they also harbored the hope that after its defeat Germany would once
again establish a democracy. For those serving in the European and north
African sectors, every time they took a step closer to Berlin, they thought
of their families, friends and Gross Breesen comrades. Miraculously, all
Hyde Farmlanders survived the war, but one Gross Breesen American
soldier, Gerhard Buehler, who played a leading role in the capture of 1,500
German officers near Cherbourg, was killed in action.[146]

Even during periods of combat, Hyde Farmlanders wrote letters to Bondy,
who published them in the continuous dissemination of the *Circular Letters*.
The letters often revealed the serious thoughts that occupied their minds as

they pushed deeper into Europe and Germany. Bondy wrote back and urged his boys to consider the future. In a letter dated October 1944, he wrote, "Most of our boys certainly are in a…difficult situation. They do not have a home and a family to come back to, and some even don't know where to go at all when they return to the States." He answered their predicament positively. Those in the States who helped before would be there to assist again.[147] He tried to help the soldiers focus beyond the surviving of day to day. He urged each to think about what he wanted to do in the future and asked how each could possibly obtain training for that profession or vocation while still in the army.

This perspective could have been considered ludicrous for anyone involved in combat, but the soldiers knew what Bondy was driving at. Self-consciousness, awareness and hope would help control the chaos of the moment. The Gross Breesen mindset strove to know the difference between realistic hope and baseless optimism. Bondy's writing was his way of being in the battle to crush the Nazis, and in his way, he began the rehabilitation of his war-weary students. In Richmond, he had already introduced a new course that trained counselors who would be advising returning servicemen/women in their endeavors to map out their future.

Some of the soldiers participated in the Normandy invasion, and some experienced the joy of liberating villages in France and Italy. As they pushed into Germany, they feared what they might find. The following account appeared in the *Richmond Times-Dispatch* on June 4, 1945. The title of the article was "SERGEANT WRITES DR. CURT BONDY OF MASS BURIAL OF INTERNEES IN GERMANY." Tom Angress wrote to Bondy, and he, in turn, released the letter to the newspaper:

> *Today we buried the dead that we found in the concentration camp right outside of our town. We buried them in the public square of the town, right opposite the castle of the Grand Duke, and the whole population as well as the captured German generals and high ranking officers had to attend.*
>
> [The concentration camp was] *just a small camp, with about 10 buildings behind the usual barbed wire, and it housed from 200 to 300 slave laborers. The sight was the most horrible one I have ever seen. The place was filthy and smelled of decay, of dead bodies, and foul turnips; gnawed-on turnips were lying around on the barrack floors, in addition to the filth and dead bodies of the inmates. You found them all over the place; piled up, head to feet; in the latrine, in*

the so-called wash room, in the barrack corners. Two hundred of them lay there, unburied, simply starved to death. Their limbs partly fallen off their bodies already, were as thin as sticks. It was a repulsing, sickening sight. Their bodies were shrunk, only bones and skin. And over a thousand more bodies were being dug out of mass graves by the German population right then, while I was up there. But six kilometers away were people living in a town as good as you can imagine, a bit rationed but not suffering, in nice houses, with dogs and cats that had to be fed and with good clothes to wear. I found several survivors in the camp yet, and talked with them. They still wore their striped suits, they looked more dead than alive, and their faces regardless of age, looked old. They showed me their numbers which were tattooed to the arms, they told me of their suffering. And even if they had not done so, the sight out there talked louder than these people could...It is one dirt spot in the history of Germany which will never be washed off.

Angress continued to describe the funeral service for the dead prisoners. The entire town was forced to witness the burials and walk past each corpse in a gesture of respect. The German officers stood at attention to give witness to the slaughtered:

[The] *group of German officers led by five generals, who stood in front of the population at rigid attention, with faces of stone, stared into nothing...Their faces betrayed nothing. In front of them, facing the row of graves, stood our two generals and their staff. When the bodies were lowered, the chaplains said prayers for the Protestant, Catholic and Jewish victims, and one chaplain read a speech in German and English, telling once more the story and explaining why those people were buried in the middle of the town. He said that it was the crime of every German, actually committed by cruel guards, or indifferently tolerated by the people. He warned the people never to allow again any party or any man to arise and do things like that. He appealed to the human decency to atone for these crimes.*

Our national anthem followed. We saluted, and so did the German officers...Then the bugles sounded taps...Thus were buried 200 human beings. Dutch, French, Poles, Russians and Jews, buried by their former oppressors, and by the liberating Americans, who had come too late for them, in the middle of a German town.

When Angress returned to Amsterdam, he found his mother and two brothers still alive. They had survived by living underground throughout the war, but his father perished at the hands of the Nazis.

Questions about Germany's future and what the Allied role should be in reconstructing a democracy after more than a decade of fascist dictatorship often surfaced in the letters to Bondy. The young soldiers were impressed by how rapidly the Germans wanted to clean up the rubble of military defeat and start over again. George Landecker, on his return to Munich, wrote that the people wanted to establish normalcy as soon as possible:

> *They were willing to build up but they want guidance and supervision in a way and will get it, they need lots of supervision and a strict hand, in my opinion. They know what a lost war means and most of them now realize the horror the Nazis have done, but there are many young people who are still filled with the belief of the greatness of Germany and who will need close attention.*[148]

Others commented on the problems of reeducating the younger generation. Ernst Loew (Americanized from "Loewensberg") wrote:

> *I question*[ed] *my younger POW's as to their youth movement affiliation prior to 1933…Those people will again be the ones whose confidence we must gain in order to win the peace. By calling them "Nazischwein"* [Nazi pigs], *nothing will be accomplished…not all Germans are alike…You will also find young men of my age who have very reasonable ideas, who see now that they have been betrayed and who are willing to do anything to obliterate the bad name which the German nation made itself during the past 15 years. Boys, who don't just change their mind because they want to please us, they are convinced of their wrong.*[149]

Far from the quiet farmlands of Burkeville, Hyde Farmlanders revisited former homes and places of employment. Most received a welcome, but often they dismissed the smiles and handshakes. A cynical refusal to forget painful, earlier memories dominated their own responses to German hospitality, feigned or authentic.

The Gross Breesen soldiers had come full circle, returning to their roots, returning to places of anguish. One occasion rose to the height of tragedy revisited. On April 13, 1945, Ernst Cramer returned to the Buchenwald concentration camp, nearly six years after he and the other students

had been incarcerated during the Kristallnacht pogrom. Because of his German fluency, Cramer, now a sergeant, was attached to the Division for Psychological Warfare of the Third Army. Headquarters was informed that Buchenwald had been liberated and that twenty-one thousand were still alive there. There were three thousand critically sick with little medicine, medical supplies or disinfectants available. The report called the situation "desperate." His commanding officer received the order to go to Buchenwald to "prepare" it for a visit by General George Patton. Cramer was asked to accompany his commanding officer. The ride to Buchenwald in an open jeep took them through the countryside. As the jeep traveled slowly over potholed roads, Cramer sat silently:

> *Although I had never been here before, I felt at home. After all, wasn't this wooded area we were driving through Germany's spiritual heartland, where Bach was born and Luther translated the Bible into German? Wasn't this the landscape where Goethe, Schiller, Wieland and Herder wrote? This bumpy ride through the foothills of the Thuringian Forest reminded me how deeply German culture was a part of me, despite my U.S. uniform.*

As he drove closer to the city of Weimar, the memories of Kristallnacht and the brutal journey to Buchenwald became more vivid. In his haunted imagination, he could hear the screams of pain from those who were beaten, and he could hear the yelling of the SS, the snarling of German shepherds and the pushing and falling. He could feel the wooden stick slam onto his shaven head. He remembered all. Then he arrived:

> *We were right in front of the camp, on a road through which I had often been hounded. The first prisoners approached us, many of them stumbling. At the main gate, where the American soldiers were having some difficulty pushing back the masses of prisoners…What we saw on that short path between the gate and the barracks made everything I went through in autumn 1938 shrink into meaninglessness.*
>
> *Figures marked by death came toward us. Some collapsed from the effort to speak. Others lay on the ground, their joints dislocated. When Henry tried to give some of these poor people something to eat, the lieutenant stopped him, saying: "If that man takes one bite of that rich food, he's a goner." Emaciated corpses were piled up like firewood. Others lay in scattered corners, seemingly unnoticed. People wearing rags,*

nothing but skin and bones, tried to speak to us. Some died right in front of us. The stench of corpses mixed with the smell of antiseptic lime. It was appalling. The thought that conditions must have been far worse in Auschwitz and other death camps was practically unbearable.[150]

Ernst Cramer had been offered a position to stay on in Germany. His superior officer commented to him: "After what we saw in Buchenwald today, I understand why you want to get out of here as fast as possible and back to your alma mater, and that you won't be available for the military government." Cramer then responded: "This experience today has shown me where my path lies in the near future. After all that horror we saw, I feel it's practically my duty to stay here, to help rebuild and do my bit to bring Germany back to reason, decency and justice…Without answering, Colonel H. stroked my head."[151]

Haka did not think of peaceful Virginia fields when he stopped at the Mauthausen concentration camp. He realized that "there [was] little doubt left that…[his parents] shared the fate of so many millions and have perished in one of the Nazi concentration camps."[152] He was overcome by the condition of the prisoners who still clung to life, many of whom suffered from tuberculosis and other diseases. He could not refrain from describing the camp:

[A]nd within this little fortress there is the crematory, only a small one, as this was one of the "better" camps. They burned but 240 human beings a day in the last few months. Oh, they gave them an easy death, these Nazis, they did not murder them. Oh, no, they first gassed them under an apparatus resembling a shower, then they cleaned the chamber and moved the victims to the crematory and the "shower room" was ready for another batch. Most all of the children were separated from their mothers and killed that way to begin with. Most of the ashes were dumped into the Danube.[153]

Often, during the war and its aftermath, Hyde Farmlanders encountered one another unexpectedly. These shocking reunions were always emotional and joyous. It was a wonder that the world had grown so small as to invite such meetings.

Every edition of the *Circular Letters* announced the news that everyone wished would not be true. One death notice, in particular, saddened every Gross Breesener scattered throughout the world. Dr. Julius Seligsohn had died in the Sachsenhausen concentration camp. He was a highly decorated frontline soldier in World War I, but that meant nothing to his captives.

William B. Thalhimer and a Rescue from Nazi Germany

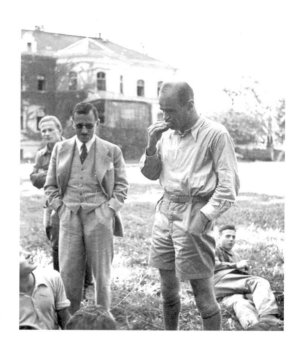

Julius Seligsohn, *left*, and Curt Bondy at Gross Breesen. *Courtesy of George Landecker.*

He was one of the best friends that Gross Breesen had. Indeed, he was instrumental in the formation of Gross Breesen and, with Martin Buber, the selection of Curt Bondy as its leader. He worked with Raymond Geist and his vice-consuls to procure the visas for the Gross Breesen students earmarked for Hyde Farmlands. He could have left Germany, but he chose to remain in order to work for the release of prisoners and the granting of visas. The letter informing of his death was written by a fellow inmate:

> *He did not regret…to sacrifice himself to the cause of German Jewry… Not to see his family again, even though he knew that he was suffering for a just cause, was the hardest thing to bear…harder than hunger and cold, harder than cutting wood and clearing land, harder even than the impotence vis-à-vis our annihilators and the hopelessness to escape the fate they had planned for us…I think of the esteem, the love and the devotion with which he always spoke of his loved ones in spite of the wall of the great distance between them.*[154]

Otto Hirsch and Julius Seligsohn were two of the greatest friends and supporters of Gross Breesen.

During the war years, Bondy and Thalhimer kept in touch in Richmond. Bondy continued to teach and write. He, along with Bruno Bettelheim, was the first to write analytically elaborated eyewitness reports on concentration camp life, which were published in the *Journal of Abnormal and Social Psychology* in 1942–43. William, whose health had suffered drastically during the early 1940s, largely recovered, and he continued to be involved in refugee resettlement matters, though immigration halted as the war developed. He realized that he had done all that he could in responding to refugee needs at that time, so he turned to activities that served the war effort. One of his most favorite was the creation of block parties for soldiers stationed near Richmond in the parking lot of Thalhimers Department Store. Here, soldiers from all over the region's training camps relaxed and socialized with the volunteers from the Richmond community.

After the War

The Nazi war machine soon collapsed and Germany was defeated. A new era began for the conquered country that had scorched humanity beyond comprehension. With the war over, the Hyde Farmlanders were older and wiser from their experiences, and they were anxious to begin new lives. With military service, three key objectives that Thalhimer and Bondy emphasized were achieved: one, everyone learned English very well; two, all learned more about American culture; and three, through military service, all of the soldiers became American citizens and benefited from the GI Bill after the war. Also, during the war years, the young women of Hyde Farmlands experienced the newfound independence and mobility that American women cherished.

After the war, the *Circular Letters* kept everyone connected. Most continued their education and eventually became academics, nurses, social workers, artists, lawyers, accountants, teachers, businessmen, journalists and tradesmen, and some owned their own dairy farms. Ernst Loew married Eva Jacobsohn and established their dairy farm in Connecticut. Eva became a registered nurse who divided her time between delivering calves in the morning and babies in the afternoon.[155] Tom Angress, who became a Phi Beta Kappa at Wesleyan University under the GI Bill and, later, a history professor and writer, often hitchhiked to eastern Connecticut on the weekends to visit his old friends. The very minute he arrived, he changed into work clothes and transformed from college student to farmer.

William B. Thalhimer and a Rescue from Nazi Germany

Drs. Hans George Hirsch and Harvey Newton (Prinze) became renowned agricultural consultants. Hermann Kiwi owned a thriving cabinet business in Richmond. Friedel Dzubas became a world-famous abstract painter. Ernst Cramer returned to Germany and became prominent in the publishing profession and rose to top positions in Axel Springer. He was recognized throughout Germany for his efforts to launch Germany on the path to democracy and received many awards, including an honorary doctorate from Israel's Bar-Ilan University. Isidor Kirshrot achieved the rank of colonel before he retired to become a college professor. Ernst Loew became a farmer and rose to become a colonel in the Army Reserve. Luise Tworoger became a teacher. Mariane Regensburger became a TV documentary producer in Germany. Ruth Hadra became an occupational therapist. George Landecker successfully managed his own dairy farm. Ken Herman owned a dairy farm and later succeeded as a realtor. Howard Irvin became an engineer and inventor, particularly significant in the development of plastics. Leroy Cohen, the right-hand man of Thalhimer as the lead legal negotiator with the State Department, became a major in the army and served as a lawyer at the Nuremberg trials. Later he argued a case before the Supreme Court.

In the late 1940s, while still a professor at the Richmond Professional Institute, Curt Bondy returned to Germany to teach during the summers. In 1950, he moved to Germany after he accepted the William Stern Chair of the Psychology Department of Hamburg University. He brought considerable funding with him to rebuild the study of psychology in postwar Germany. He was credited for bringing new methods and theories to the study of psychology, and one of his significant projects was to formalize the Wechsler-Intelligence Scales for children and adults. Though very appreciated by his students because of his intense interest in their studies, he personally suffered from the memories and fears of a latent racism in the German people. This was intensified when his successful efforts to reinstate the depth psychology teachings of Sigmund Freud and his successors into the curriculum was met with resistance from his colleagues. As Germany reinvented itself, Bondy grew more comfortable and effective. In 1961, he was elected to the presidency of the Professional Association of German Psychologists. His prominence led to lecturing throughout Europe. In 1972, Herr Doktor Bondy died. He had nurtured a new generation of German psychologists and researchers. He was mourned by all of his students, new and old.

During the war years and after, Thalhimer's health was precarious, but he and his wife, Annette, lived life to the fullest. In 1954, William B. Thalhimer received the Richmond Jewish Community Council Award for Distinguished Service. There were many accolades, but his tireless work in behalf of refugees stood out:

> *But, if nothing else had been accomplished by this all-important individual, except helping to save these victims of oppression from Hitler's Germany this would have been enough to place him in the annals of history. What he has done for suffering humanity at home and abroad will remain in the hearts and minds of all people everywhere and they in turn will remember and shall forever be grateful to him for these noble, humanitarian deeds.[156]*

At one of the reunions, George Landecker, voicing the gratitude that all the Hyde Farmlanders felt, commented: "There is no doubt that Mr. Thalhimer's action was our escape route out of Germany and probably saved our lives."[157]

Raymond Geist returned to the United States during the war years and continued to be a vocal and respected critic of the Nazi regime, as seen in a May 23, 1942 *Washington Post* article entitled "U.S. Official Indicts Entire German Nation." He returned to Germany to testify at the Nuremberg trials. In 1954, the West German government awarded Geist its Commander's Cross of the Order of Merit "for intervening with the highest officials in Nazi Germany on behalf of the victims of Nazi persecution and helping the latter to leave Germany...[He acted] far beyond the bounds of the duties of his office...without consideration of potential personal disadvantages."[158] In addition, the Raoul Wallenberg Foundation recognized Geist as a "Diplomat of Courage."[159]

The lives of the Hyde Farmlanders progressed and prospered; in addition to raising families, they committed themselves to activities that benefited their local communities, serving on city councils, boards and sundry volunteer organizations. Eva Loew, for example, sat on the board of education for more than twenty-five years and engineered the development of a regional high school. The Eva Award ("**E**xtraordinarily **V**aluable **A**sset") was established in her honor and is awarded annually to an outstanding Hampton, Connecticut citizen. Each, in his own way, lived authentically, and the Gross Breesen Spirit remained the guiding principle of their lives and their families. Even though they denied being "special" in any way, they were. They and their family members met throughout their lives at several

reunions, including in Israel, where they joined others from Gross Breesen from all over the world. They held two reunions at Hyde Farmlands with the descendants of William B. Thalhimer. The *Circular Letters* continued for more than seventy years.

They never forgot Curt Bondy's influence and lifelong dedication to their welfare. They never forgot those who gave their lives for their safety and rescue. They never forgot how William B. Thalhimer fought for their immigration and saved their lives by bringing them to Hyde Farmlands in Burkeville, Virginia.

23.

A FINAL ACCOUNTING

A financial accounting of Hyde Farmlands Operating Corporation was made to the State Department and to those who had donated to the Hyde Farmlands Foundation. It revealed the costly endeavors to establish and maintain the resettlement community from its inception in April 1938 to its closing in 1941. Two letters reviewed the financial records.

The first statement of cash receipts and disbursements from April 19, 1938, through January 31, 1941, was sent to the State Department. The bottom line numbers indicated that total cash receipts were $72,377.65, while the disbursements totaled $65,497.89, with $6,879.76 in the bank. This, on the face of it, looked to be a wash, but with closer examination, it showed that William Thalhimer had purchased $24,000.00 worth of stock in the corporation and had loaned it $22,000.00. In short, Thalhimer had financed the majority of the operation.[160]

The second accounting appeared in a letter written to William Rosenwald, Thalhimer's close partner at the NCC and NRS. This letter informed Rosenwald, who had contributed $250 to the Hyde Farmlands Foundation, that the farm was closing and included a financial accounting. In the letter, Morton Thalhimer, in behalf of the ailing William, related:

> *The basic premise upon which the farm program was undertaken was that the refugees could eventually become self-supporting provided they were furnished with a farming property, equipment and facilities and interim support; they to repay over an extended period of time and upon the easiest possible terms a portion only of the cost of the project, the*

returned portion to be used to finance similar projects. Upon reviewing the operations as of December 31, 1940 in light of experience since April 1938, it became manifest that the farm itself could not be made to produce sufficient income for any reasonable number of residents thereon in any foreseeable future, even were they given the assets and relieved of all liability for past support. Therefore, it was decided to liquidate Hyde Farmlands provided all of its residents could be placed in vocations or positions which would enable them to support themselves and to be inducted further into the American way of life.

Morton presented a summary of the financial picture of the life of the farm:

Total outlay for land, buildings, furniture, equipment, live stock, etc, including cost of maintenance and support from April 21, 1938 to July 1, 1941—$63,791.00. Less: by sale of portion of farm and personal property—$10,005.00, to equal $53,786.00. Estimated liquidation value of remaining portion of the farm is $10,000.00. The estimated unrecoverable amount was $43,786.00. Of that amount, the Foundation raised $8,214.00. In addition, there was a $9000.00 corporate contribution [that was probably given by Morton Thalhimer himself] *leaving a balance of $26,572.00.*

…It is believed by those closely associated with this enterprise that despite the abandonment of the farming project, constructive work has been done and a very worthy objective attained…These facts are presented to you, first, because you are entitled to know them, and second, because Mr. William B. Thalhimer feels that he personally should refund your contribution to you if you are in any wise of the opinion that the purposes for which you gave it have failed or have not been accomplished.[161]

William B. Thalhimer, even after all that was accomplished in rescuing immigrants and resettling them on the farm, still felt obligated to refund a contribution. To the very end, he acted with utmost integrity. It is estimated that Thalhimer contributed approximately $30,000 for the Hyde Farmlands' Virginia Project. That was a substantial sum of money in the late 1930s.

24.

MISCONCEPTIONS

For more than seventy years, there have been misconceptions about how the Gross Breeseners came to America.

The constant understanding by the students and those who heard their personal stories, including family members, believed that the shares that William Thalhimer assigned to each of them automatically ensured their being granted visas for immigration—that somehow he had devised the shares strategy to maneuver "outside" of the usual channels of immigration and quota considerations. That notion was incorrect. In reality, the students never received individual shares, for they were not issued to them because the Hyde Farmlands Operating Corporation was disbanded and never fully repaid the debt to Hyde Farmlands Incorporated.

The students believed that by their having "ownership of American land" through the shares they rightfully could gain entrance into the United States. This, too, was incorrect. A landownership consideration was not included in immigration law in the 1930s. In truth, the shares were extremely important, for they served to satisfy those in the State and Labor Departments who questioned whether immigrants working on a farm conflicted with the already-established contract labor laws. In addition, the shares helped convince the State Department officials that the students would not become LPC wards of the state. This was crucial.

The students also believed that they immigrated "outside" of the immigration quota. This was not true. The students always fell within the quota of twenty-seven thousand from Germany/Austria.

The students thought that they were granted "agricultural preferences" outside of the quota. This belief was also not the case. No one earned the professional designation outside of the quota.

Finally, no student ever received the "agricultural preference" label within the quota. Only two qualified for such a category within the quota, and they were instructors at Gross Breesen.

In short, no one ever knew the total truth about the significance of the granting of shares by Hyde Farmlands Operating Corporation. Most ironic, the shares issue became radioactive, and instead of fast-tracking the visas decisions, it delayed them for well over a year. Most important, no one ever really knew the extent of hard work that Thalhimer and Leroy Cohen performed in behalf of the Gross Breeseners. And perhaps of greatest significance, by far, is that no student ever fully comprehended that it was Thalhimer's indefatigable personality and character that won over the State Department officials who granted the visas that probably saved their lives.

In addition, the students were never completely aware of the financial sacrifice that Thalhimer and others made on their behalf. At a time when the United States was still struggling to recover from the Depression, when businesses were precarious at best, their benefactor poured large sums of money into the farm for their individual support.

And lastly, all of the newspaper reports and stories about Hyde Farmlands over the years were incorrect in regard to the chronology of events. Hyde Farmlands, as a refugee resettlement institution, ended long before America entered World War II. The farm was dissolved in February 1941; Pearl Harbor occurred on December 7, 1941. The entering into World War II had nothing to do with the closing of the farm.

25.

SHAREHOLDERS FOR LIFE

William B. Thalhimer and Dr. Curt Bondy towered as heroes in a time of incomprehensible inhumanity and social chaos. Each stood firm against the tide of Nazi madness. Each committed himself not only to saving lives but also to building new ones. The two men became comrades in the mission to rescue young people, and both had a vision for how that future would emerge. But did the two succeed or fail?

In some ways, they both failed. Hyde Farmlands never evolved into the resettlement funnel for the displaced refugees that Thalhimer had envisioned. It never emerged into an ongoing agricultural training institute and cooperative community. It never became the hoped-for paradigm for refugee retraining that could be replicated throughout the country.

Bondy's vision of transplanting Gross Breesen colonies throughout the world, and living in accord with the finest of German humanistic values, never came to be. It is true that most of the "first generation" of Gross Breeseners were saved from the eventual Holocaust, but of those who arrived later, most perished.

Those are the negatives. They cannot be denied. But they are dwarfed in comparison to the accomplishments that both men attained through their efforts.

First and foremost, lives were saved. There is a Jewish saying: "If you save just one life, it is as if you have saved the entire world." Both men saved the world. They never wavered as they worked to exhaustion in their commitment to students who were helpless and adrift. They existed for years on the adrenaline of courage and love, and when they were discouraged, they never gave into it. Both won the good graces of others through their limitless desire to help others.

Bondy and Thalhimer gifted spiritual shares to the young men and women whose lives were renewed in the red clay fields of central Virginia. The refugees shared mutual memories of pain and despair, but they also were embraced by the freedom and hope of the American dream. For the rest of their lives, they never settled for the ordinary, instead always striving to live by Bondy's urgings: to be aware, to be courageous, to share in the responsibilities of being ultimately human…"to remain Gross Breeseners." Indeed, all were characters in the true story of the shareholders for life.

Above: Eva Loew, Bob Gillette and Jacqueline Jacobsohn, Eva's daughter. *Photo by Marsha Gillette.*

Below left: Werner (Tom) Angress. *Courtesy of the Angress family.*

Below right: George Landecker. *Courtesy of Gloria Infusino.*

Abbreviations

AJC	American Jewish Committee
CCC	Civilian Conservation Corps
CGJC	Reichsvertretung, the Central German Jewish Committee
CL	*Circular Letters*
JDC	Joint Distribution Committee
NCC	National Coordinating Committee
NRS	National Rescue Service
RJCC	Richmond Jewish Community Council

Notes

Chapter 1

1. Friedlander, *Leo Baeck*, 42.
2. Julius Seligsohn, NCC records, RG 247, YIVO Archives, mkm 3.1–3.6.
3. *American Jewish Committee Year Book* 35, page 36.
4. NA, RG 59, 811.1185, Box 231, Hyde Farmlands, August 22, 1938.
5. Ibid.

Chapter 2

6. Ernst Loewensberg in the *Circular Letters* (hereafter *CL*), 129.
7. Nottoway County Records, Deed Book 3–4, 385.
8. Cummins, *Nottoway County, Virginia*, 33.
9. Turner, *Old Homes and Families*, 113–16.
10. Cummins, *Nottoway County, Virginia*, 34.
11. Elizabeth Vaughan Fowlkes genealogy file, Jones Historical Library, Lynchburg, Virginia.
12. Leroy Cohen memorandum, NA, RG 59, 811.1185/231, 4.
13. Nottoway County Records, Deed Book 80, 455.
14. Commonwealth of Virginia, State Corporation Commission, Office of the Clerk, letter of verification, May 12, 2008.
15. *Richmond Times-Dispatch*, May 17, 1938.
16. *CL*, 121.
17. Ibid.

CHAPTER 3

18. Tolischus, "Trouble-Shooter In Berlin."
19. Stiller, *George Messersmith*, 28.
20. George S. Messersmith Papers, MSS 109, Item 1051.
21. Ibid., Item 417.
22. Ibid., Item 1051.
23. Ibid.
24. Brodnitz, "Memories of the Reichsvertretung," 275.
25. Ibid., 276.

CHAPTER 4

26. Feingold, *Politics of Rescue*, 8–9.
27. Ibid., 19, quoted in *New York Times*, February 4, 1938, 12.
28. Bauer, *History of the Holocaust*, 134–35.

CHAPTER 5

29. *CL*, 129–130.
30. Ibid.
31. Ibid., 155.
32. Ibid.
33. Ibid.
34. Ibid., 130–31.
35. Ibid., 179.

CHAPTER 6

36. NA, RG 59, 811.11184, Box 231, Hyde Farmlands, July 11, 1938.
37. Ibid., page 2.
38. Ibid.
39. Ibid.
40. NA, RG 59, 811.11184, Box 231, Hyde Farmlands, August 26, 1938.

CHAPTER 7

41. NA, RG 59, 811.11184, Box 231, October 5, 1938.
42. Ibid., page 2.
43. Ibid., October 25, 1938.
44. Ibid.
45. NA, RG 59, 811.11184, Box 231, Hyde Farmlands, November 1, 1938.
46. Ibid.

CHAPTER 8

47. *CL*, 169.

48. Ibid., 183–84.

49. *American Jewish Committee Year Book*, 1939, 262.

CHAPTER 9

50. NA, RG 59, 862.40 6/1813, M 1284, Roll 22, November 10, 1938.

51. Angress, unpublished English translation of ...*immer etwas abseits*, 144.

52. *CL*, 1,205.

53. Loewenberg, "Kristallnacht as Degradation Ritual," 311.

54. *CL*, 1,572.

55. Curt Bondy, "Problems of Internment Camps," *Testament of Survivors*, found in *CL*, 245.

56. Harvey Newton, "Reminiscences of the Concentration Camp, Buchenwald," 1944, found in *CL*, 1,205.

57. Bondy, "Problems of Internment Camps," *CL*, 426.

58. Ibid.

59. Ibid., 247.

60. Angress, *Between Fear and Hope*, 115.

61. NA, RG 59, 811.111, M 1284, Roll 22, 840.48 Refugees/910, November 15, 1938.

62. Angress, ...*immer etwas abseits*, 188.

63. Ibid., 190.

64. NA, RG 59, 811.111, M 1284, Roll 22, November 19, 1938.

65. Ibid., November 26,1938.

66. Ibid., December 8, 1938.

67. Ibid., December 10, 1938.

68. Angress, *Between Fear and Hope*, 103.

69. NA, RG 59, 811.111, M 1284, Roll 22, December 10, 1938.

70. Ibid., Dec. 23, 1938.

CHAPTER 10

71. Angress, *Between Fear and Hope*, 109.

72. Ibid., 112.

73. *CL*, 245.

74. Ibid.

75. Ibid.

76. Angress, *Between Fear and Hope*, 132.

77. *CL*, 137.

78. Ibid., 231.

CHAPTER 11

79. *CL*, 209.
80. Klinkenborg, "Root Hold," *New York Times*, November 14, 2009.
81. Jacqueline Jacobsohn (Eva's daughter).
82. *CL*, 206.
83. NA, RG 59, Box 231, April 22, 1939.
84. *CL*, 297.
85. Ibid., 318.
86. Ibid., 259.
87. Ibid., 260.
88. Ibid.
89. Ibid., 351.
90. Eva Jacobsohn's work diary, April 10, 1939.
91. Eanes, *Memories of Virginia*, 3.
92. See Covington, *Tobacco Rows in Prince Edward County*.
93. *CL*, 207.

CHAPTER 12

94. NA, RG, 811.11184, Box 231. Hyde Farmlands, November 16, 1938.
95. Ibid., March 1, 1939.
96. Ibid., February 16, 1939.
97. Ibid., March 1, 1939.
98. Ibid., March 31, 1939.
99. Ibid.
100. Ibid., April 22, 1939.
101. Ibid., May 8, 1939.
102. Ibid., May 11, 1939.
103. Ibid., May 16, 1939.
104. Ibid., May 22, 1939.
105. Ibid., June 22, 1939.
106. Ibid., July 18, 1939.
107. Ibid.

CHAPTER 13

108. Angress, …*immer etwas abseits*, 204.
109. Ibid., 258.
110. Cummins, *Nottoway County Virginia*, 33.

CHAPTER 14

111. Dorothy Thompson, "On The Record," *Richmond Times-Dispatch*, August 22, 1939.
112. NRS, RG 248, Bulletin 1, Razovsky and Haber, September 8, 1939, YIVO Archives, mkm 13.4.

CHAPTER 15

113. *CL*, 349–51.
114. Ibid., 441.

CHAPTER 16

115. Angress, *...immer etwas abseits*, 266.
116. Iterviews with Richard Hamlin, Richmond, Virginia, 2008.
117. *CL*, 318.
118. Interviews with Francis and Gloria Weishaar, Crewe, Virginia, 2009–2010.

CHAPTER 17

119. Interview with George Landecker, 2008.

CHAPTER 18

120. Kirshrot and Blackman, *Isi's Story*, 25.
121. Angress, *...immer etwas abseits*, 279–80.

CHAPTER 19

122. *CL*, 415.
123. Thalhimer Family Archives.
124. NA, RG 59, 8111.11184, Box 231, May 8, 1940.
125. Ibid.
126. Ibid., December 2, 1940.
127. Angress, unpublished Hyde Farmlands diary, May 20, 1940.
128. Ibid.
129. *CL*, 400.
130. Ibid., 414.
131. Ibid., 441–42.

CHAPTER 20

132. *CL*, 415.
133. NA, RG 59, 811.11184, Box 231, Hyde Farmlands, January 1, 1941.
134. Ibid., January 31, 1941.

135. Ibid.

136. Angress, Hyde Farmlands diary, February 14, 1941.

137. *CL*, 442.

138. Interview with George and Jesse Landecker, November 2008.

CHAPTER 21

139. *CL*, 428.

140. Ibid., 472.

141. Ibid., 463.

142. Ibid.

143. Ibid., 470–71.

144. Ibid.

145. Ibid., 472.

CHAPTER 22

146. *CL*, 554.

147. Ibid., 558.

148. Ibid. 584.

149. Ibid., 582.

150. Ibid., 1,572–73.

151. Ibid., 1,573.

152. Ibid., 584.

153. Ibid.

154. Ibid., 581.

155. Ibid., 655.

156. Samuel Troy, RJCC Award Banquet, 1954, RJCC Archives, Beth Ahabah archives.

157. George Landecker, quoted in "Thalhimer's List: Saved from Nazi Germany," *Amelia News Journal*, December 4, 1997.

158. Breitman and Kraut, *American Refugee Policy*, note 72, 265.

159. http://www.raoulwallenberg.net/saviors/diplomatslist/dr-raymond-herman-geist-790.

CHAPTER 23

160. NA, RG 59, 811.11184, Box 231, January 1941.

161. M. Thalhimer to Rosenwald, October 20, 1941, YIVO Archives, NRS, RG 248, mkm 13.1–13.69.

BIBLIOGRAPHY

T he Virginia Plan, referenced by the State Department under the heading of Hyde Farmlands, was researched through several collections. First and foremost, the National Archives, located at College Park, Maryland, contains the State Department records dealing with visa and refugee matters. The complete records of the Hyde Farmlands project, from 1938 to 1941, were found in RG 59, Stack 230, Compartment 23, Shelf 07, labeled NND775007, Box 231, 811.1185/231. This file revealed the details of the State Department's deliberations regarding the visas of those coming to Hyde Farmlands. Other valuable information was gleaned from individual files on immigrants and through the microfilmed communications between the State Department and the consul general in Berlin. The consulate's records in Berlin were destroyed during the war. William Thalhimer's personal and legal papers were lost, as were those of Leroy Cohen.

THE *CIRCULAR LETTERS*

The *Circular Letters*, the *Rundbriefe*, is not presently a book in the normal sense of the word. It exists as digital matter that is provided via the Internet (http://grossbreesensilesia.com). It is a huge archive, a compilation of letters, essays, news reports, reunion reports, personal thoughts and documents, all related to the students of Gross Breesen. This immensely important source, available digitally, was preserved and produced largely through the gigantic effort of Herbert P. Cohn (Herko), a Gross Breesener who immigrated to

Australia in the late 1930s. The *Circular Letters* is the most accurate source for understanding the lives of the students who escaped from Gross Breesen.

The *Letters* began as a vehicle to communicate information about the agricultural training institute at Gross Breesen. In May 1936, about nine weeks after it opened its doors, Bondy wrote, on page 26, "Therefore we have assembled several letters and hope that they can report something of what Gross Breesen is, and what we plan to do." This was the beginning of numerous editions that circulated worldwide among the students and staff for more than seventy years. After Bondy's death, Ernst Cramer, Werner Angress and Herbert Cohn took on the responsibilities of editing, producing and disseminating the *Letters*. It was through the *Letters* that the spirit of Gross Breesen was kept alive and continued to exert its influence.

The *Circular Letters* provides primary information that has not been tainted by secondary interpretation. It is interesting how earlier events and concerns were viewed by the students as they reflected on their individual and collective experiences later in life. Sometimes, it took fifty years before the meaning of past events could be understood. The *Circular Letters* is a testament of the endurance and flexibility of the human spirit. Without it, the story of Gross Breesen and Hyde Farmlands could not be accurately researched.

BOOKS

Angress, Werner T. *Between Fear and Hope*. New York: Columbia University Press, 1988.

———. *...immer etwas abseits, Jugenderinnerungen eines juice Berliners 1920–1945*. Berlin: Edition Hentich, 2005.

———. Personal diary (unpublished), 1938–41.

Baker, Leonard. *Days of Sorrow and Pain: Leo Baeck and the Berlin Jews*. New York: Macmillan Publishing Co., Inc., 1978.

Bauer, Yehuda. *A History of the Holocaust*. Danbury, CT: Franklin Watts, 2001.

Berman, Myron, *Richmond's Jewry, 1769–1976*. Charlottesville: University Press of Virginia, 1979.

Breitman, Richard, and Alan M. Kraut . *American Refugee Policy and European Jewry, 1933–1945*. Bloomington: Indiana University Press, 1987.

Cohn, Herbert, ed. "A Testament of the Survivors, A Memorial to the Dead: The Collection of Gross Breesen Letters and Related Materials," 2010. http://grossbreesensilesia.com.

Commonwealth of Virginia, State Corporation Commission, Office of the Clerk records.

Bibliography

Covington, Julian, and Edwina Covington. *Tobacco Rows in Prince Edward County*. Appomattox, VA: Village Print Shop, 2006.

Crowe, David M. *The Holocaust: Roots, History, and Aftermath*. Boulder, CO: Westview Press, 2008.

Cummins, A.B. *Nottoway County Virginia: Founding and Development with Biographical Sketches*. Richmond, VA: W.M. Brown and Son, Inc., Printers, 1970.

Eanes, Greg. *Memories of Virginia Civilian Conservation Corp Camps*. Crewe, VA: E&H Printing, 1999.

Evans, Richard J. *The Coming of the Third Reich*. New York: Penguin Books, 2005.

Feingold, Henry L. *The Politics of Rescue: The Roosevelt Administration and the Holocaust, 1938–1945*. New York: Holocaust Library, 1970.

Finder, Gabriel N. "Education Not Punishment: Juvenile Justice in Germany, 1890–1930." PhD dissertation, Department of History, University of Chicago, June 1997.

Friedlander, Albert H. *Leo Baeck: Teacher of Theresienstadt*. Woodstock, NY: Overlook Press, 1991.

German Jewish History in Modern Times 1600–1945. New York: Leo Baeck Institute, n.d.

Gilbert, Martin. *Kristallnacht: Prelude to Destruction*. London: Harper Press, 2006.

Kirshrot, Isidor, and Martin Blackman. *Isi's Story: A Long Unlikely Life*. Tacoma, WA: self-published, 2000.

Leff, Laurel. *Buried by the Times: The Holocaust and America's Most Important Newspaper*. New York: Cambridge University Press, 2005.

Lipstadt, Deborah E. *Beyond Belief: The American Press and the Coming of the Holocaust 1933–1945*. New York: Free Press, 1986.

Mau, Hermann, and Helmut Krausnick. *German History 1933–1945: An Assessment by German Historians*. London: Oswald Wolff (Publishers) Limited, 1978.

Meyer, Michael A., ed. *German-Jewish History in Modern Times*. Assistant ed. Michael Brenner. New York: Columbia University Press, 1998.

Morse, Arthur D. *While Six Million Died*. New York: Overlook Press, 1998.

Niewyk, Donald L. *The Jews in Weimar Germany*. New Brunswick, NJ: Transaction Publishers, 2001.

Nottoway County Records, Deed Book 3–4, 1747–53, 385.

Southside Electric Cooperative. *50th Anniversary, 1937–1987: Helping Rural Families Live Better…Electrically*. Virginia: SEC Public and Member Relations Department, 1987.

Stiller, Jesse H. *George Messersmith, Diplomat of Democracy*. Chapel Hill: University of North Carolina Press, 1987.

Turner, W.R. *Old Homes and Families in Nottoway*. Blackstone, VA: Nottoway Publishing Co., Inc., 1950.

Wyman, David S. *The Abandonment of the Jews*. New York: New Press, 1998.

————. *Paper Walls: America and the Refugee Crisis, 1938–1941.* New York: Pantheon Books, 1985.

Wyman, David S., and Rafael Medoff. *A Race Against Death: Peter Bergson, America, and the Holocaust.* New York: New Press, 2002.

Zucker, Bat-Ami. *Cecilia Razovsky and the American-Jewish Women's Rescue Operations in the Second World War.* Portland, OR: Valentine, 2008.

————. *In Search of Refuge: Jews and US Consuls in Nazi Germany 1933–1941.* Parkes-Wiener Series on Jewish Studies. Portland, OR: Valentine, 2001.

PERIODICALS AND JOURNALS

Angress, Werner T. *Auswandererlehrgut Gross Breesen* 10 (1965): 168–87. *Leo Baeck Institute Year Book.*

Baeck, Leo. "In Memory of Two of Our Dead: Otto Hirsch and Julius Seligsohn." *Leo Baeck Institute Year Book* (1956): 51–56.

Boas, Jacob. "German-Jewish Internal Politics under Hitler, 1933–1938." *Leo Baeck Institute Year Book* 29 (1984): 3–25.

————. "The Shrinking World of German Jewry, 1933–1938." *Leo Baeck Institute Year Book* 31 (1986): 241–66.

Breitman, Richard, Alan M. Kraut and Thomas Imhoof. "The State Department, the Labor Department, and German Jewish Immigration, 1930–1940." *Journal of American Ethnic History* 3, no. 2 (Spring 1984).

Brodnitz, Friedrich S. "Memories of the Reichsvertretung: A Personal Report." *Leo Baeck Institute Year Book* 31 (1986): 267–76.

Klinkenborg, Verlyn. "Root Hold." *New York Times*, November 14, 2009.

Lipstadt, Deborah E. "The American Press and the Persecution of German Jewry. The Early Years 1933–35." *Leo Baeck Institute Year Book* (1984): 27–55.

Loewenberg, Peter. "The Kristallnacht as a Public Degradation Ritual." *Leo Baeck Institute Year Book* (1987): 309–23.

Moss, Kenneth. "George S. Messersmith: American Diplomat and Nazi Germany." *Historical Society of Delaware* 17 (1977): 236–49. Wilmington, Delaware.

Sauer, Paul. "Otto Hirsch (1885–1941): Director of the Reichsvertretung." *Leo Baeck Institute Year Book* (1987): 341–68.

Schatzker, Chaim. "The Jewish Youth Movement in Germany in the Holocaust Period: Youth in Confrontation with a New Reality." *Leo Baeck Institute Year Book* (1987): 157–81.

————. "Martin Buber's Influence on the Jewish Youth Movement in Germany." *Leo Baeck Year Book* 19 (1974): 77–95.

Schneiderman, Harry, ed. *American Jewish Committee Year Book* 34–42 (October 1, 1932–September 21, 1941). Jewish Publication Society, Philadelphia.

Shafir, Shlomo. "American Diplomats in Berlin 1933–39 and their Attitude to the Nazi Persecution of the Jews." *Yad Vashem Studies on the European Jewish Catastrophe and Resistance* 9 (n.d.): 71–104. Jerusalem.

Stahl, Rudoph. "Vocational Retraining of Jews in Nazi Germany 1933–1938." *Jewish Social Studies* 1, no. 2 (April 1939): 169–94.

Strupp, Christoph. "Observing a Dictatorship: American Consular Reporting On Germany, 1933–1941." *GHI Bulletin*, no. 39 (Fall 2006): 79–98.

Tolischus, Otto D. "Trouble-Shooter in Berlin." *New York Times Magazine*, July 23, 1939.

Zucker, Bat-Ami. "Francis Perkins and the German-Jewish Refugees, 1933–1940." *Journal of American Jewish Historical Society* 89, no. 1 (March 2001): 35–59.

ARCHIVAL COLLECTIONS

American Jewish Archives, Cincinnati, Ohio. Collection 13, File 30, Boxes 2–3.

Crewe Chronicle.

Messersmith Papers, Special Collections, University of Delaware, Newark, Delaware.

National Archives: State Department Records, RG 59.

 RG 59, Stack 230, Compartment 23, Shelf 07, labeled NND775007, Box 231, 811.1185/231.

 RG 59, Refugees, 811.1184.

 RG 59, Curt Bondy, 811.11184.

 Microfilm: RG 59, M1284.

Richmond News Leader.

Richmond Times-Dispatch.

Thalhimer Family Archives. Richmond, Virginia.

Virginia Holocaust Museum Archives, Richmond, Virginia.

YIVO Archives, Center for Jewish Research, New York.

 NCC records found in RG 247, microfilm only, mkm 3.1–3.6.

 NRS records found in RG 248, microfilm only, mkm 13.1–13.69.

PHOTOGRAPHIC COLLECTIONS

American Jewish Archives.

Angress Family Collection.

Robert Gillette, Private Collection.

George Landecker Private Collection.

Eva Loew Private Collection.

Thalhimer Family Private Collection.

Virginia Holocaust Museum Archives.

INDEX

ABOUT THE AUTHOR

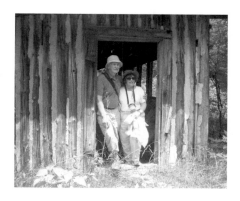

Author Bob Gillette and his wife, Marsha, research chicken houses at Hyde Farmlands. *Courtesy of Suzie Jackson.*

B ob Gillette's entire professional career revolved around young people. For forty years, he was a public school educator. He was nationally recognized for his high school program OTO, Opportunities to Teach Ourselves, in Fairfield, Connecticut. For his innovations in experiential education, he was awarded the Mary Gresham Chair, a $300,000 grant by the New England Program of Teacher Education and the Department of Commerce. He has spoken and consulted nationally on educational topics. Simultaneously, he directed religious education programs and created curricula in Jewish education. He is a graduate of Wesleyan University, earning a BA and an MAT, and he studied at the Hebrew Union College, the Reform Jewish rabbinical seminary. An avid canoe and kayak paddler, his first book, *Paddling Prince Edward Island*, a Falcon Guide, was published in 2006.

Bob and his wife, Marsha, paddling partners for fifty-one years, live in Lynchburg, Virginia. They both were smitten with the Hyde Farmlands story and its people. Together they interviewed several of the surviving students. As Connecticut Yankee transplants, they are both committed to discovering their new "southern Jewish roots." They have three sons, daughters-in-law, four granddaughters, a grand-cat and two grand-dogs.

Visit us at
www.historypress.net